DRAWING BASICS and
VIDEO
GAME
ART

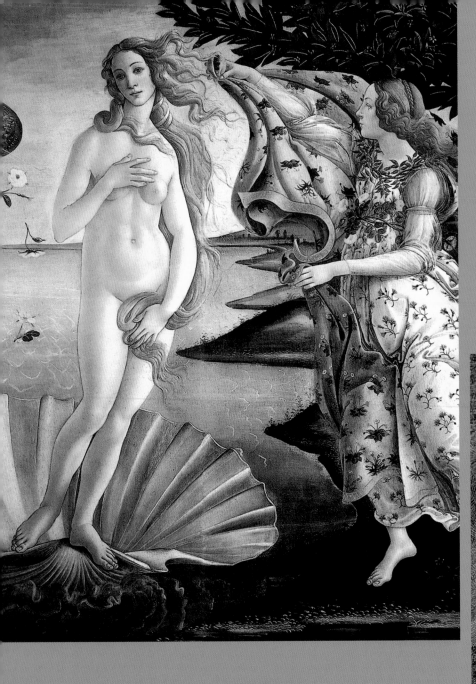
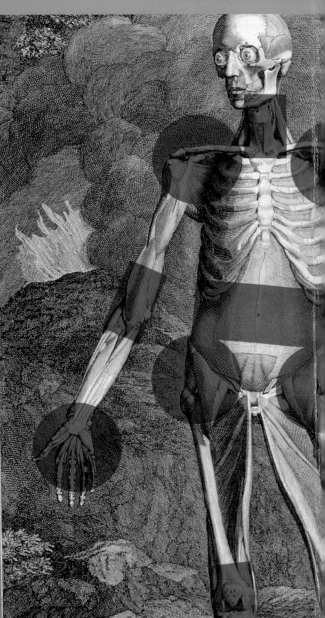

DRAWING BASICS and VIDEO GAME ART

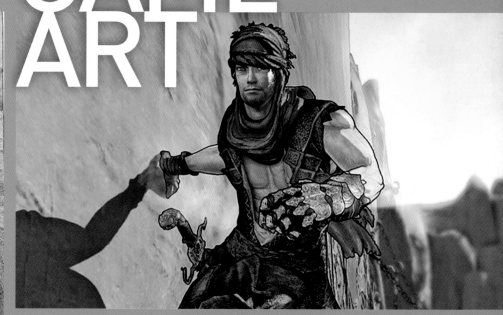

CLASSIC TO CUTTING-EDGE
ART TECHNIQUES FOR
WINNING **VIDEO GAME DESIGN**

CHRIS SOLARSKI
FOREWORD BY **TRISTAN DONOVAN**

WATSON-GUPTILL
NEW YORK

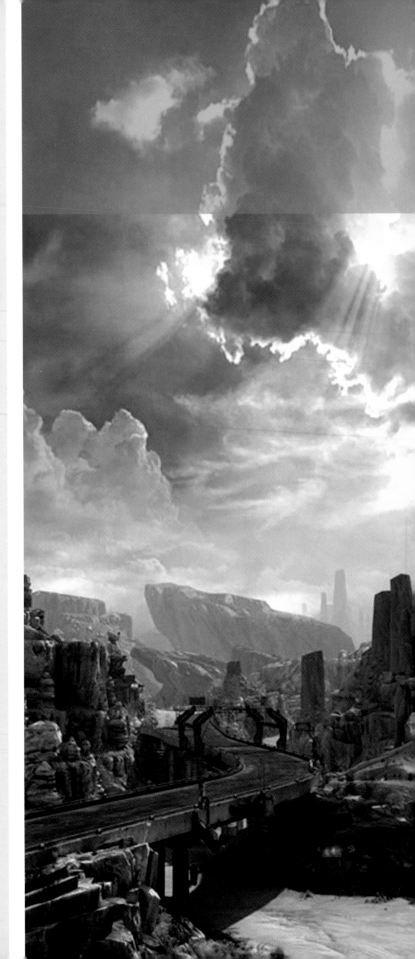

Published in the United States by Watson-Guptill Publications, an imprint of the Crown Publishing Group, a division of Random House, Inc., New York.

www.crownpublishing.com
www.watsonguptill.com

WATSON-GUPTILL is a registered trademark and the WG and Horse designs are trademarks of Random House, Inc.

Artwork by Chris Solarski, except as otherwise noted throughout and below:

Images from *Gears of War*® on pages 6, 71, 120, 170, 220, and 221 © Copyright 2006 Epic Games, Inc. used with permission from Epic Games, Inc. *Unreal, Unreal Engine, Gears of War* and Epic Games are trademarks or registered trademarks of Epic Games, Inc., in the United States of America and elsewhere. All rights reserved.

Flower artworks on page 182 © 2008 Sony Computer Entertainment America LLC. *Flower* is a registered trademark of Sony Computer Entertainment LLC. Developed by thatgamecompany.

Journey artworks on pages 1, 43, 148, 149, 162, 172, 183, 206, 218–219, and 226 © 2011 Sony Computer Entertainment America LLC. *Journey* is a registered trademark of Sony Computer Entertainment LLC. Developed by thatgamecompany.

Library of Congress Cataloging-in-Publication Data

Solarski, Chris.
Drawing basics and video game art : classic to cutting-edge art techniques for winning video game design / By Chris Solarski.
1. Computer games — Design. 2. Video games — Design. 3. Art — Technique. I. Title.
QA76.76.C672S65 2012
794.8'1536 —dc23
2011046341

ISBN 978-0-8230-9847-7
eISBN 978-0-8230-9848-4

Printed in China

Book and cover design by Karla Baker

Cover art: Front (clockwise, left to right): *Self-Portrait, Frowning* by Rembrandt van Rijn; anatomical studies of the leg by Peter Paul Rubens; *New Super Mario Bros.; Assassin's Creed.*
Back (clockwise, left to right): *Gears of War; Little Big Planet; Journey.*
Spine: Mario.

10 9 8 7 6 5 4 3 2 1

First Edition

HALF-TITLE PAGE *Journey*

TITLE PAGE Detail of *The Birth of Venus* by Sandro Botticelli, *Skeleton with Muscles* by Bernhard Siegfred Albinus, *Prince of Persia*

OPPOSITE *RAGE*

I dedicate this book to **Didi Meier**, who courageously endured my absence while I was writing.

"Thank you for your love and support, Didi!—*most* of the time. ;)"

ACKNOWLEDGMENTS

I would like to sincerely thank the following people for their support in making this book possible: my family and friends; Victoria Craven, Editorial Director at Watson-Guptill, who had the vision to see a book when she read my *Gamasutra* article; my editor, Martha Moran, whose patient guidance and diligence was instrumental in bringing everything together; Ben Fisher, for dedicating precious time to reviewing the anatomy sections of this book and for his invaluable insights; Tristan Donovan, Alex Learmont, Dr. Bob Sumner, Andi Brandenberger, Alex Pons Carden-Jones, Michael Lew, and Pascal Mueller for their feedback and assistance; my most influential teachers, whose wealth of knowledge is much a part of this book: Brendan Kelly, Michael Mentler, and Zofia Glazer; at Gbanga: Matthias Sala, cofounder and CEO, and Werner Sala, cofounder and CFO, for their limitless generosity and kindness and for giving me time away from my duties at Gbanga when I most needed it; Christine Matthey and Sylvain Gardel for their ongoing support through www.GameCulture.ch and the Swiss Arts Council; Christian Nutt, features editor at *Gamasutra*, who published the online article that was the original inspiration for this book; Spring Gombe for kindly hosting discussions at Up the Rock: Salon der Künste and those who attended to give their crucial input, including Eugeniya Kareva, Marc Bodmer, Serge Pinkus, and Ulrich Götz; Janina Woods and Kaspar Manz for being on call to share their extensive knowledge of video games.

 This book could not have happened if it wasn't for the following people who kindly helped source the outstanding artwork featured throughout (and equally the images that didn't make it in) despite their hectic schedules: Craig Adams and Jori Baldwin at Superbrothers; Emily Britt at 2K Games; Jonnie Bryant at Blizzard Entertainment; Myrna Anderson at Atari, Inc.; Sam Woodward and the team at Irrational Games; Ruth Kelly, Emma Tietjens, and Michael Evans at SCEE; Brian Dunn and Claudine Rican at SCEA; Jenova Chen at thatgamecompany; Arnt Jensen at Playdead; Cathy Campos, Emrah Elmasli, Mike McCarthy, and Tak Saito at Lionhead Studios; Simon Flesser at Simogo; Moby Francke at Valve Corporation; Janna Smith at Namco Bandai Games; Mark Healey, Alice Liang, and Luci Black at Media Molecule; Chris Boba at Corel and Alexander Hopstein at Adobe for giving me support with their fantastic graphics software.

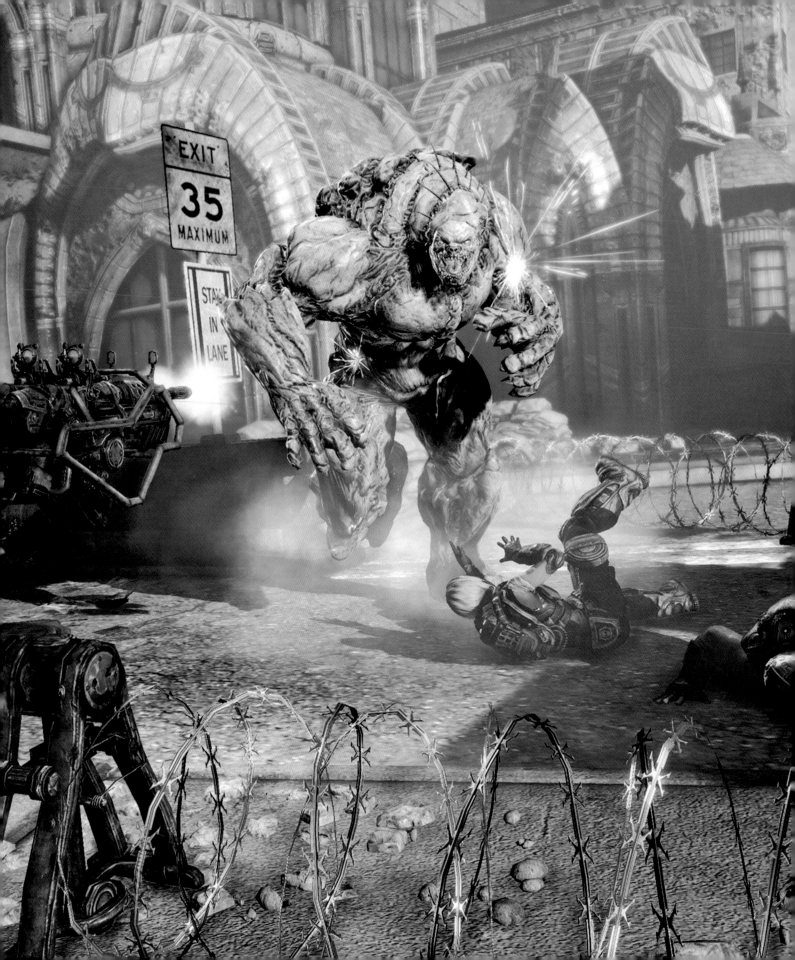

CONTENTS

Gears of War 2

FOREWORD

We often treat games as if they exist in a bubble. Players and nonplayers alike talk as if they are separate, somehow dislocated, from the rest of society and culture. Yet games are very much shaped by the wider world and visual vocabulary honed over centuries by artists past and present.

But too often game developers don't know or fail to draw on this treasure chest of artistic know-how. Since the earliest days of video games they have repeatedly defaulted to the conservative visual tropes of Tolkienesque fantasy, *Blade Runner* sci-fi, and Japanese manga and anime without any vision for how to reinvigorate them. At other times they are lured by the Siren call of realism, mistaking an extra million polygons' worth of detail for an artistic leap forward when it's just another layer of information for player brains to filter through.

Game art doesn't have to be this unimaginative, as Chris Solarski expertly demonstrates within this book. He explains clearly and accessibly how art's rich past offers game makers an arsenal of visual techniques that can heighten, reinvent, or shape the player experience in emotional as well as visual terms. We learn how *RAGE* follows in Michelangelo's footsteps, how *Team Fortress 2* echoes Tintoretto, and how an artist's understanding of shapes can explain the importance of roundness in Mario's appeal.

This isn't an academic art history polemic, though. It's an immensely practical book that seeks to equip game developers with tools they can use in their daily work. It explains, from an often-neglected visual viewpoint, why some of gaming's most iconic characters and environments are so memorable and enduring.

Even for a non-game-developer such as myself, Solarski's book is an indispensable guide to the visual lexicon of art and interactive entertainment that shines a clear, bright, illuminating light on why the visuals of some games "work" and others do not.

Tristan Donovan, author of *Replay: The History of Video Games*
www.tristandonovan.com

PREFACE

I CAME TO THE VIDEO GAME INDUSTRY with a foundation in digital art. After graduating with a degree in computer animation I was lucky enough to secure work at Sony Computer Entertainment's London Studio as a 3D environment and character artist.

It was at an art workshop organized by ConceptArt.org (a forum that promotes, develops, and showcases concept art for illustration, film, and game production), when I saw artists like Andrew Jones demonstrate the amazing ability to create lifelike characters straight from their imaginations, that I began to question my lack of traditional art training. I saw that it was their mastery of classical art principles that placed them in the enviable position of being first to visualize characters and environments in the development process, for which artists like me would produce 3D models and textures based on their designs. I had a lot of catching up to do if I wanted to be involved in the highest levels of game design.

I took part-time painting lessons from the award-winning painter Brendan Kelly while continuing to work in video game development. Brendan taught me about the discipline and dedication to classical art training that is required to become a successful artist in any field.

Armed with a solid foundation in classical painting, I abandoned video game development altogether and spent the next two years on an intense program of self-guided study in Poland, where I attended daily life-drawing sessions at the Warsaw Academy of Fine Art and the atelier of professor Zofia Glazer, simultaneously sharing my experiences and learning from the online figurative drawing community at the Society of Figurative Arts (www.tsofa.com), created by the artist and teacher Michael Mentler.

During these two years I developed a deep appreciation for the value of a classical art education and the techniques of the Old Masters. I realized that the majority of video game artists (me included) significantly undervalue these skills.

In 2008 I was back in game development as art director at Gbanga (developer of the pioneering location-based gaming platform for mobile phones) and continued to work on figurative drawing and painting.

Switzerland's Arts Council, Pro Helvetia, invited me to give a talk about the connection between classical art and video games at the first Game Culture conference. It was while preparing for this lecture that I really saw the connections that I had previously taken for granted between the two disciplines. Video games are a natural progression of classical art, and the same visual grammar and artistic techniques and principles underpin both disciplines. I realized that applying classical art techniques to video game art would enable artists to create more meaningful visual and emotional experiences for the video game player.

This book is the culmination of the unique experiences and insights I accumulated over the past ten years that have enriched my video game art and enhanced my career. Not everyone is in a position to take a couple of years away from work to study at an art institute. I've designed the lessons in this book to be your own personal art school, and my hope is that this knowledge and experience will take your art to new and higher levels.

CHRIS SOLARSKI

StarCraft II: Wings of Liberty (Artwork courtesy of Blizzard Entertainment)

INTRODUCTION:
CLASSICAL ART VS. VIDEO GAMES

VIDEO GAMES ARE NOT A REVOLUTION in art history, but an *evolution.* Whether you are drawing on paper, canvas, or a computer screen, the medium on which you draw is always an inanimate, flat surface that challenges you to make something without depth feel like a window onto a living, breathing world.

The technology powering today's games influences the way we experience visual art in a new way—with the gentle push of a player's thumb we can now interact with these visual worlds. But take away that interaction and what remains is the static visual artwork itself. And the success of that artwork relies on the same visual grammar (lines, shapes, volumes, value, color) and classical art techniques that have evolved over two thousand years.

The focus of this book is how far we can push the world of game art in purely visual terms without relying on the technology of interaction, that is, on sound, special effects, and animation. By going back to square one and studying the basic elements and significance of visual grammar and technique, you will discover how visual grammar can be artistically shaped to create a range of emotional experiences using classical theory of depth, composition, gravity, movement, and artistic anatomy. (That's why distinguished video games like *BioShock*, *Journey*, *ICO*, and *Portal 2* are featured alongside the work of Old Masters such as Michelangelo, Tintoretto, and Rubens in all the drawing exercises throughout the book.) Later in the book these essential skills are applied to game art creation, providing you with reliable processes for creativity and imagination, character development, environment design, and color. I'll also show you how to put together a professional portfolio to help you secure work in game development.

Viewed from an angle, the similarities between drawing, painting, and game imagery become more apparent, as the illusion of life and depth in each artwork is created on a two-dimensional, static surface. Without the benefits of digital animation and interaction, the challenge of creating a window into a make-believe world is the same for video game artists as it was for the Old Masters.

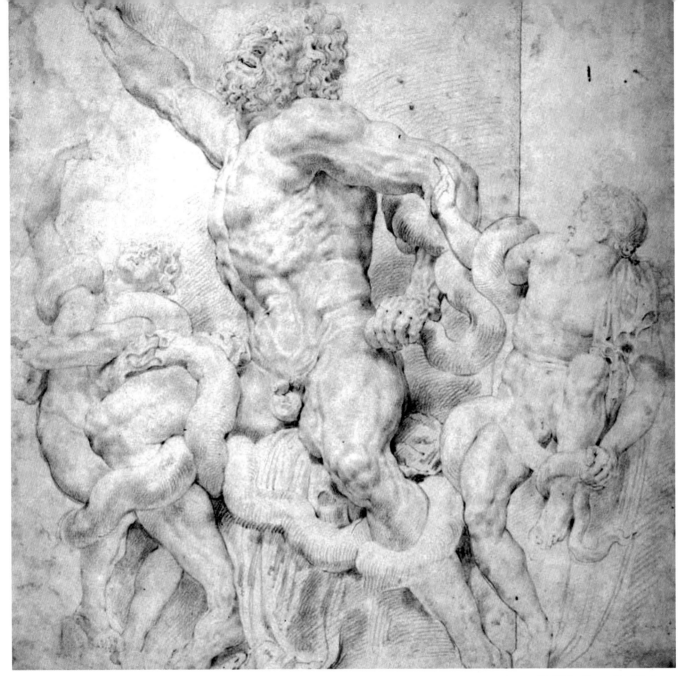

Study of the Laocoön Group (1601) by Peter Paul Rubens (1577–1640)

The Laocoön Group sculpture was created sometime around 25 BC, more than sixteen hundred years before Rubens made this study. Rubens and other master artists like Michelangelo and Tintoretto continued to make studies of ancient Greco-Roman sculptures throughout their careers.

There are a significant number of techniques to master in this book. Although each is fairly simple, the drawing process becomes significantly more difficult when managing several techniques simultaneously while rendering complex subjects, such as human figures. Discipline through repeated practice is required to maintain a clear and structured process when drawing.

Ideally, you should practice drawing every day. One of the best ways to practice is to copy artworks of artists you admire. Copying art allows you to absorb the artist's ideas and experience his or her process and then apply it to your own work. The Old Masters themselves used this technique, refining and perfecting their skills by endlessly copying artworks like the statues of the Greeks and Romans. The lessons in this book are based on this copying concept, and each of the classical and game artworks is a drawing lesson. (The text accompanying the art explains the visual grammar and techniques in the work.) Keep a sketchbook and pencil at hand as you work through this book, making a quick study of each artwork as you read through the chapters. The straightforward quality of the drawing medium will allow you to easily identify skills that need improving and will help you develop a higher level of dexterity and understanding of artistic principles when creating artwork for video games.

Classical artists made their studies and preparatory drawings deliberately small, as a small drawing is easier to manage and quicker to complete. The art in this book is purposely sized to make it easy to copy in your sketchbook without having to scale it down to fit the page.

Whether you're a student looking for a career in video game development or an industry veteran, this book will give you the tools to be creative on demand and to design video games with a broader range of emotional experiences that affect players in new and meaningful ways.

Let's get to work!

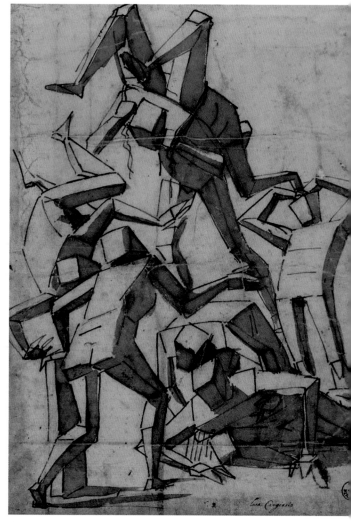

Group of Figures by Luca Cambiaso (1527–1585)

The preparatory sketches of Luca Cambiaso are explicit examples of the conceptual process that classical artists practiced to simplify complex forms. They distilled objects to basic geometric volumes, which gave them the ability to create convincing figures from their imaginations, as you can see in this Cambiaso sketch. This process of visualizing complex forms as basic volumes allowed the Old Masters to freely design compositions and work out complex problems of depth, light, anatomy, proportions, and the illusion of movement. Until details were added, the theme and identities of their figures could go in any number of directions.

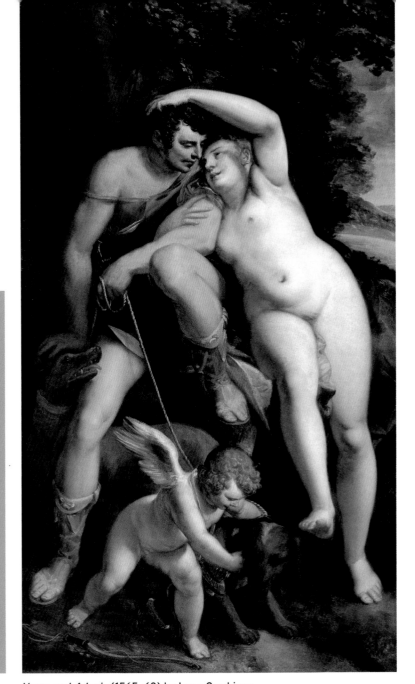

Typical 3D character base mesh, by Andi Brandenberger

The classical preparatory stage is mirrored in game development, where every 3D model starts off as a nondescript *base mesh*. The forms and proportions of the base mesh are shaped to the general design of the final character before subsequent stages of refinement are undertaken. Unlike traditional mediums, the computer automates many of the technical challenges of calculating perspective and light.

Venus and Adonis (1565–69) by Luca Cambiaso

Luca Cambiaso would have likely created his preparatory composition sketches from imagination but relied on models for studying details and for the final stages of painting. Any details he introduced would then overlay the composition and conceptual volumes established in the earlier preparatory stages.

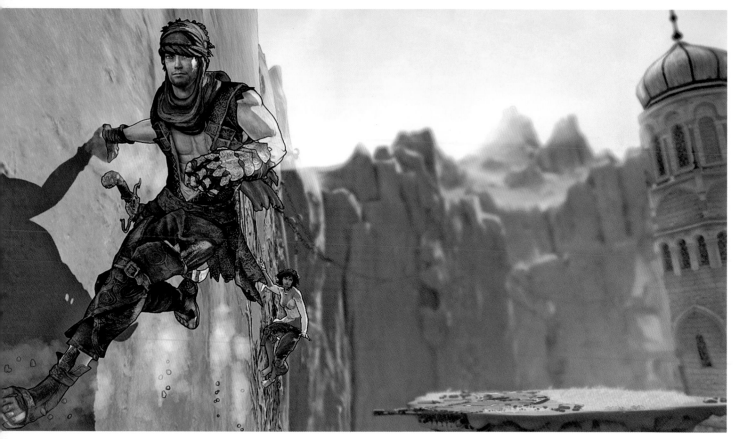

The Prince and Elika in Ubisoft's *Prince of Persia* (2008)

After the broader forms of the base mesh are established, artists can go about adding details such as facial features, textures, and animation based on previsualization and research relating to the game's overall theme.

The surprising thing we'll discover throughout this book is that it's the preparatory base mesh stage, not the details, which is primarily responsible for the viewer-player's emotional experience. Details are merely the fine-tuning of a broader concept.

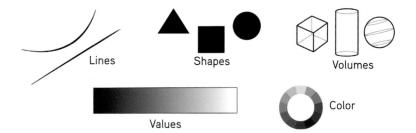

Lines

Shapes

Volumes

Values

Color

How do we go about creating complex emotions for our characters and game designs? And what exactly is visual grammar? The answer is surprisingly simple: lines, shapes, volumes, value, and color. Each element is deceptively simple but it's how we manipulate, stretch, combine, contrast, subvert, and animate these elements that creates an infinite number of expressive possibilities. You'll develop an understanding for the significance of each element through the practice of drawing.

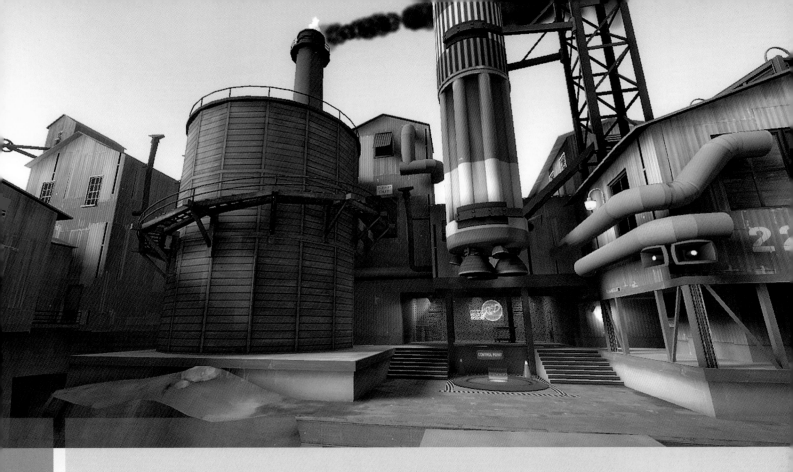

LEVEL 01 [FUNDAMENTALS

THE FUNDAMENTAL TECHNIQUES we'll cover in this level—learning to use drawing media and tools; basic concepts like perspective, volume, light, shadow; and the basic drawing process—provide the foundation for all subsequent lessons in this book. The fundamental techniques—along with Levels 2 and 3—represent the base mesh stage. Practice them until you have some proficiency before moving on to subsequent chapters where increasingly complex subjects will be simplified using the techniques learned in this level.

Team Fortress 2 (Artwork courtesy of Value Corporation)

MATERIALS

The best tools for practicing classical art techniques are pencil on paper because these straightforward media allow you to really focus on the fundamentals of the drawing process: *position*, *direction*, and *pressure*.

You'll need just a few supplies for all the drawing exercises in the book—pencils, erasers, a ruler, and paper. (For research and development, which we'll cover in Level 6, you will also need a computer with Internet access and a scanner.)

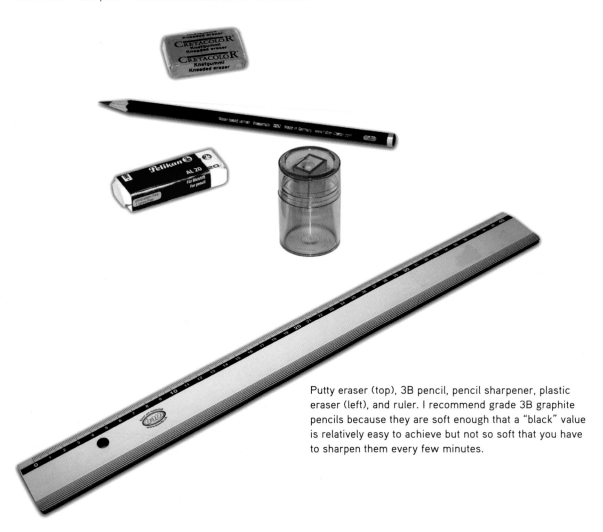

Putty eraser (top), 3B pencil, pencil sharpener, plastic eraser (left), and ruler. I recommend grade 3B graphite pencils because they are soft enough that a "black" value is relatively easy to achieve but not so soft that you have to sharpen them every few minutes.

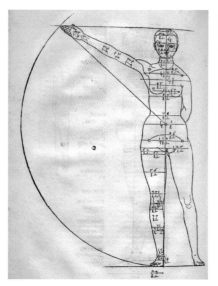

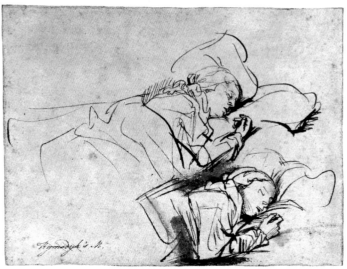

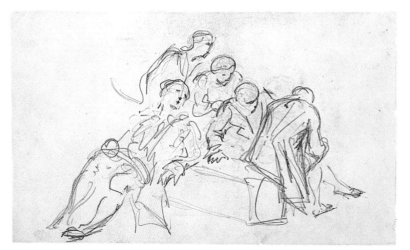

Sketchbook studies by (clockwise from top) Albrecht Dürer (1471–1528), Rembrandt van Rijn (1606–1669), John Singer Sargent (1856–1925), Eugène Delacroix (1798–1863)

Most artists find inspiration and ideas when they're away from their studio or drawing space, so it's useful to have a portable sketchbook on hand at all times as a visual diary for daily experiences and ideas. The above examples from Master artists' sketchbooks illustrate these myriad uses, ranging from Dürer's proportion studies to Sargent's gesture drawings. The moments just before going to sleep and when waking up are often the most creative, so be ready to capture those thoughts on paper before you forget them. Sketchbook paper should be acid-free, for archival purposes, and around 80 lb (170 gm).

BASIC PENCIL TECHNIQUES

Even if you're an experienced artist it's worth working through these fundamentals, which will improve processes that you may otherwise take for granted—like how you hold a drawing pencil. Most of us instinctively assume the same grip for drawing that we use when writing; fingers and thumb near the tip with the heel of the hand resting on the paper for stability. But, unlike writing letters, drawing requires sensitivity and freedom of movement, which necessitates a different style of grip and motion. Your eraser is your pencil's companion, and using it with skill entails a lot of practice and experimentation. Here are some basic pencil, eraser, and shading exercises that will help you develop and perfect your skills.

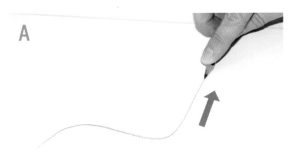

A

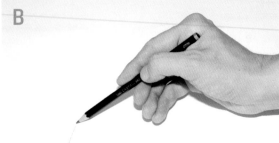

B

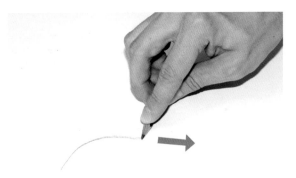

Here are the two most common ways to hold a drawing pencil. With grip (**A**) the pencil is held from above with the forefinger pressing down on the pencil shaft. This grip is great for general drawing purposes as it allows free movement to pull or swipe the pencil in almost any direction. Vary the line quality between sharp and soft by changing the angle of your wrist in relation to the direction of movement.

Grip (**B**) is useful for light and delicate lines like perspective guidelines. The grip for (**B**) is further up the shaft, so there's less pressure placed on the tip.

Both grips prevent the heel of your hand from resting on the paper (as when writing), making you draw from the shoulder and enabling a wider pivot so you can create longer, flowing lines.

Which grip you use and how high or low you hold the pencil will vary constantly according to the quality of line you desire.

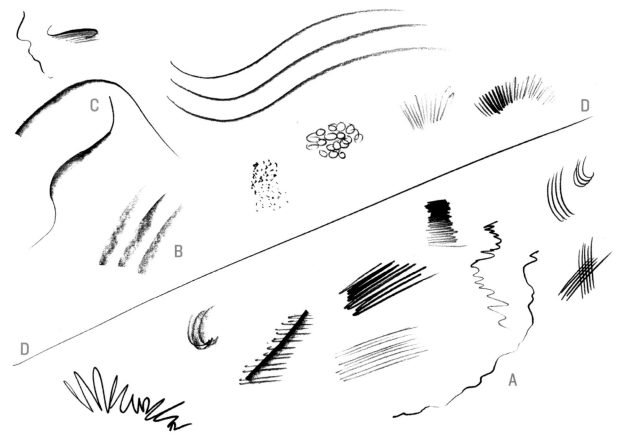

Try the various grips with a series of mark-making exercises as shown here. Draw with the pencil tip for thin lines (**A**) and use the side of the tip for wider lines (**B**); or try switching between the two along the length of a line (**C**). Also have a go at drawing long straight lines across the entire paper surface (**D**). Take at least one opportunity to see how hard you can press before the pencil's tip breaks off.

It's important to keep the pencil sharp at all times. A neat trick to avoid constant sharpening is to rotate the pencil along its length as you draw.

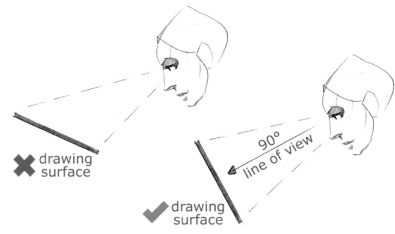

Foreshortening is the optical illusion linked to perspective that makes distant objects look smaller in relation to closer objects. It is a useful visual tool to create the illusion of depth, but if you work too large or draw on a surface not angled properly, your perspective may be distorted, causing you to unnecessarily exaggerate features to compensate for foreshortening. To avoid this problem, always draw on a surface tilted at a perpendicular (90-degree) angle to your line of view and keep your drawings small; 6" x 8" (14.8 x 21 cm) is sufficient for a full-figure study.

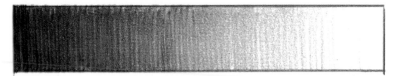

A fundamental exercise with any artistic medium is creating a black-to-white value scale as shown here. You may find it helps to change the pencil grip to achieve the full range of values: nearer the tip for darker values, delicately shifting the grip further up for lighter marks.

It's vitally important that you achieve a strong *black* at the darkest end of the scale as strong darks will be essential to achieving realistic value contrasts in your drawings. If you're finding it difficult to get the necessary contrast, you might need to try a different brand of 3B pencil or switch to a softer, grade 4 pencil. More often than not it's just a case of having the confidence to push down more firmly on the paper surface.

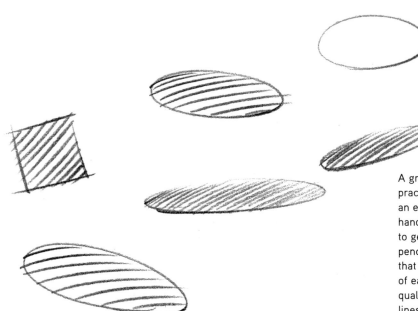

A great exercise to perfect your pencil technique is to practice drawing ovals and squares, filling them in with an even value of shading. This exercise helps develop hand-eye coordination and control, which is essential to getting your ideas down clearly and quickly. Lift the pencil off the page at the end of each pencil stroke, so that you have more control over the shape and direction of each line, giving your shading a stronger, descriptive quality. Shading with a zigzagging motion and scratchy lines will make your drawings undefined and accuracy difficult to achieve.

The contour line that forms each oval should overlap precisely at the point where it starts. If you find that the start and end of each line are not linking up, then you're likely drawing from the wrist and resting the heel of your hand on the paper, thus restricting your freedom of movement. You may also need to make swifter circular actions to create tighter circles. Try to keep your shading within the bounds of the outer contour lines.

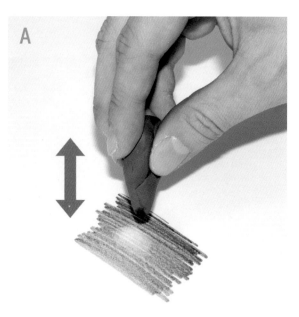

A

You'll need both putty and plastic erasers because each has a unique purpose. The plastic eraser is the most familiar to us, used primarily to remove large amounts of shading to take the paper back to its original white.

The putty eraser (shown here) is more like a drawing tool and is used in combination with the pencil. Think of the putty eraser as your white and the pencil as your black. It can be kneaded into different shapes to achieve different line qualities, and comes in handy when you need to delicately lighten areas of shading or soften edges, either by dabbing (A) or rubbing (B) the soft eraser gently across your drawing. Experiment with different eraser shapes and techniques until you are as proficient with the eraser as you are with your pencil.

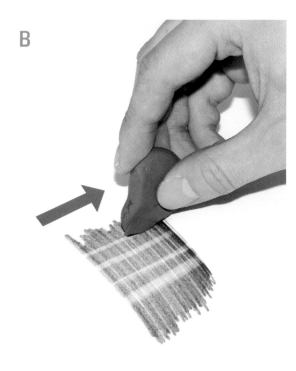

B

The Seven Basic Pencil Marks or Strokes

Seven basic marks or strokes form the fundamentals of drawing and visual communication. You'll learn that a single line, a single stroke, can communicate any of them. These are the ABCs of drawing: learn them well, as you'll be using them repeatedly for the rest of your artistic life!

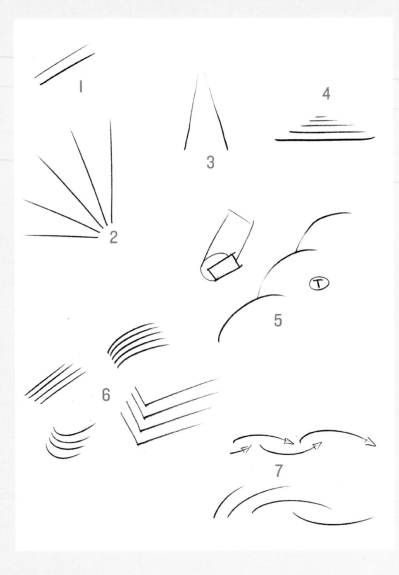

01 LIGHT It's possible to communicate whether an object is in light or shadow, even before doing any shading, by changing the value of contour lines. Vary the pressure you place on the pencil when describing forms to create light and dark contour lines to suggest that a surface is receiving more or less light than surrounding forms.

02 DIRECTION The angle of a line relative to the frame can communicate the orientation of an object in space or the direction of movement. Horizontal and vertical lines suggest a state of static balance. Diagonal lines create the illusion of suspended energy, as in a falling object frozen in space.

03 DEPTH Lines that converge give the illusion of depth. Additionally, lines that lighten in value as they recede give the illusion of atmospheric perspective, which is discussed in more detail on page 53.

04 SCALE Drawing lines of various lengths and thickness communicates a relative scale. The distribution of lines, that is, how close or far apart they are from one another, can also communicate depth.

05 OVERLAP To create a strong sense of depth, it's important to be aware of spatial relationships between forms. Drawing overlapping foreground and background forms (even deliberately adding overlap when none is visible on your subject) enhances the feeling of depth because the nearest form appears to obscure the form situated behind it. This technique is known as the "T" rule because of the T-like intersections where two contour lines meet.

06 FORM Varying the angle and curvature of hatchlines describes an object's surface shape and orientation.

07 MOVEMENT A system of opposing curves creates the illusion of movement, because it provides viewers with a visual path along which their eye will travel. The mechanics of this illusion are described in sequence (2), which starts with an upright, static line that appears to topple forward before flowing into a series of opposing curves. This sequence of lines can represent an entire figure in motion. Additionally the system of opposing curves can be incorporated into a drawing of a static figure or object to give it a sense of energy and life, as we'll see throughout Level 4: Anatomy, starting on page 74.

BASIC PERSPECTIVE

Perspective is our primary tool for creating an illusion of three dimensions on a two-dimensional paper surface. This visual device must be well understood as it not only applies to drawing buildings and landscapes but also to figures. The five steps on page 24 cover the basics of creating box forms in 1-, 2-, and 3-point perspective. Feel free to use a ruler for precise lines.

The five steps on page 24

1-, 2-, AND 3-POINT PERSPECTIVE

The numbers 1, 2, and 3 refer to the number of *vanishing points* in the perspective drawing. Selecting which perspective to use depends on the angle from which you want to draw a particular object: 1-point perspective if the object is to be viewed face-on; 2-point perspective if the object will be viewed from an angle, that is, from the side; 3-point perspective for looking up or down at a very large object.

Because it's rare to have a scene where objects are perfectly aligned to the picture plane, 1-point perspective mostly serves as a starting exercise. The predominance of vertical and horizontal lines with 1-point perspective also makes the scene appear static.

The diagonal lines that go with 2-point perspective more accurately represent how we tend to view objects in reality. The predominance of diagonal lines gives the scene a dynamic effect, which serves most general purposes.

3-point perspective should only be used if you want to communicate a sense of great scale, because each additional vanishing point increases the complexity of the drawing. Drawing is difficult enough as it is, so keep things simple whenever possible.

NOTE ON TERMS: *Volume* describes the three-dimensional space that an object occupies and *form* refers to its external shape. Therefore, a sphere can be described as both a spherical volume and a spherical form depending on the context.

The Five Basic Steps of I-, 2-, and 3-Point Perspective

01 **FRAME** Get into the habit of drawing a frame before starting each drawing. The frame's size and shape is as important as all subsequent steps because every mark you put down will relate to these initial four lines.

02 **HORIZON LINE (HL)** The horizon line represents the viewer's eye level. The position of the HL changes within the picture frame depending on the vantage point of the viewers and whether they're looking down, along, or up toward an object.

03 **VANISHING POINT (VPI, VP2, VP3)** A vanishing point (VP) is a point on the horizon to which parallel lines converge. Lines that are parallel to the HL are an exception to this rule. A straight set of railway tracks appears to converge at a VP on the HL, while the sleepers holding the tracks together remain parallel to it. The angle and position of the HL and VPs constitute the foundation of your imagined scene. Every object you create must reference these elements if it is to convincingly exist within the same space. Artists often label these elements "HL" and "VP," and reinforce the HL with a permanent marker to ensure they remain visible as subsequent pencil lines are added.

04 **GUIDELINES** Guidelines emanate from each VP in a 360-degree radius and are the guides along which parallel lines of an object converge to the VP. When drawing freehand, it's easier to draw long, straight lines if each pencil stroke is made away from your body, so rotate your drawing paper as you work. Draw guidelines lightly; they're for reference only. If drawn too dark, lighten them using a putty eraser. Each line should be clear and precise; poorly defined lines make accuracy difficult. Before drawing each line, practice the motion without touching the paper, then draw the line confidently and in a single stroke.

05 **BOX CONSTRUCTION** Box forms are a vital element of every artist's repertoire, as almost every physical object can be conceptualized as a simple box form before complexity and details are overlaid. A box form consists of six flat surfaces, known as *planes*: front, top, bottom, two sides, and a back plane. Planes are named according to which direction the plane is facing in relation to the viewer. For instance, a front plane of the box form is the one that faces toward the viewer, while a side plane is oriented at an angle. In reality the back-facing plane would not be visible. However, to develop a strong conceptual understanding of three-dimensional volumes, it's important to consider all six surfaces when drawing a box form.

With 1-point perspective it's easiest to construct the box form by starting with its **front plane**, the surface that also happens to be closest to you in this conceptual 3D scene. Note that its vertical lines should be perpendicular to the HL and its horizontal lines parallel to it.

When drawing a box with 2- and 3-point perspective, it's easiest to start with the vertical edge closest to you in 3D space, drawing it up or down toward the horizon line depending on its position above or below the horizon.

Side planes. Every line you create to construct the box form starts and finishes at a certain point. Every one of these points should be connected with guidelines to all the vanishing points in the scene. *So for every new line that you draw, ensure that its start and end points have a guideline referencing every vanishing point in your scene.*

Draw the remaining vertical lines to define the side planes while keeping foreshortening in mind. The side planes should be drawn narrower than the front plane to give the illusion that they're turned away from the viewer and receding into space.

Back-facing planes. Make a habit of indicating the back-facing planes of each object. This will help you develop a stronger understanding of objects as solid 3D forms rather than mere two-dimensional shapes, and create objects with a believable physical presence that give viewers the sense that they could reach out and *feel* the imagined forms.

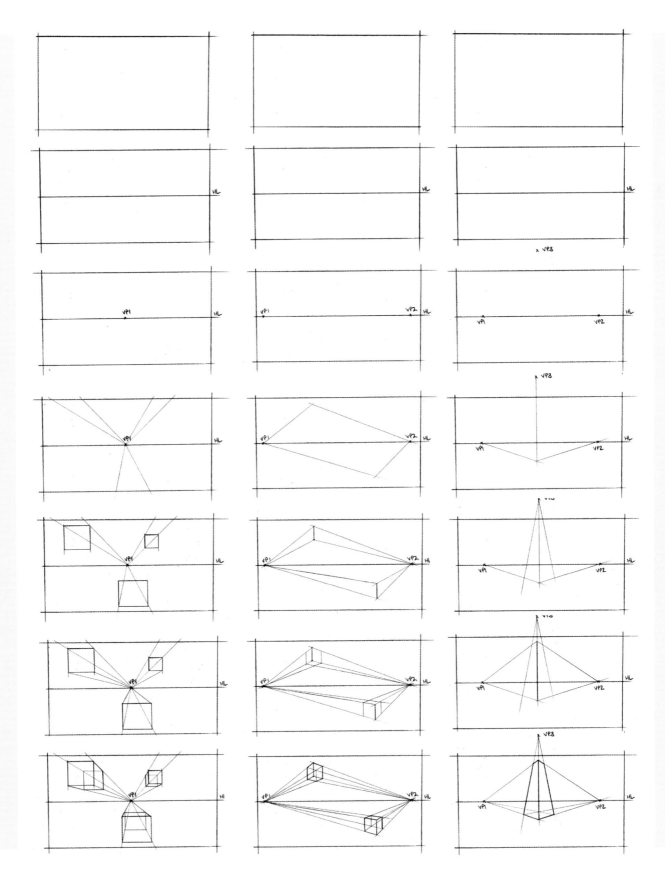

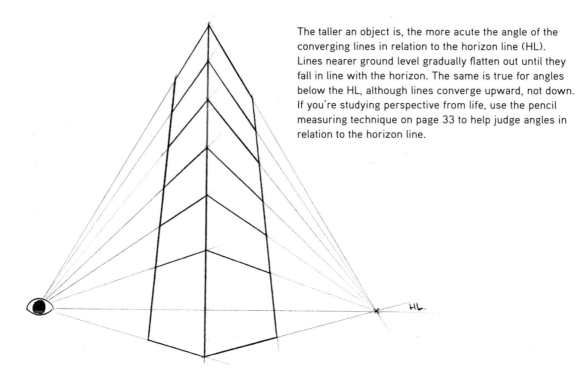

The taller an object is, the more acute the angle of the converging lines in relation to the horizon line (HL). Lines nearer ground level gradually flatten out until they fall in line with the horizon. The same is true for angles below the HL, although lines converge upward, not down. If you're studying perspective from life, use the pencil measuring technique on page 33 to help judge angles in relation to the horizon line.

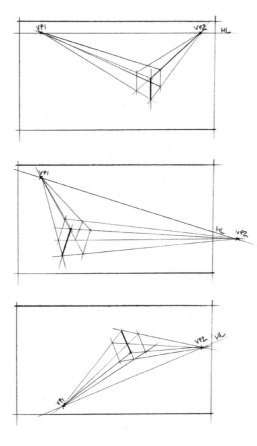

A clear example of a horizon line (HL) is the edge where sky and sea meet. The HL represents eye level, so your viewpoint (whether sitting, standing at ground level, or looking down from a greater height) affects the HL's vertical position within the frame.

Placing the HL in the center has a neutral emotional effect because the top and bottom half of the frame are equally balanced. Make the composition more dynamic by moving the HL up or down within the frame, or use a diagonal HL for a disorienting feeling. Experiment placing the HL at unusual angles and make sure you follow the five steps of perspective (page 24) in the order, or your imaginary world may skew to one side. In 1- and 2-point perspective the vertical lines should always be at 90 degrees to the HL, which means that they will appear tilted if the HL is at an angle.

BASIC VOLUMES

As discussed in the Five Basic Steps of Perspective (page 24), almost every physical object can be conceptualized as a simple box form before complexity and details are overlaid.

 Now that you have a command of drawing box forms in 1-, 2-, and 3-point perspective, it's time to practice a freehand drawing approach, without the help of a horizon line, vanishing points, and a ruler. This practice will help you develop an instinctive feeling for perspective that you'll need for the many occasions when there are simply too many objects in a scene to create vanishing points for each one. All this practice may seem irrelevant to character and environment design, but you'll see the benefits once we get into Anatomy (page 74) and study the drawings of the Old Masters.

Have a go at copying these box forms or draw similar forms from your imagination to test the extent of your knowledge of perspective. Take a moment to highlight the nearest edge and point of each object as if you could really reach out and touch them.

 The simple perspective rule to keep in mind is that parallel lines of an object must converge. Sometimes it's helpful to exaggerate convergence to enhance the feeling of perspective and depth.

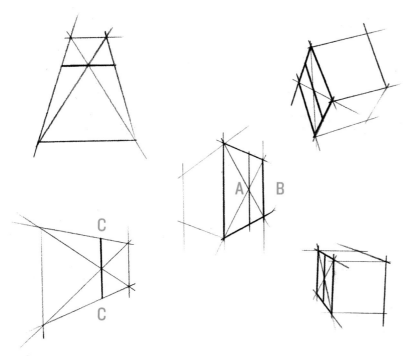

Practice drawing a centerline down the middle of each plane. Keep in mind that the closer half (A) should be larger than the farther half (B), due to foreshortening. You can find the exact midpoint of a plane by creating a cross that links all four corners. The point at which the two diagonal lines meet indicates the center of the plane (C).

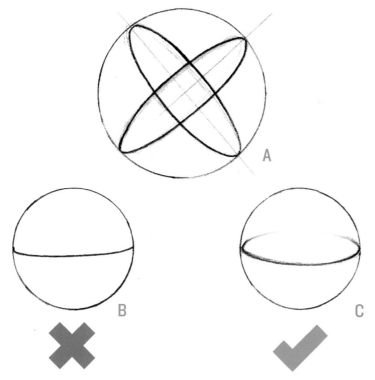

Also practice halving spherical forms. Note that fore-shortening will make the circular cross-sections appear oval (A).

Drawing from the shoulder using pencil grip (A) on page 18 will help you draw contour lines that link up at the start and finish with a little overlap. Avoid stopping the curved halving line at the circular form's edge (B). Draw it as if it continues around to the back of the form, suggesting a continuation (C).

BASIC LIGHTING AND VALUES

One of the biggest challenges for visual artists is to create the illusion of depth and three-dimensional form on a two-dimensional surface. The perspective exercises on pages 24–25 gave us tools to create the illusion of depth and volume using only lines. Adding an imaginary light source to the scene allows us to additionally model the volumes with light and shadow. Using perspective and light in unison enhances the palpable three-dimensionality of each volume. Let's start with some simple box forms to illustrate how lighting and value work with perspective to create the illusion of form, before moving on to more complex objects. Ultimately there's no right or wrong approach to value and depth. Lighting decisions are based on artistic choice, with full understanding of how light can effectively model form, and the emotions that you want to evoke in the player.

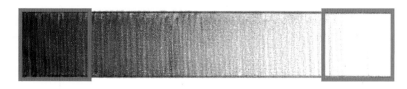

THE TWO-VALUE SCALE As a first step to rendering light, you can simplify your values to two, black and white. The paper surface is white and pencil shading is black. Once the direction of an imaginary light source has been decided, you're left with only two choices on how to light each plane of a box form: either the plane is turned toward the light (white) or it's turned away (black).

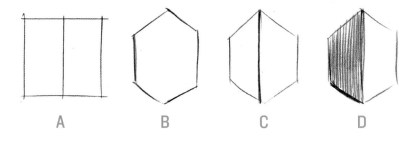

A B C D

Note how perspective and light work together to describe form. Box (**A**) has no sense of form because it lacks converging lines and values. When you add converging lines (**B**) the suggestion of depth and volume becomes apparent. Box form (**C**) communicates an even better sense of form because the interior edge has been drawn to define the two side planes.

 Box form (**D**) is lit from the right by an imaginary light source and the two visible planes have been lit accordingly. As a result you get the strongest illusion of form because converging lines and values clearly define the planes of your box form.

Team Fortress 2: Dustbowl map (Artwork courtesy of Valve Corporation)

Team Fortress 2 provides a first-rate example of in-game lighting that emphasizes the illusion of 3D form and depth. The lighting setup for the Dustbowl clearly defines which planes in the environment face toward the light and which face away. Limiting your lighting to a single directional light source is the best solution to model form in this way.

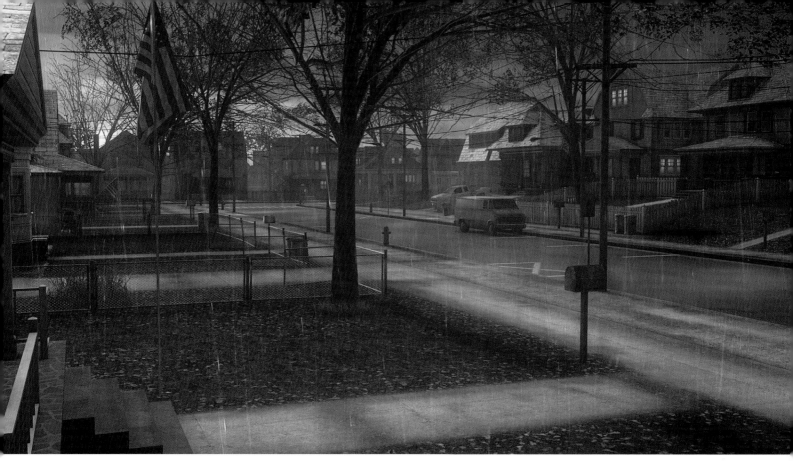

Heavy Rain (Artwork courtesy of Quantic Dream)

Now compare the screenshot from *Team Fortress 2* (opposite) with this image from *Heavy Rain*. Notice how the diffused lighting in *Heavy Rain* reduces the illusion of form. This is particularly noticeable in the houses across the street, whose front and side planes have similar values. *Heavy Rain*'s lighting is well suited to evoke the shadowy and melancholic atmosphere of the game.

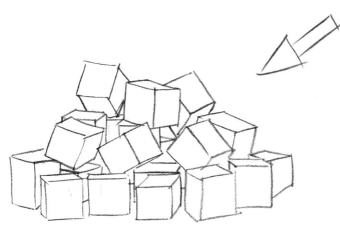

Box forms make it significantly easier to shade objects drawn from your imagination because individual planes are clearly defined. These simple volumes and value systems make it easy to conceptualize light sources from different directions, and to shade each plane accordingly. The boxes on the left are shaded according to a light source illuminating from the left. Now shade the same set of box forms on the right as if the light source is coming from the upper right. Keep the values simple: either a plane is facing upward/toward the light or downward/away from the light.

Although there is no definition for what constitutes correct and incorrect shading, the hatch lines you use should communicate the direction and orientation of the plane that they're describing.

VISUAL MEASURING TOOLS

There is so much superfluous visual information around us in daily life that only becomes apparent when we sit down with a pencil and paper and, perhaps for the first time ever, really *look*. This information threatens to overwhelm our ability to draw because there is so much detail to take in. The exact way in which a subject is deconstructed will differ from artist to artist; however, the standard set of visual measuring tools we'll learn about here are used by every skilled artist and will allow us to screen out extraneous detail and systemically deconstruct a complex subject to simpler, manageable components.

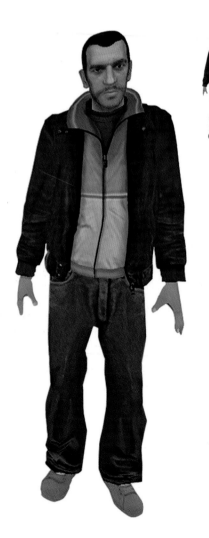

Grand Theft Auto IV: Niko Bellic

Details hold very little importance in drawing because it's an object's characteristic shapes and proportions that make up the broader silhouette that we recognize first and foremost. If you were to line up your closest friends at a distance of 100 yards, though you couldn't discern any details, you'd still be able to identify individuals just by their unique silhouettes.

 If you've played *Grand Theft Auto IV,* you'll be familiar with the character of Niko Bellic. Details, including the blue line across Niko's track top and his eyes, become virtually indistinguishable at a lower resolution or greater distance. But Niko himself remains recognizable at any distance because of his characteristic silhouette and the larger abstract shapes in his figure, such as his haircut and the beige panels and collar of the tracksuit top.

Nine Tools for Solving Visual Distraction

The question is how to begin a drawing without getting distracted by extraneous visual information. Luckily this problem was long ago solved with the following nine tools, which can be applied to any subject matter, including figures and landscapes.

Each tool is simple to understand, but using them accurately in combination with one another requires discipline. Continue to practice and your measuring dexterity will improve to a point where you can make quick assessments of your subject without drawing guidelines.

The order in which these tools are presented is only a general guide, as they're most effective when used in various combinations, depending on the subject. Let's take a look at how the tools can help simplify the drawing process when faced with a subject as richly detailed as *The Laughing Cavalier* by Frans Hals (ca. 1580–1666) on page 34.

Have a go at making several studies of the same subject, concentrating on each tool individually before trying them in combination. Your drawings are unlikely to become museum pieces, so don't be afraid to fill them with guidelines and annotations. You can always erase them later and subsequent details may hide them anyway.

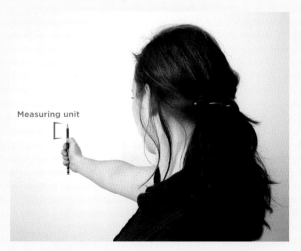

Measuring unit

PENCIL MEASURING Before you begin the lesson, practice the measuring technique, which will help you more accurately measure subjects, the alignment between them, and determine perspective. To measure your subject, stretch out your hand toward the subject with your drawing pencil held in a vertical or horizontal position. Your arm must be fully extended, elbow straight. While looking down the length of your arm, as though you were aiming down the site of a gun, align the top of the pencil with the top of whatever you're measuring; now move the tip of your thumb to mark the other end of what you're measuring: the space between the tip of the pencil and your thumb is your measuring unit. Be sure to keep your arm as straight as possible and stand in the same position because small changes will drastically affect the size of the unit.

You can likewise use this technique to help check alignment (page 35) between elements and for estimating perspective angles.

The Laughing Cavalier (1624) by Frans Hals, Wallace Collection, London

01

01 SQUINTING Squinting (as in half-closing your eyes until objects appear blurred) is one of the most undervalued tools for reducing visual complexity. It merges fragmented details into simpler shapes made of light and shadow. Squinting is a discipline and takes a lot of practice because the natural inclination is to open your eyes fully to see everything in detail.

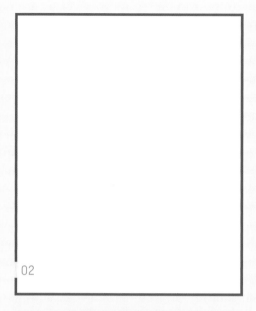

02

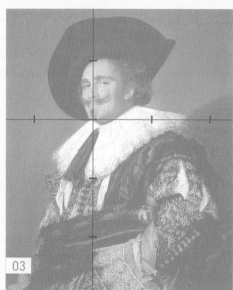

03

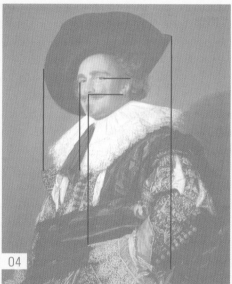

04

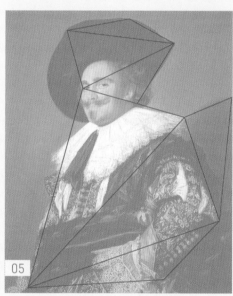

05

02 FRAME The first step of the perspective exercise on page 24, the frame, forces us to think as broadly as possible about the image. You can temporarily ignore the complex subject by first focusing on the right width-to-height ratio for your four-sided frame. The frame is critical to composition, as it affects the placement and relationship of all subsequent elements of a drawing.

03 MEASURING UNIT Establish a unit that can be used to measure elements in your drawing. For example, the head is the standard unit of measure in figure drawing. In landscape and other genres, you can choose something convenient, such as the vertical height of a window frame. Use the unit to measure only horizontally and vertically; diagonals are difficult to realign and measure with consistency. (See Pencil Measuring on page 33.)

04 ALIGNMENT Checking the relative alignment of elements in the composition helps on both a large and small scale. You can check the alignment of an ear in relationship to the foot or zoom in to check the alignment of lips in relation to the corners of the eye.

05 TRIANGULATION Refers to cross-referencing each imaginary point of your subject against two or more points. Start triangulating points that are far apart within the image to check the accuracy of the bigger shapes before zeroing in on smaller details.

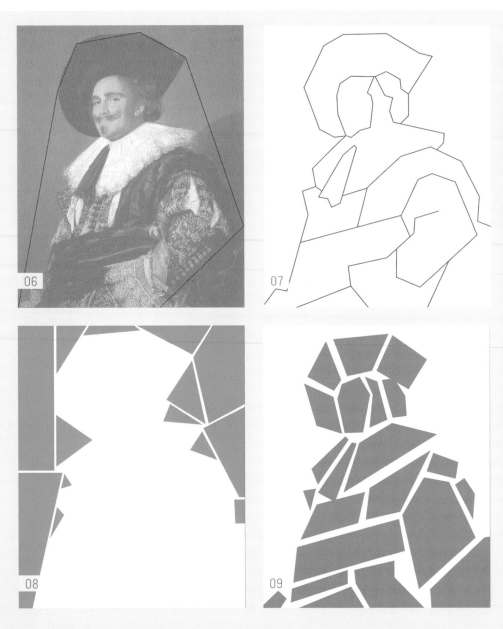

06 ENVELOPE Enveloping the subject helps you visualize it in very broad terms by focusing on the extremities of a subject over small changes in contour and detail. You may be more familiar with this concept if you've worked with 3D digital modeling, where programs refer to the feature as a *bounding box*.

07 SIMPLIFIED LINES Avoid drawing curved lines for the initial stages of a drawing, because organic shapes are extremely difficult to assess visually. Reducing curved shapes to a series of straight lines makes it easier to judge whether a shape was drawn correctly. It's easy to soften and curve the lines to match the subject once you're confident of the essential shapes.

08 NEGATIVE SHAPES This is arguably the most reliable tool for assessing the accuracy of a drawing. Negative shapes work on the principle that you draw the empty space around your subject rather than the subject itself. This is such an effective tool because the subject becomes an abstract puzzle, void of detail. A negative shape drawing can often stand on its own in describing the unique silhouette of a person. Use this tool in combination with triangulation and simplified lines to judge the accuracy of your shapes.

09 POSITIVE SHAPES This is a tricky tool because it ventures into the dangerous territory of drawing the subject itself in all its eye-catching detail. Reduce the positive shapes of your subject to simple geometric shapes: circles, rectangles, and triangles.

DRAWING PROCESS

Digital software is a very forgiving drawing medium because it allows you to fix mistakes as you make them using the undo function. There is no such function when working with traditional media, but classical drawing practice offers a structured drawing process that makes it easy to keep track of the steps in your art, so that you can manually identify and correct any mistakes as you go along. The drawing process that follows relies on knowing how to use the nine visual measuring tools (pages 33–36), so be sure you've practiced them all. Though the exercises are applied here to a landscape, the same process applies to figure drawing.

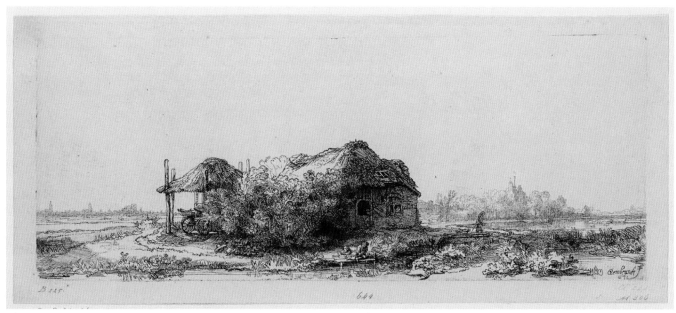

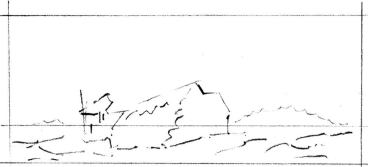

Landscape with a Cottage and Hay Barn (1640) **by Rembrandt van Rijn (1606–1669)**

01 **BLOCK IN** The first stage of drawing is the block in, where you lightly outline the largest masses. Be accurate with placement and proportions of shapes and lines, taking advantage of this loose stage to make adjustments with the help of the visual measuring tools (pages 33–36).

Don't forget to indicate the horizon line, keeping in mind that all *parallel* lines above the horizon converge downward and those below converge upward. You can also lightly suggest general values to distinguish the bright sky from the darker ground plane.

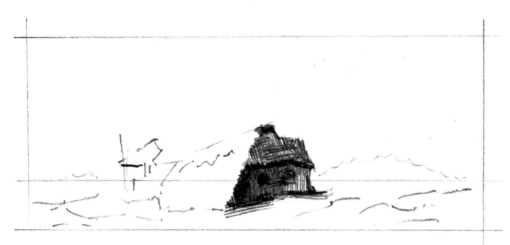

02 **ANCHOR POINT** Once you've blocked in everything using simplified lines it's time to decide on an anchor point, which is usually the center of interest or something that has a strong and simple shape. The anchor point is the point of reference against which to judge the placement and proportions of all subsequent elements, so it's important to keep refining it until you're confident of its accuracy. And just when you think it's right, check it again!

03 **SPIRALING** The next element you draw should be adjacent to or overlap the anchor point. Refine this shape until it's as accurate as you can possibly make it, using the anchor point to judge relative shapes and proportions. Continue working systematically, spiraling outward from the anchor point and only moving to an adjacent element when you've double-checked the existing shapes.

Spiraling is the undo function of drawing. This logical order for image construction makes it easy to trace back your steps to identify the exact place you made a mistake so you can correct it. Once you've spiraled the entire image, you can go back over it to refine values and shading and add details.

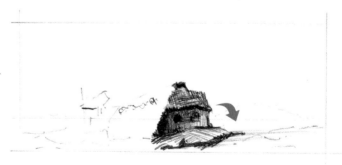

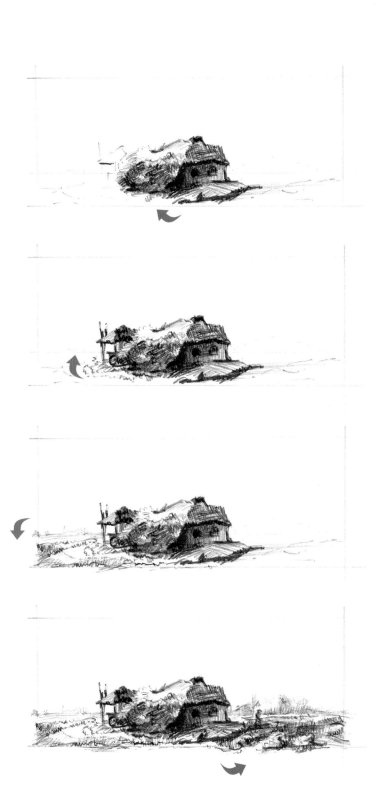

LEVEL UP!

Congratulations on completing Level 1 of the book. The tools covered so far are the fundamentals for every drawing challenge you'll ever encounter. Remember that complete understanding and mastery only comes with a significant amount of practice. In the following chapters we will investigate how these tools can be applied to increasingly complex forms and drawings. We'll also investigate in greater depth the significance of visual grammar and how you can integrate concepts of line, shape, volume, value, and color into your video games to design engaging emotional experiences.

LEVEL 02 | ADVANCED DRAWING CONCEPTS

IN LEVEL 1 WE COVERED THE FUNDAMENTALS of drawing through exercises that gave us confidence in pencil strokes, light, and perspective. We also learned about the correct process of observation and drawing, which requires focus and self-discipline but also makes drawing accurate and easier. In Level 2 we will explore more advanced concepts for volumes and lighting that will wrap up all the tools and techniques you'll need to tackle any subject. This section primarily focuses on landscape drawing, but you'll see that all objects, including human figures, can be reduced to a common set of basic shapes and volumes. While you can learn the techniques of landscape drawing through these exercises, I recommend that you take your sketchbook and pencils outdoors and have a go at drawing the real thing as well.

RAGE

ADVANCED PERSPECTIVE AND VOLUMES

Having a command of drawing spheres in perspective is essential in both landscape and fig-
ure drawing because you almost never see perfect circular forms in nature. Circular shapes
are usually distorted to look like ovals due to the effect of foreshortening. The exercise on
page 42 is an extension of the process we used to find the midpoint of a box's plane (page 28)
and will allow you to draw circles with a convincing sense of depth.

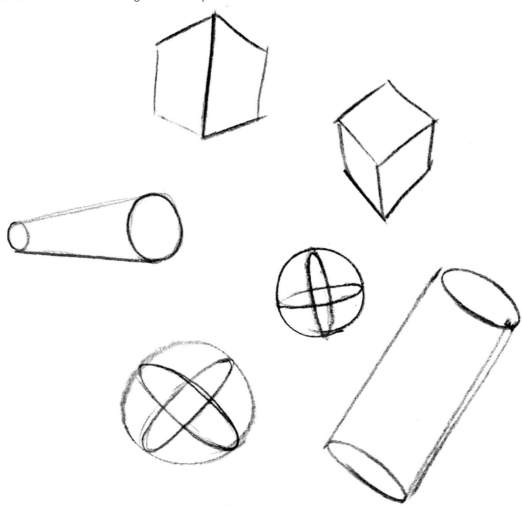

FREEHAND VOLUMES In this section, you will amass
the skills to draw a range of basic volumes, including
the box form, sphere, and cylinder. Continue to practice
drawing these volumes freehand from various angles
until the process becomes instinctive.

Four Steps for Drawing Circular Forms in Perspective

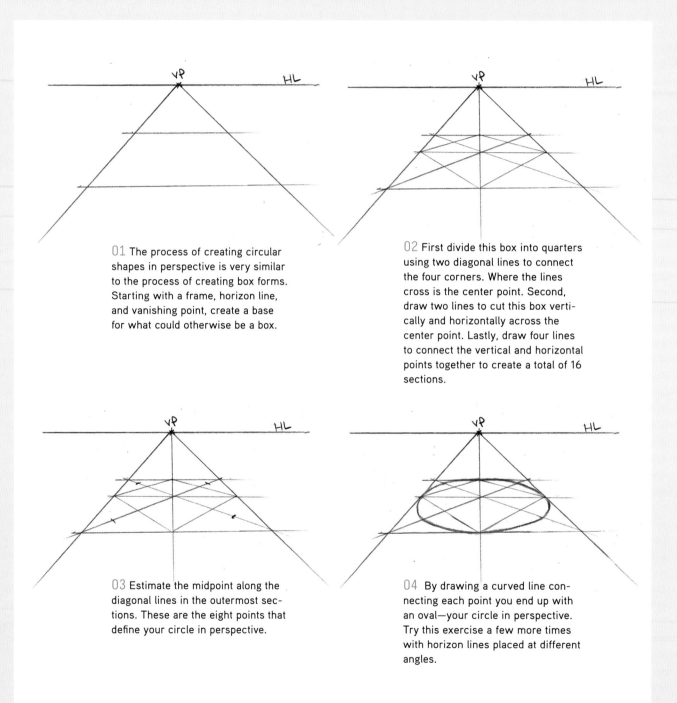

01 The process of creating circular shapes in perspective is very similar to the process of creating box forms. Starting with a frame, horizon line, and vanishing point, create a base for what could otherwise be a box.

02 First divide this box into quarters using two diagonal lines to connect the four corners. Where the lines cross is the center point. Second, draw two lines to cut this box vertically and horizontally across the center point. Lastly, draw four lines to connect the vertical and horizontal points together to create a total of 16 sections.

03 Estimate the midpoint along the diagonal lines in the outermost sections. These are the eight points that define your circle in perspective.

04 By drawing a curved line connecting each point you end up with an oval—your circle in perspective. Try this exercise a few more times with horizon lines placed at different angles.

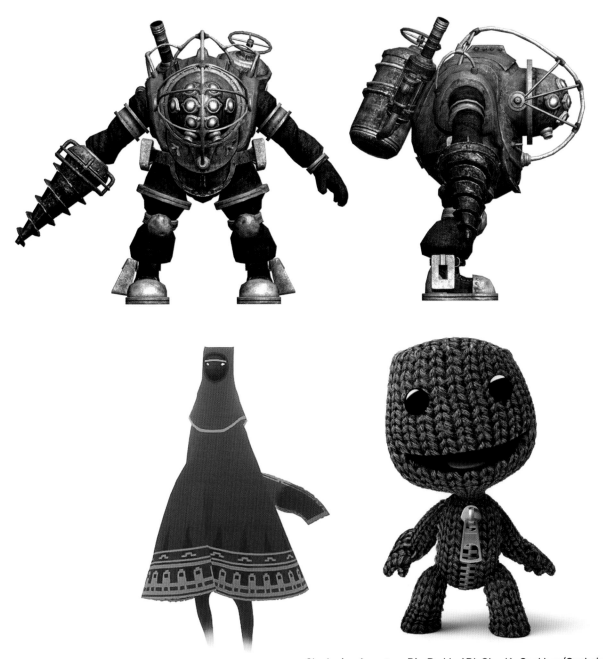

Clockwise from top: Big Daddy (*BioShock*), Sackboy/Sackgirl (*Little Big Planet*); character from *Journey* (*BioShock* artwork courtesy of Irrational Games)

Some of the video game industry's most iconic and memorable characters are modifications of the volumes you've been practicing. Make pencil studies of each character above, using only the box, sphere, cylinder, and pyramid volumes in various combinations. You may wish to search for alternative views of these characters to get a better understanding of their volumetric concept. Once you know a character's volumetric concept, you'll be able to redraw it from any angle with ease using the perspective techniques that we explored in Level 1.

ADVANCED LIGHTING AND VALUES

We looked at the way lighting describes form in Basic Lighting and Values (page 29). When we draw from life there are more varieties of volumes and lighting conditions to consider, which require more advanced concepts.

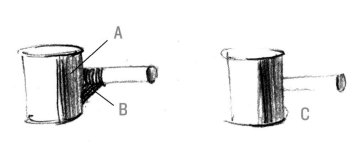

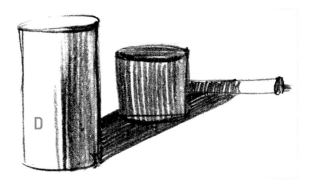

The two cylinders in the above left illustration demonstrate the difference between shadow on a form and cast shadow. The shadow on the upright cylinder (**A**) shows its form as the surface slowly turns away from the imaginary light source, nicely modeling its shape. This same form also casts a shadow (**B**) by preventing some of the light from reaching the horizontal cylinder in the background. This is called a *cast shadow*.

Cast shadows help to communicate spatial relationships between objects, as demonstrated by situation (**C**). Without the cast shadow connecting the two cylinders we cannot determine the relative proportions of these objects or whether they sit on the same plane.

Cast shadows were not discussed in Level 1 because they often have the effect of visually confusing the modeling of forms or flattening the sensation of form altogether. One of our primary goals is to create the illusion of depth, so cast shadows should therefore be used judiciously. Notice how the cast shadow of the foreground cylinder (**D**) has eliminated the form shadow of the middle cylinder and, hence, the illusion of depth. The Old Masters were very careful in using cast shadow for this reason, often subduing or removing them altogether to maintain a strong sense of depth.

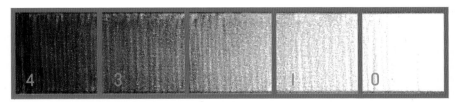

THE FIVE-VALUE SCALE From right to left: (0) white of the paper or light, (1) highlight, (2) middle values, (3) core shadow, and (4) cast shadow.

While a two-value scale was sufficient for modeling simple box forms, you must expand the scale to render more complex, rounded forms as well as cast shadows. Artists traditionally use a scale composed of ten values, the lightest value being the white of the drawing surface, but a five-value scale is, in fact, sufficient for all your needs and reduces the number of elements to consider while drawing. A five-value scale may seem limiting, but it is really only a conceptual simplification. More subtle variations of values will appear naturally once you begin drawing and blending values together in subsequent exercises.

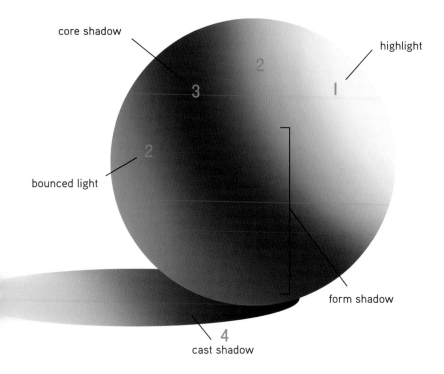

core shadow

highlight

bounced light

form shadow

cast shadow

FIVE-VALUE SCALE This illustration demonstrates how a five-value scale is used to model a spherical form. The shadows are ordered in a 1-2-3-2-4 value system in which values **1** to **3** represent form shadow and 4, the cast shadow.

The darkest value on the form, known as the *core shadow* or *terminator* is located at 90 degrees from the light source, where light and shadow planes meet. The reason the middle and not the furthest point from the light is darkest is because the away-facing planes receive bounced light from the environment, such as a table surface.

Characteristic of the cast shadow (4) is that it's always one value darker than the core shadow (3). Cast shadow edges are generally harder than those of the form shadow.

The cast shadow becomes lighter and its edges softer as it falls away from the shadow-casting object. This happens because the further away a cast shadow is from the shadow-casting object, the more light it receives from the surrounding environment and ambient light sources.

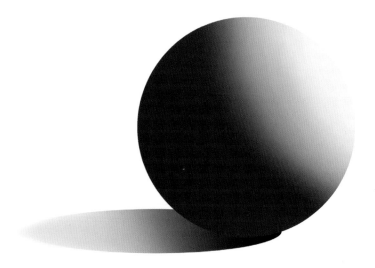

BOUNCED LIGHT The danger of disregarding bounced light is that forms appear flatter without it, as in the above example. According to the lighting situation in this scene, the left side of the sphere is missing the bounced light that is vital to creating the illusion of a form turning in space.

Bounced light is a detail often lost in photo references, as the values are usually too subtle for cameras to capture. So be careful when studying photographs, making sure to suggest bounced light in your drawing even if none is visible in your photo reference.

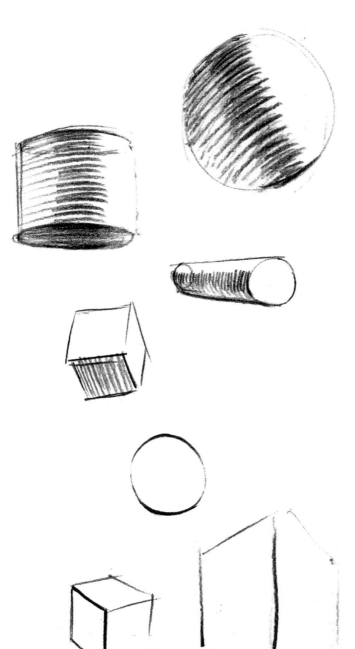

HATCH LINES Every pencil stroke should be as descriptive as possible when shading forms per the five-value system. Straight lines best describe the angle and orientation of flat planes, as in a box form. Rounded hatch lines better describe rounded forms. The sense of form is destroyed if you use straight lines to describe a spherical form and vice versa.

 Keep perspective in mind when deciding on which way to curve or angle your hatch lines. For instance, if you're looking up at a cylindrical object, the hatch lines should curve downward to reinforce the illusion of perspective.

 We can also see the difference between *soft* and *hard* edges in the transition between light and shadow. The speed of transition reflects whether the form is spherical, in which case the transition is soft and gradual. If the transition is sudden, the edge is described with a sharp transition (often referred to as a *plane break*) between light and shadow.

CONTOUR LIGHTING The five-value system can even be suggested with contours alone by varying the weight of the lines themselves. If the surface you're describing is in light, the contour line should be light; if the surface is in shadow, the line should be thick and heavy. Resist the temptation to fully enclose objects with a solid, dark line—as is common with comic-book drawings—as this effectively flattens the form.

Little Big Planet 2

Cast shadows can also be used to suggest objects outside the visible frame. It's not always clear what objects are casting the shadows in *Little Big Planet 2*, which creates the illusion that parts of the environment exist beyond the confines of the screen, encroaching into our reality and increasing our sense of immersion in the game.

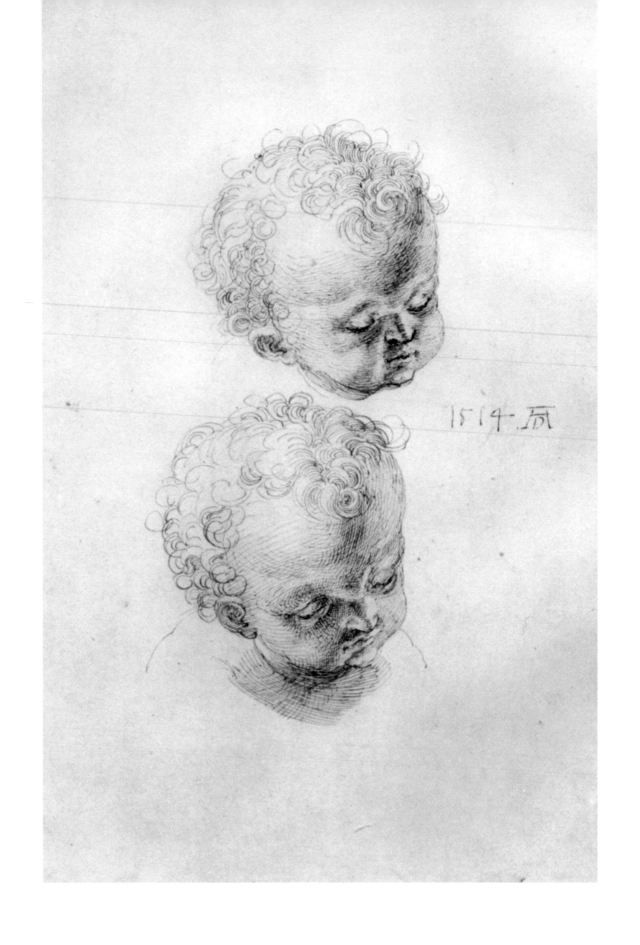

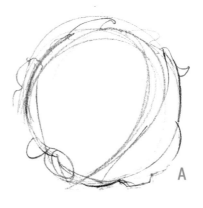

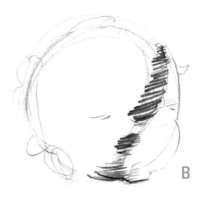

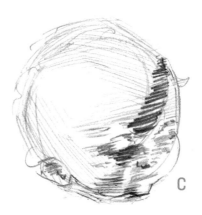

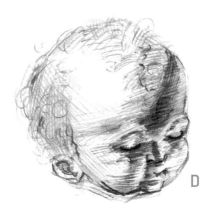

Do a quick study of Dürer's drawing: Start with a circle (A), and refine it to suggest the contour of the head. The next step is to draw the core shadow (B). You can see how effective the core shadow is in creating the illusion of light and in describing the surface of the spherical form turning in space. You can finish the study by laying down a general layer of shading to map out the remaining form shadow (C) before adding details (D).

Notice how Dürer reduced details in the highlights to give a stronger sense of light. This effect is known as *light bloom* in computer graphics. In drawings it's a tool to compensate for the limitations of traditional media in translating the range of values witnessed in reality.

OPPOSITE **Study sheet with children's heads by Albrecht Dürer**

The Old Masters used the concept of basic volumes and light whenever they wanted to communicate form. The spherical volume that Dürer had in mind when drawing the head of this child could hardly be more explicit.

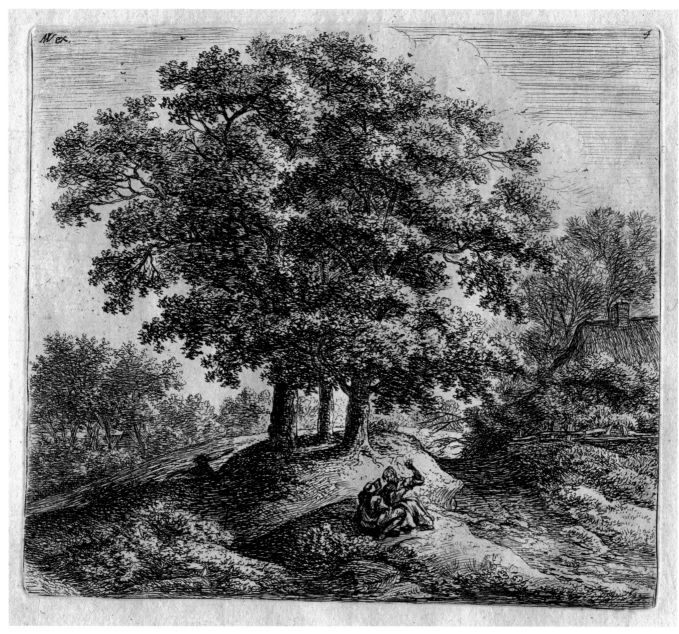

Man and a Woman on a Hummock (ca. 1688) by Antonie Waterloo
(1609–1690)

Basic volumes modeled with core shadows and bounced light are so good at
creating the illusion of depth and form that classical artists used them repeat-
edly as conceptual foundations for their subjects, even for objects that are
not perceived as solid forms, like the trees in Waterloo's etching. Though tree
forms are largely composed of empty space defined by an external layer of
leaves, Waterloo conceptualized the combined mass of the trees as one large
spherical form and modeled it with light accordingly.

 The etching is filled with intricate details that make this concept difficult to
decipher until you squint at it to reduce light and shadow masses to simpler
shapes that reveal the lighting concept of the artist.

ATMOSPHERIC PERSPECTIVE

Sketching on location is the first real test of how well you've grasped the various concepts covered so far in the book. There are literally millions of elements to distract you, not the least of which are the constantly shifting light and weather conditions. Outdoor drawing is the yardstick against which to measure your progress. If you remain focused on drawing the bigger, simpler forms under such changeable conditions, then you're doing well. Given the short development time for most games, firsthand research is not always possible. By mastering the classical concepts of art landscapes, you'll have a repertoire of real-life skills to apply to imaginary video game landscapes.

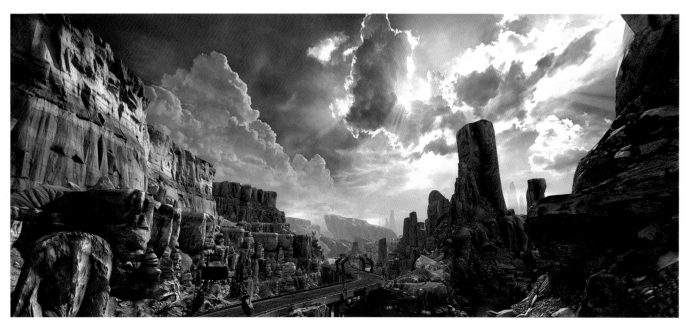

RAGE

One valuable experience of drawing outdoors is the sense of distance and depth you develop. *Atmospheric perspective* is a great tool to create this illusion of depth, and one much used by classical artists. The effect is caused by water vapor in the air, which creates a diminishing level of contrast and blurring of forms with distance.

The environments of *RAGE* perfectly demonstrate the concept of atmospheric perspective. Compare the furthest ridges with those in the foreground and notice how shadows become lighter with distance until the landscape and sky begin merging together. The background elements additionally have softer edges and fewer details than those in the foreground. You'll also find this effect applied to classic figurative drawings, such as Michelangelo's *Study for the Battle of Cascina* (page 125), in which background forms are more lightly shaded than those in the foreground.

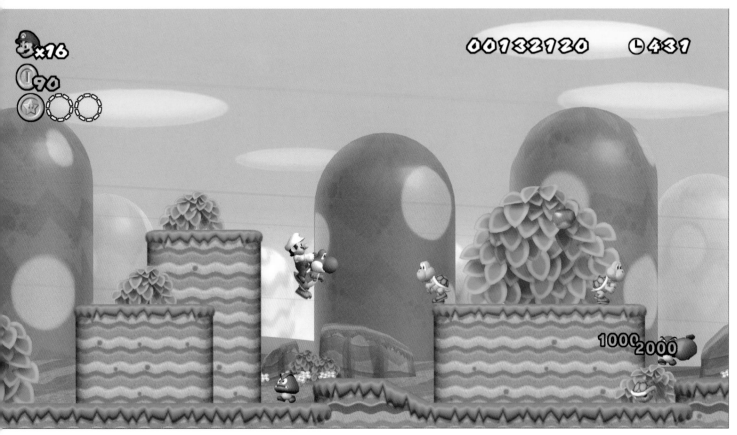

00132120 **L431**

New Super Mario Bros.

New Super Mario Bros. has an abstracted version of atmospheric perspective, which works well for the style of the game. A sense of depth is created by T-intersections between overlapping objects, and by placing the darkest values and sharpest lines in the foreground, such as Mario's hair and red overalls.

LANDSCAPE DRAWING

You've now garnered enough tools to tackle a more challenging landscape study. *Landscape* by Russian artist Alexei Savrasov offers an opportunity to practice drawing with the putty eraser in combination with the pencil.

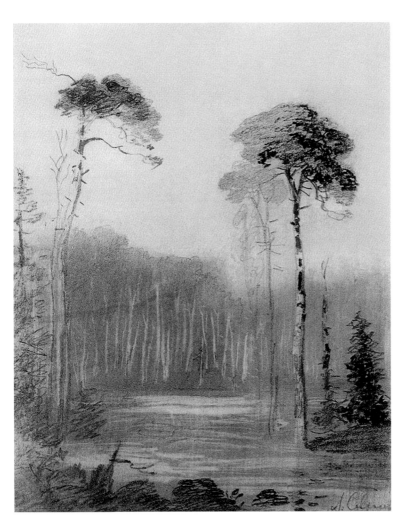

Landscape by Alexei Savrasov (1830–1897)

Throughout this drawing exercise keep in mind the tools you've learned to create the illusion of depth. So far you've worked on overlapping forms and T-intersections to describe the depth relationship between objects and have seen the effect that atmospheric perspective has on distant objects, diminishing the levels of contrast and softening forms.

In landscape drawing it's useful to organize the scene into *foreground, middle ground*, and *background* elements. The foreground will feature the strongest contrasts, the sharpest edges, and the most details. Elements in the background will be lighter, softer, and relatively void of detail. With this in mind, the general order of drawing a landscape is from background to foreground.

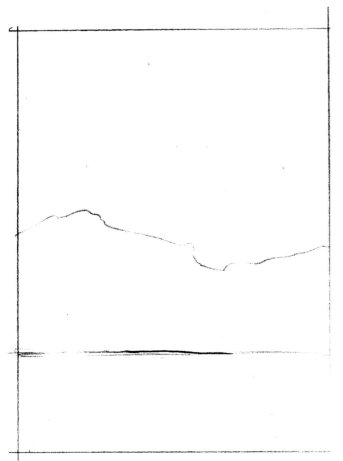

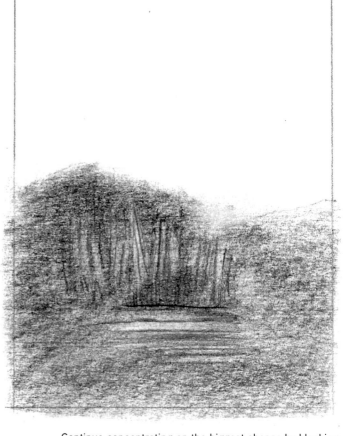

Begin your quick study by drawing the frame, matching the proportions of the original as accurately as you can. For the initial block in stage (described in Drawing Process on page 37) focus on outlining the biggest shapes first by indicating the horizon line and the top edge of the background trees to define the dominant break between light and shadow.

Continue concentrating on the biggest shapes by blocking in the lower half of the drawing with an even layer of shading. Savrasov would have likely smudged the lines with his finger or a paper blender to create a more even layer of value. The distant trees are "drawn" using the putty eraser kneaded into a blade-like shape.

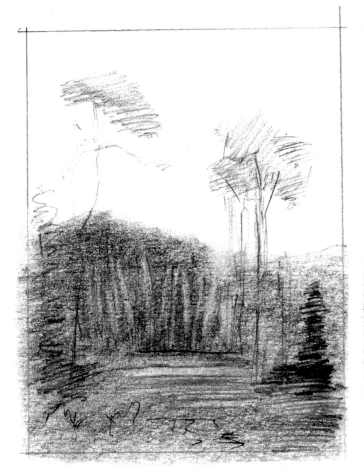

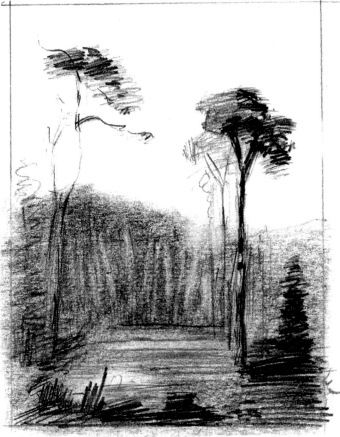

Having established the softer background elements, you can tackle the objects in the middle and foreground. Savrasov deliberately placed the trees on either side of the central avenue to align along imaginary guidelines that appear to converge toward a vanishing point. This has the useful effect of enforcing the illusion of depth. The repeating forms of the trees as they appear to get smaller with distance also communicate depth.

Your first pass over the middle and foreground should be fairly light, so you can easily make corrections and cut out the highlights before adding the darkest values.

Quickly mass in the branches of the trees and plants, paying closest attention to the texture of their contours, to suggest the internal forms.

For the final pass, go in and add the darkest values, noting that Savrasov purposely concentrated the strongest contrasts and details on and around the foreground tree on the right, which he chose as his center of interest.

Make some refinements to the ground plane, adding horizontal lines to distinguish it from the upright trees in the background. Lastly, let loose, mimicking the great variety of pencil lines Savrasov used to describe the different textures.

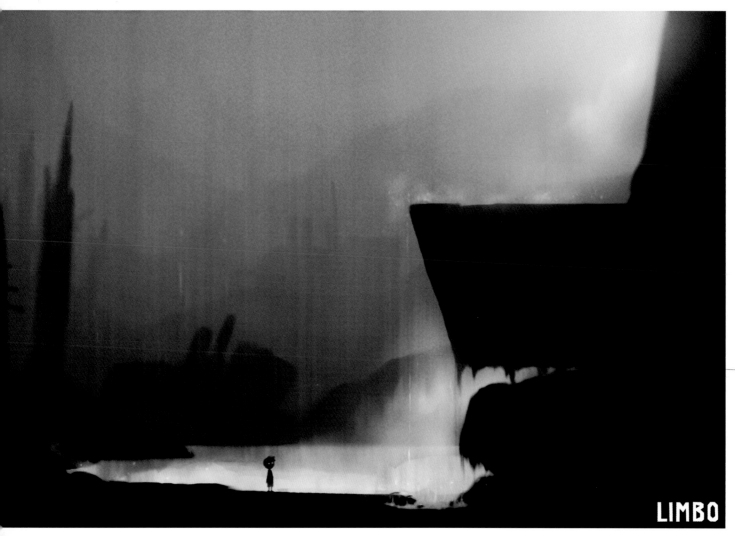

LIMBO

LIMBO (Concept image courtesy of Playdead)

The award-winning visuals from *LIMBO* are the brain-child of game director Arnt Jensen. Although in many ways more stylized than Alexei Savrasov's drawing, both images have a lot in common in terms of the visual tools used to create the illusion of depth: overlap, diminishing contrasts, and softening of forms with distance and repetition of shapes.

Texture suggested in contours can convey enough information for viewers to imagine the missing visual information of the internal forms. Jensen has skillfully taken advantage of this phenomenon by giving objects ambiguous shapes that invite players to use their own imagination to complete the missing information. Each player will find different meaning in the shapes based on their personal experiences. If Jensen had gone the other way and made every detail explicit, there would be less room to engage the player's imagination and emotions.

LEVEL UP!

You've only completed Levels 1 and 2 and already have an advanced understanding of how to create images with a believable sense of depth and volume. These drawing tools are sufficient for almost every subject you'll draw. Now let's see how to advance your existing knowledge and add a sense of human life, movement, and weight to your lines, shapes, and volumes.

LEVEL 03 [THE HUMAN FIGURE

IF YOU'VE EVER HAD THE EXPERIENCE of rotating a 3D character model in a digital modeling program, you'll be familiar with the weightless sensation. The character model remains rigid as it's rotated on any axis with the effortless click and drag of the mouse. To bring the character to life the illusion of weight and movement must be created by the artist with a skillful use of lines and shapes.

The following section covers the fundamental concepts of anatomy and the forces involved in human movement. These concepts will help you instantly bring a sense of life and energy to your characters, but I recommend that you also draw from life whenever possible. Drawing from life is the best study method for understanding the figure because it allows you to record experiences firsthand and that translates to more believable figures in the realm of virtual space.

Detail with overlay of *Skeleton with Muscles* by Bernhard Siegfried Albinus

GRAVITY AND MOVEMENT

Much of what makes each of us distinguishable as individuals is communicated in the way we carry our physical weight. What artists must keep in mind when studying the figure is the unseen force of gravity, which our bodies constantly oppose. In this section you'll explore the anatomical mechanisms that prevent us from collapsing against this downward force, the human skeletal and muscular structures that work together to create a tension that holds us upright.

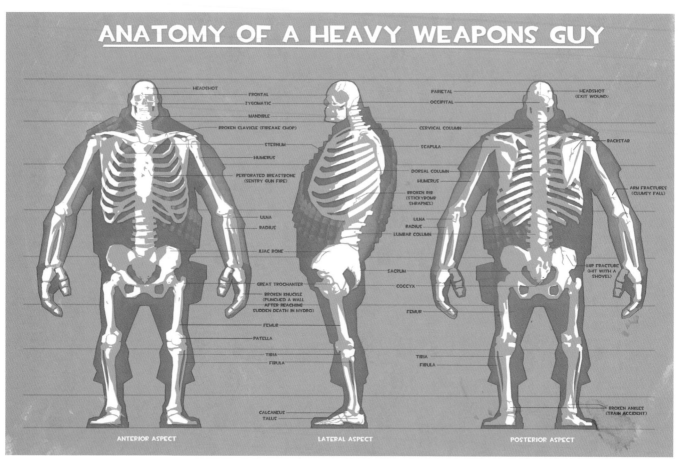

Team Fortress 2: Anatomy of a Heavy Weapons Guy (Artwork courtesy of Valve Corporation)

You can think of the human skeleton as being like the structural frame of a building. Every architectural structure starts with a solid, supportive skeleton over which the walls and roof are built. Without this supportive frame the building would collapse. The supportive frame of the human figure is the skeleton, which would likewise collapse into a pile of bones if it weren't for the muscles and tendons keeping it upright.

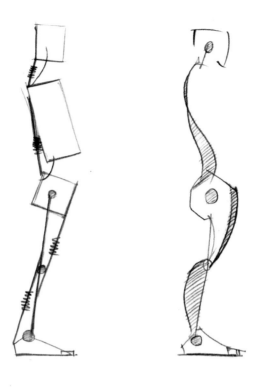

Humans can stand upright because our bodies have developed a series of muscles collectively known as *antigravity muscles.* They function like metal springs, maintaining tension between body parts. Starting at the heel, these muscles work their way up the body, alternating from the front to the back in a system of opposing curves to create forces that keep us from collapsing against the pull of gravity.

Each curved contour is complemented on the opposite side of the figure by a straight line. In reality the human figure doesn't feature straight lines, but artists use straight (or relatively straight) lines to suggest the supportive skeletal structure that holds the figure together, like the nearly straight bones of the upper and lower leg. Muscles, in contrast, tend to be rounder so opposing curves are generally used to trace the flow of muscles throughout the body and create an illusion of movement and life. This play of curved against straight lines is fundamental to creating believable figures.

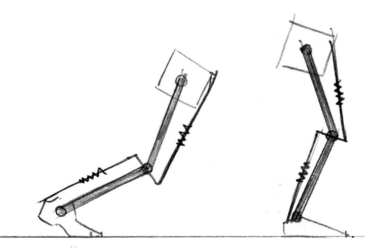

The antigravity muscles of the lower leg feature a muscle group that connects the heel with points *above* the back of the knee. A similar arrangement of muscles is also present for the upper leg, where muscles connect the pelvis and a point just *below* the kneecap.

The attachment points of the muscle groups across the knee keep our legs locked in the upright position when standing and support our weight when walking. If these muscle groups didn't overlap the knee, the entire leg would topple forward under the force of gravity.

The concept of opposing curves is especially important for movement, as without the alternating placement of antigravity muscles, the action of walking would not be possible.

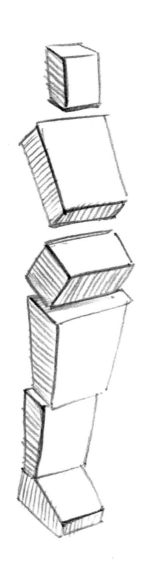

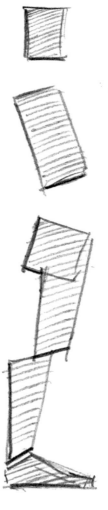

Moving up the leg, take note of the increasing mass and weight being transferred down through the legs to the feet. The largest, and therefore the heaviest, mass of the body is the ribcage. Its position at the front of the body creates an imbalance, shifting the body's weight toward the toes so that the body has a natural urge to fall forward. Luckily antigravity muscles allow us to choose when this happens. In the action of walking, the antigravity muscles of the legs exploit the downward pull of gravity *and* our body's imbalance to create forward motion.

To restore an element of balance, the form of the ribcage is tilted backward, which the pelvis must counterbalance with its forward tilt.

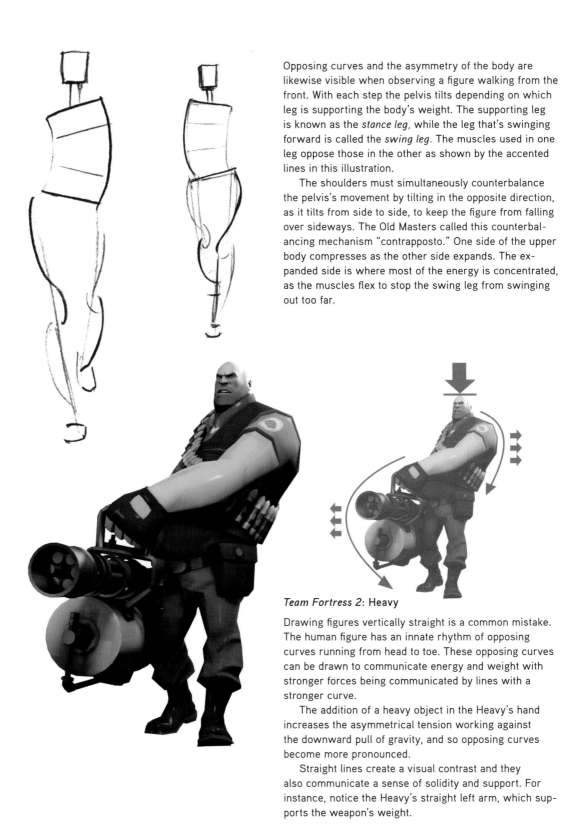

Opposing curves and the asymmetry of the body are likewise visible when observing a figure walking from the front. With each step the pelvis tilts depending on which leg is supporting the body's weight. The supporting leg is known as the *stance leg,* while the leg that's swinging forward is called the *swing leg.* The muscles used in one leg oppose those in the other as shown by the accented lines in this illustration.

The shoulders must simultaneously counterbalance the pelvis's movement by tilting in the opposite direction, as it tilts from side to side, to keep the figure from falling over sideways. The Old Masters called this counterbalancing mechanism "contrapposto." One side of the upper body compresses as the other side expands. The expanded side is where most of the energy is concentrated, as the muscles flex to stop the swing leg from swinging out too far.

Team Fortress 2: Heavy

Drawing figures vertically straight is a common mistake. The human figure has an innate rhythm of opposing curves running from head to toe. These opposing curves can be drawn to communicate energy and weight with stronger forces being communicated by lines with a stronger curve.

The addition of a heavy object in the Heavy's hand increases the asymmetrical tension working against the downward pull of gravity, and so opposing curves become more pronounced.

Straight lines create a visual contrast and they also communicate a sense of solidity and support. For instance, notice the Heavy's straight left arm, which supports the weapon's weight.

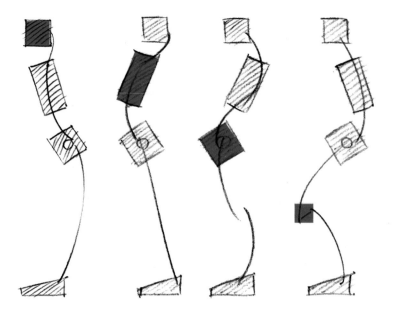

The distribution of energy throughout the body varies from person to person. Acclaimed concept artist Iain McCaig refers to stock characters from physical theater to categorize various character types based on which part of the body they lead with (from left): thinkers with their heads; heroes with their chests; lazy types with the pelvis; cowards with their knees.

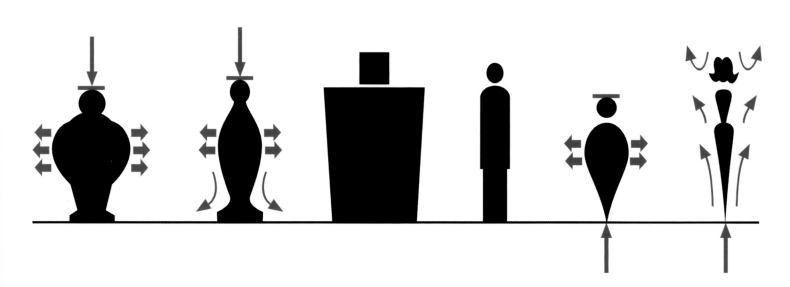

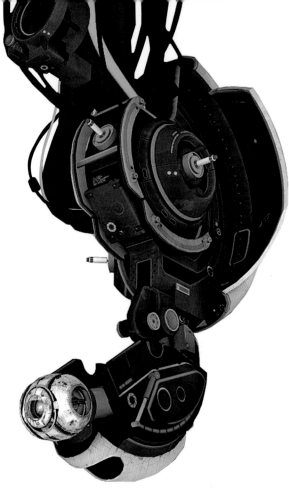

The effect of using lines to communicate energy is applied in an interesting way in the design of GLaDOS and Wheatley from *Portal 2*.

The overextended position of GLaDOS's head and body is the culmination of a series of opposing curves that begin with line (A), visible from this view as a straight line, to give a convincing feeling of energy and support. You can see just how important such cables are in creating tension and giving GLaDOS a powerful sense of menace when Wheatley takes over her body. During this changeover, tension is released when the cables are removed, leaving Wheatley hanging with a significantly lighter and less threatening appearance.

OPPOSITE You should always consider the communication of energy with line when designing characters. Much like the downward forces suggested by the bowing out of the sides of Greek Doric columns (see page 209), you can make a character look heavier by manipulating the curvature of lines and increasing the character's contact with the ground. Alternatively, straight lines communicate effortless energy and strength.

You can play even more with proportions and weight for different effects. For instance, a person with a small point of contact with the ground appears lighter, even if they have a rounded silhouette.

If you replace the rounded silhouette with straight lines (far right) you arrive at a contemporary idea of feminine beauty that communicates a feeling of weightlessness. Artist Albert Lozano used this concept to create the young Ellie for Pixar's *Up*, describing her shape as an "exclamation point, sort of light on her feet and lifting up into the air."

Weight doesn't actually exist in digital space, so you must employ such visual tricks to create an illusion of its presence.

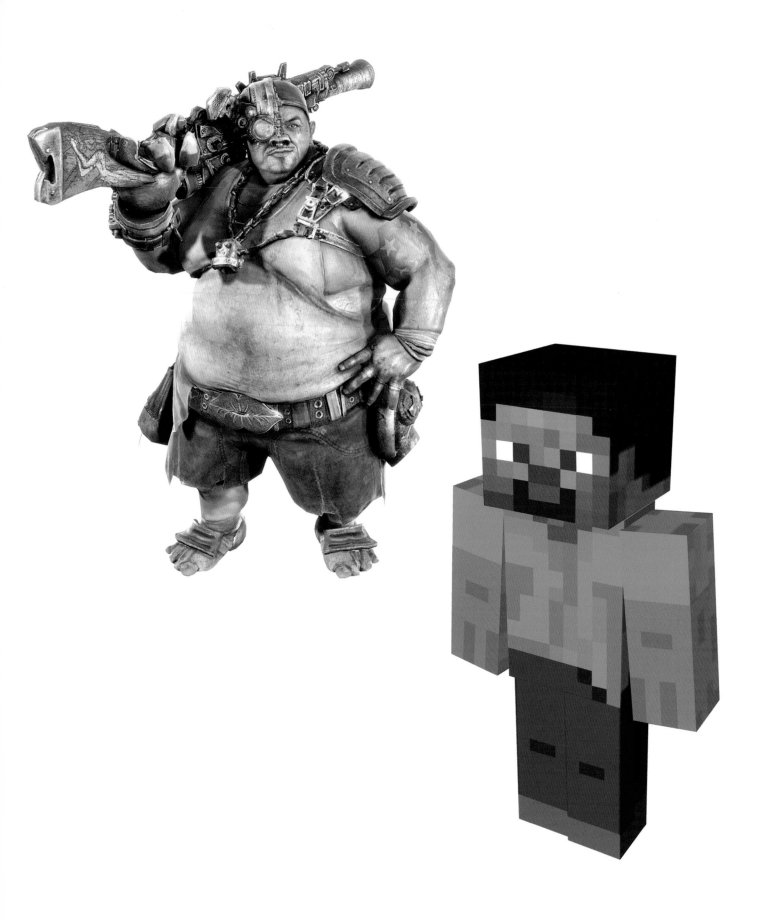

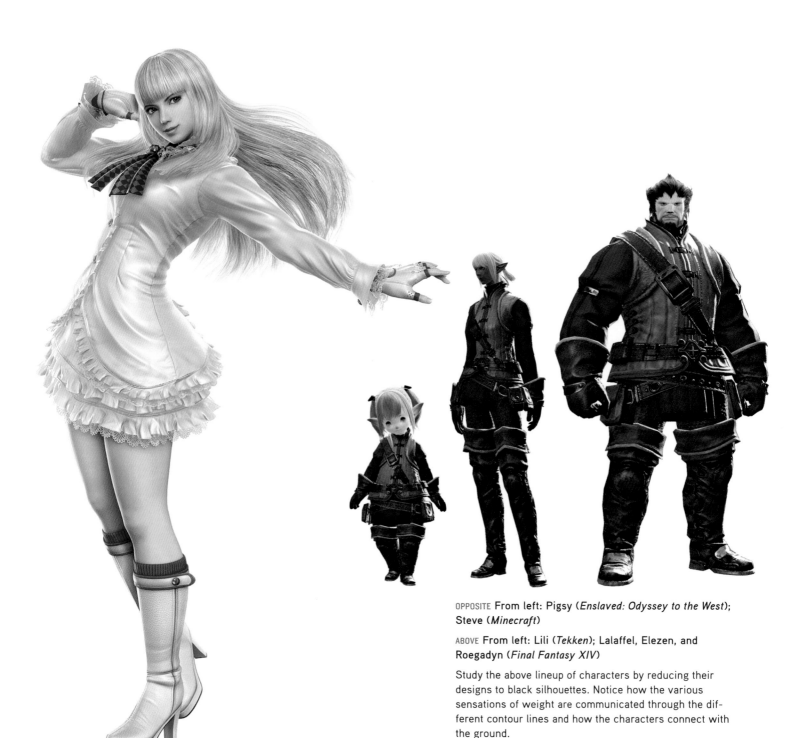

OPPOSITE **From left: Pigsy (*Enslaved: Odyssey to the West*); Steve (*Minecraft*)**

ABOVE **From left: Lili (*Tekken*); Lalaffel, Elezen, and Roegadyn (*Final Fantasy XIV*)**

Study the above lineup of characters by reducing their designs to black silhouettes. Notice how the various sensations of weight are communicated through the different contour lines and how the characters connect with the ground.

The *Minecraft* miner communicates no sense of weight whatsoever due to the straight contour lines of his design. This design fits the style and charm of *Minecraft*, but in cases where a stronger sense of life and movement is wanted it's important to consider incorporating curves into the silhouette.

PROPORTIONS

Studying proportions is the practice of applying a measuring system to the human form. The figure is such a complex subject that artists throughout history had to develop personal measuring systems based on a mix of systematic observation and personal taste.

 The standard unit for measuring the human body is the human head. The average adult person is 7.5 heads tall, although some artists prefer to use a measure of 8 heads in height. Whatever standard unit an artist prefers, that unit is consistently applied to determine the proportions of the figure being drawn, whether from life or imagination.

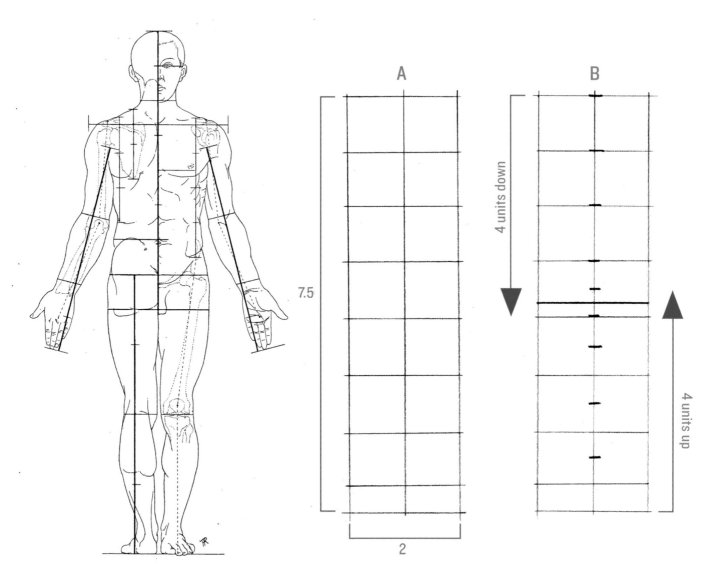

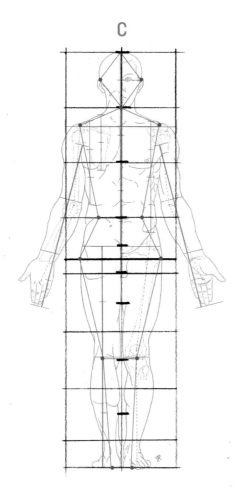

C

OPPOSITE **Figure proportions from *Artistic Anatomy* by Dr. Paul Richer**

Dr. Paul Richer's illustrations, from his book *Artistic Anatomy* (Watson-Guptill), are widely considered to be among the most accurate and clear references for artistic anatomy. It's a worthwhile exercise to make studies of his suggested system of proportions, starting with a lightly drawn grid 7.5 units in height and 2 units wide (**A**). To locate the vertical placement of key anatomical landmarks, Richer has counted 4 units down from the top and 4 units up from the base (**B**).

Once your grid is set up, you can start by indicating anatomical information with simple lines and points that will help you memorize the relative position of various anatomical features. Where an anatomical feature falls between a head unit, divide the unit into halves or thirds (as shown) rather than smaller increments that would be harder to memorize. Add increasingly complex anatomical information as your knowledge of the human figure develops.

Note how Richer's system references the underlying skeleton as opposed to fleshy points of the body. The reason for this is that the skeleton is more reliable as a measuring tool because of its solid and relatively standard form. Soft fleshy landmarks have a tendency to shift between poses and vary more drastically between individuals.

Working from the head downward, note that the figure's midpoint is located at the top of the femur (thigh bone), where the upper leg connects with the pelvis. Take a moment to note that hands are bigger than you might think; when the fingers are stretched out wide the hand will cover the face. With the arms down by a person's side, the fingertips, if stretched out, reach all the way down to the middle of the upper leg. Record such observations by annotating your study with notes and simple line and point indications (**C**).

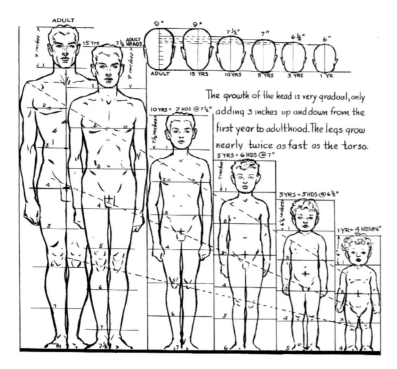

ADULT 9 inches

15 Yrs 7½ ADULT
HEADS

The growth of the head is very gradual, only
adding 3 inches up and down from the
first year to adulthood. The legs grow
nearly twice as fast as the torso.

10 YRS = 7 HDS @ 7½"

5 YRS = 6 HDS @ 7"

3 YRS = 5 HDS @ 6½"

1 YR = 4 HDS @ 6"

Suggested ideal human proportions by Andrew Loomis

Try the exercise on pages 68–69 with alternative proportion systems used by other artists. In illustrator Andrew Loomis's system of proportions note that the head is used as a consistent unit of measurement throughout human development, going from a proportion of 4 heads in height in infancy, up to 8 heads in height in maturity, as opposed to Richer's 7.5.

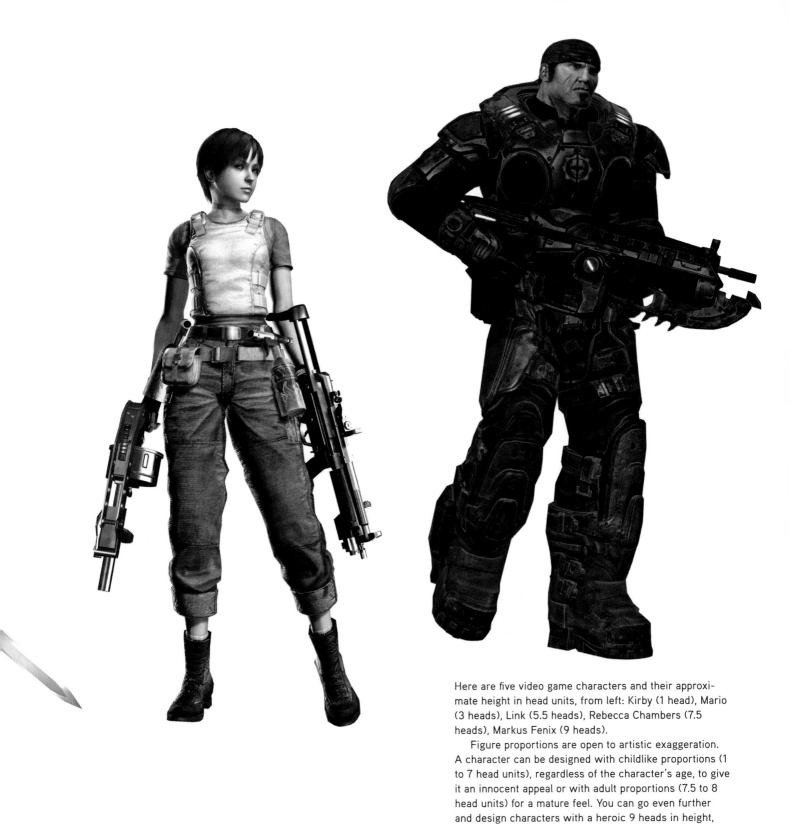

Here are five video game characters and their approximate height in head units, from left: Kirby (1 head), Mario (3 heads), Link (5.5 heads), Rebecca Chambers (7.5 heads), Markus Fenix (9 heads).

Figure proportions are open to artistic exaggeration. A character can be designed with childlike proportions (1 to 7 head units), regardless of the character's age, to give it an innocent appeal or with adult proportions (7.5 to 8 head units) for a mature feel. You can go even further and design characters with a heroic 9 heads in height, like *Gears of War*'s Markus Fenix, which is the proportion the ancient Greeks used to depict their gods. Notice how Mario appears physically younger than Link despite Mario's older age insinuated by his mature facial features.

SKELETAL LANDMARKS

Studying the human skeleton is an important aspect of figure drawing because the volumes and shape of the skeleton define much of the body's outward appearance.

Skeletal landmarks are the points on the surface of the skin where the underlying bone is nearest the surface. They serve as reliable indicators for the exact position of the skeleton because they're visible on all body types, from fat to thin. Using fleshy forms to map out your drawing is not advisable because the soft texture means that it's susceptible to change.

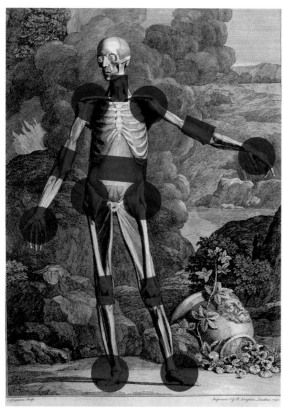

Skeleton with Muscles (1749) with overlay by Bernhard Siegfried Albinus (1697–1770)

The skeleton is a hard and solid structure that doesn't deform. It is thanks to alternating soft forms located in between the bony masses that movement is possible. These soft forms are highlighted in red and are situated across joints as well as in the neck and abdomen.

Head of an Apostle Looking Downward (1508) by Albrecht Dürer

Emphasizing the contrast between hard bone and soft flesh is critical in order to convey that a character has a believable skeletal structure holding them together. If the underlying skeleton is not suggested, then the figure will appear too soft and blob-like.

Albrecht Dürer understood the figure like few other artists in history because of his devotion to its study, which is evident in the way he has drawn the flesh of the face to appear stretched over the hard forms of the skull.

Study of Diogenes for the School of Athens (ca. 1510) by
Raphael (1483–1520)

Raphael's reclining figure, which is supporting its weight
on one arm, illustrates this contrast of soft and hard
masses. Notice how the torso appears to hang between
shoulder and pelvis much like drapery strung between
two poles. What makes this gesture possible is a combi-
nation of flexible elements of the body held together by
the rigid skeletal structure.

LEVEL UP!

This chapter demonstrated how characters can be given
a sense of movement and weight by conceptualizing them
on a series of curved lines and shapes. You also took a
look at human proportions and had a preview of artistic
anatomy and the way the figure is constructed of soft and
hard forms to make movement possible. In the follow-
ing level you will take the simple concepts that you've
learned in Levels 1 to 3 and apply them to drawings of the
Old Masters.

LEVEL 04 [ANATOMY

WE'LL LOOK EVEN MORE CLOSELY at skeletal landmarks in this anatomy chapter, which is the most complex chapter in the entire book as it combines all the elements studied so far. This may sound like a daunting challenge, but you'll shortly see that the Old Masters had some simple solutions for drawing the complex human figure.

In medical science, *anatomy* is a very technical and detailed understanding of the human figure. Artists are more interested in the body's broader volumes and functions. By conceptualizing the human figure in terms of basic volumes you'll have greater freedom in drawing it from any angle and in communicating its solidity and weight.

Every artist has their own concept of anatomical forms based on observation, study, and personal preference. The Old Masters treated the human figure as malleable and plastic, shaping it to suit their ideal taste or artistic requirements.

The lessons in this chapter are structured to draw your attention to the volume and rhythm concepts employed by the Old Masters, which they used to create a powerful sense of solidity and movement.

Battle of the Naked Men by Antonio del Pollaiuolo (ca. 1429–1498)

SIX STAGES FOR RENDERING ANATOMY

The figure has been broken down into nine elements: feet, legs, pelvis, spine and ribcage, shoulder girdle, arms, hands, head and neck, and facial expressions/emotions. Each of these elements is executed in six stages: massing, bones, skeletal landmarks, opposing curves, master quick studies, and anatomy in games.

01 **MASSING** is the process of conceptualizing an element of anatomy using a simple volume or combination of volumes to create a coherent whole. Massing should always follow the same order: establish the largest forms before moving to the details. The massing processes here are only suggestions. You'll develop your own concepts and shortcuts, as each drawing you do will present you with new challenges and insights.

02 **BONES** constitute the fundamental structure of the figure and dictate much of its outward appearance. It's more important that you develop an overall concept for general forms, rather than try to memorize the 200-plus bones of the skeleton. For instance, it's more important to understand the ribcage as an egg-like volume than it is to remember the number of ribs it has.

03 **SKELETAL LANDMARKS** are our spatial guides to map out a figure because they reveal the orientation and direction of the skeleton. It's important that you emphasize these landmarks because they convincingly communicate that your figures have an internal skeletal frame holding them together.

04 **OPPOSING CURVES** are used to create an illusion of movement by offering viewers a visual path to follow through an image. An element of interpretation is necessary when studying opposing curves because they don't reference literal lines on the figure. Which lines on the figure to emphasize is the choice of each artist: the contour of a form or muscle, a shadow edge, or an imaginary line that references the general shape of a body part. Concepts for opposing curves for the feet and hands have been combined with the larger forms of the legs and arms. There is no section on opposing curves for the pelvis and shoulder girdle because of their compact form, which makes them more useful as transitional points for a broader system of curves. The opposing curves of the leg are covered along with the foot, and those for the hand are covered with the arm.

05 **MASTER QUICK STUDIES** bring all our accumulated copying knowledge from Levels 1, 2, and 3 together. The practice of copying allows us to study the processes of different artists and gain an intimate insight into how they conceptualized the human figure.

06 **ANATOMY IN GAMES** will demonstrate how classic figure drawing concepts can be applied to video game characters. These lessons will help you combine concepts from both disciplines to design convincing characters, whether they're based on a realistic human form or something animal or imagined.

I've avoided using too many technical terms, which are often not only confusing but easily forgotten. Information about individual muscles was simplified in favor of broader concepts, because such information is often too finely detailed to be of practical help in drawing for video games, where the action is fast-paced and the characters are normally clothed. For comprehensive information regarding anatomy, refer to *Artistic Anatomy* by Dr. Paul Richer.

THE FOOT

Let's begin our detailed analysis of the figure with the feet, as this is where all the force and weight of a person is directed. We'll study the elastic properties of the feet and anatomical features that will help you better re-create the illusion of their weight-bearing energy.

MASSING OF THE FOOT

The volumetric concepts that follow are only suggestions. For example, the spheres used for the head and ribcage could also be conceptualized as boxes or cylinders. Which volumes you decide to use can vary with each character depending on the emotions that you want to communicate through its design.

Whenever you draw, consider the big forms before details, as details increase the complexity of the elements you have to consider. In drawing the foot the first thing to note is that the form has an arched shape, most prominently visible in the front and side view. The inside plane, where the two feet come together, is relatively flat.

The arch connects two box-like forms at the front and back of the foot. The bases of these box forms relate to the pads of the foot that make contact with the ground. The shape of the front pad, in particular, is susceptible to change because of the flexible bone structure beneath the surface of the skin.

Avoid drawing out each toe individually, and instead conceptualize the toes as one curved mass attached to the larger form of the foot. The exception is the big toe, which has the most maneuverability and so is often split from the larger mass of the toes while adhering to the overall structure.

BONES OF THE FOOT

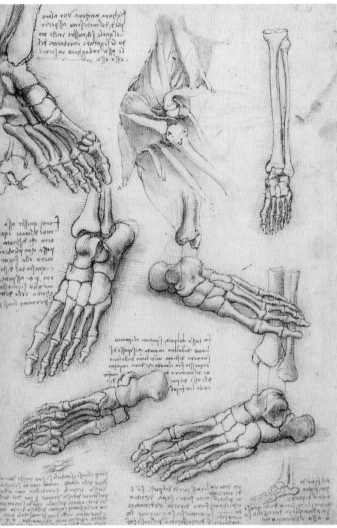

Six Studies of the Left Foot and One of the Shoulder by Leonardo da Vinci (1452–1519)

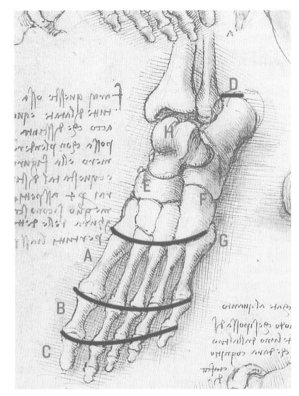

The visible portion of the toes is only a third of their full length, as the articulated bones start halfway along the foot at the metatarsals (A). The connections between the remaining two groups of bones at (B and C) can be traced by the bulky thickness of the joints.

The foot has several useful skeletal landmarks that you can use as navigation points, such as the heel (D), the navicular bone (E), the cuboid bone (F), and the hook at the base of the fifth metatarsal bone (G).

The bones of metatarsal section (A) are held together with elastic ligaments that allow them to spread outward, together with the toes, when weight is placed on the foot.

Note that the point at which the leg connects to the foot (H) is located further forward than the heel (D). This is because the muscles and tendons controlling movement of the foot require leverage. Therefore, (H) acts as the pivot and tendons attached to either side of this point control the pulling action.

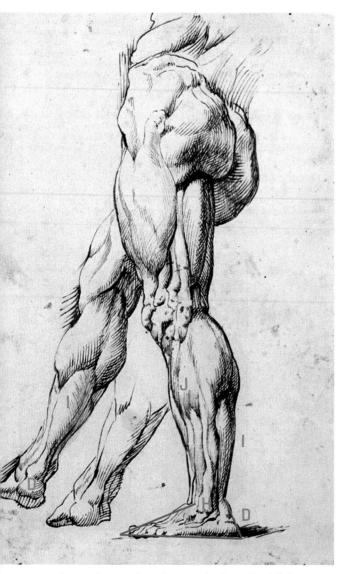

Anatomical studies of the leg by Peter Paul Rubens

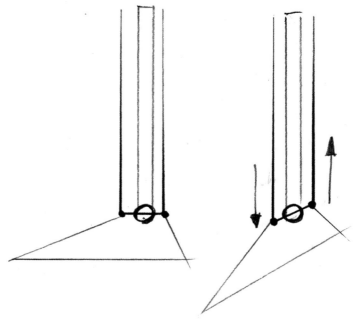

For the rapid process of blocking in a figure, particularly in the case of action poses or people in movement, artists often indicate the foot using a triangle shape because it matches the general form of the foot in the side view. Rubens's side-view drawing also illustrates the levering mechanism of the ankle joint. The Achilles tendon (I) of the calf muscles runs down the back of the leg to cup the heel (D) like a slingshot. The accompanying sketch illustrates the mechanism in action. To lift the heel the muscles of the leg (I) pull against the pivot (H). To lift the toes, the muscles around the front leg (J) pull against the pivot (H).

SKELETAL LANDMARKS OF THE FOOT

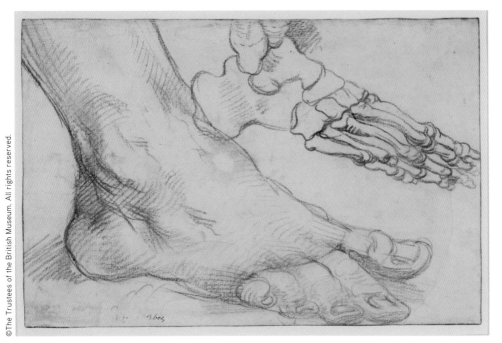

Study of a man's right foot and its skeleton by Albrecht Dürer, British Museum

Notice how the internal skeleton dictates much of the external shape of the foot. If you want to draw realistic feet (or any other part of the human body), you'll have to invest time in studying the skeleton.

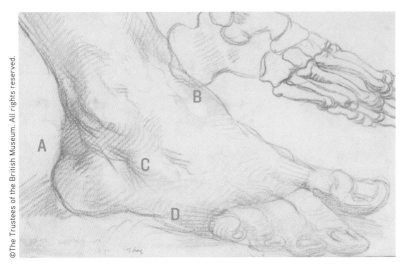

Detail with overlay of Study of a man's right foot and its skeleton by Albrecht Dürer, British Museum

Dürer dedicated a lot of time to studying anatomy, so he understood the basis of surface forms and could confidently indicate important underlying skeletal landmarks when drawing the foot: the heel (A), the navicular bone (B), the cuboid bone (C), and the hook at the base of the fifth metatarsal bone (D). Suggesting skeletal landmarks is an important element of figure drawing because they indicate the solid internal structure holding the body together.

To align the toes correctly, Dürer drew a curved line across the bulky joints between the metatarsals and toes. He has aligned the big toe at a different angle to the remaining toes, demonstrating its increased maneuverability.

The fatty pads at the base of the foot are useful tools for communicating pressure and weight. The fatty pad that is visible on the side of the foot at (D) squashes outward when downward pressure is applied and is usually more pronounced on figures with more fat.

OPPOSING CURVES OF THE FOOT AND LEG

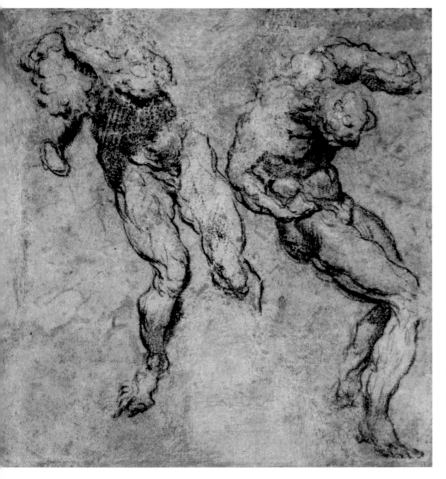

Studies for a Statue by Tintoretto (1518–1594)

Artists like Tintoretto who had expert knowledge of anatomy were masters at combining flowing systems of opposing curves to create the illusion of movement.

The opposing curves in Tintoretto's sketch switch between referencing contours, shadow edges, and internal forms (such as skeletal landmarks and muscle). Each gesture line represents a choice by the artist in response to the energy and movement that he perceived in the moment of drawing.

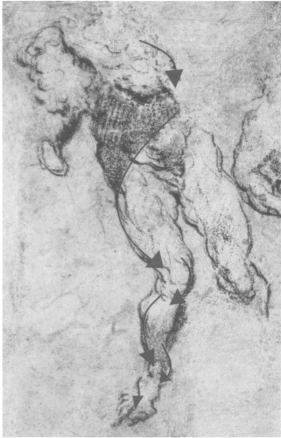

You can deduce Tintoretto's concept of opposing curves by the way he has accented certain lines to give a stronger sense of rhythm and movement. The red arrows show how Tintoretto's lines flow across the curved shadow of the abdomen, then on down the leg to bear down on the foot where the weight of the figure is concentrated. These lines create the illusion of movement by offering a path for the viewer's eye to follow through the image.

THE FOOT IN GAMES

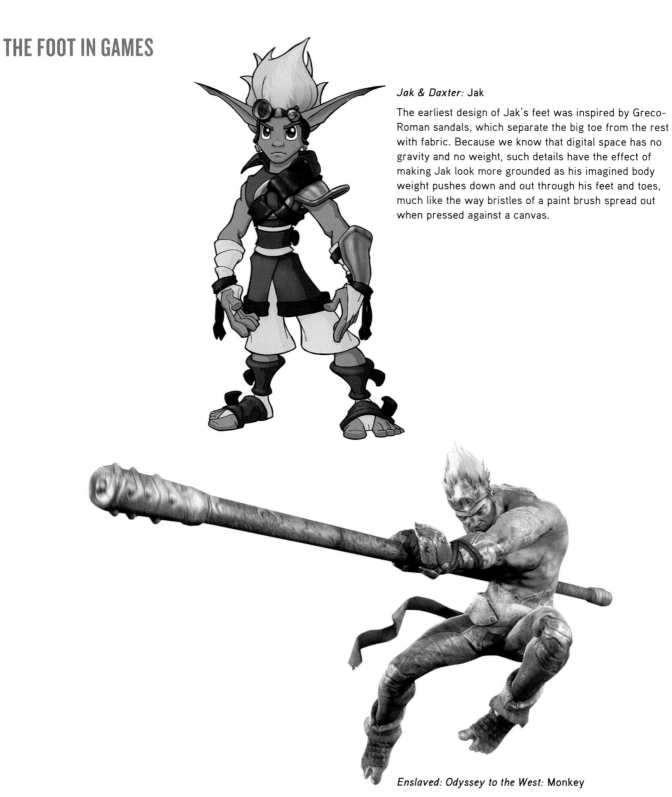

Jak & Daxter: Jak

The earliest design of Jak's feet was inspired by Greco-Roman sandals, which separate the big toe from the rest with fabric. Because we know that digital space has no gravity and no weight, such details have the effect of making Jak look more grounded as his imagined body weight pushes down and out through his feet and toes, much like the way bristles of a paint brush spread out when pressed against a canvas.

Enslaved: Odyssey to the West: Monkey

The articulation of the big toe on Monkey from *Enslaved: Odyssey to the West* adds a great deal of plasticity and life to the feet. Without that articulation, they'd look like inanimate blocks.

MASTER QUICK STUDY OF THE FOOT

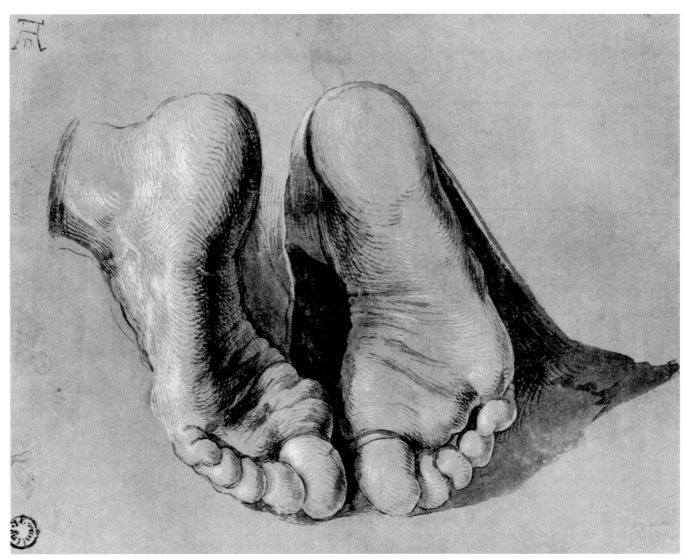

Feet of an Apostle by Albrecht Dürer

Dürer made many preparatory studies for his engravings that feature meticulous details capable of telling a story in themselves.

When doing your study of Dürer's feet, ignore the wrinkles and bumps throughout the early stages and mass in the largest shapes first. Initially use straight lines to outline each shape, which will help you with measuring and triangulation (page 35).

A good place to start is with the pads of the feet, making sure the proportions and placement of your shapes are correct because all subsequent elements will be constructed on top of this base. Even with these simple indications the feet are already recognizable.

The next step is to refine your initial contours and add more detail for the mass of the toes. Begin your shading with the strong core shadow that separates the dominant planes of the figure's left foot, delineating the planes facing toward the light and those facing away. This will automatically give a strong sense of light and form. Continue adding descriptive hatch lines for the shading, making sure that curved forms are correctly described with curving lines. Also note any overlapping forms, correctly describing which form is in the foreground and which sits behind using T-intersections.

From this point on, add as much detail as you wish. It's a simple task now that the largest shapes have been established.

THE LEG

The legs are a pleasure to draw because they feature a prominent series of opposing curves created by a combination of bone shapes and muscular forms.

MASSING OF THE LEG

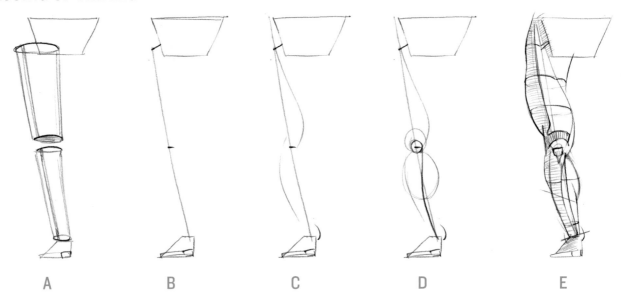

A B C D E

The basic volumes of the leg can be conceptualized as two stacked cylinders (A). When drawing the leg, your first lines establish its proportions, noting the top of the upper leg, the knee joint, and the ankle, and represent the bones of the upper and lower leg connecting to the pelvis and foot at either end (B). You can then connect these points with a spiral that wraps around the imagined cylinders behind the knee and passes on down to the inside of the ankle (C) in a system of opposing curves.

The section of the spiral connecting the pelvis and the knee defines a strong plane break between the front or forward-facing plane of the leg, and the inside plane of leg. The section of the spiral connecting the knee with the ankle defines the outside contour of the lower leg.

The next step is to suggest the calf muscle and kneecap (D), noting that the base of the calf is angled, as are the bones of the ankle joint. Draw a larger circle around the kneecap to locate the muscles on the front plane of the upper leg, which create an overhanging arch above the kneecap. You can also run a curved line downward from the base of the kneecap to suggest the strong plane break of the shin.

The remaining contours of the leg can then be added and the entire length of the leg described with modified oval cross-sections (E) that take into account the dominant planes already described.

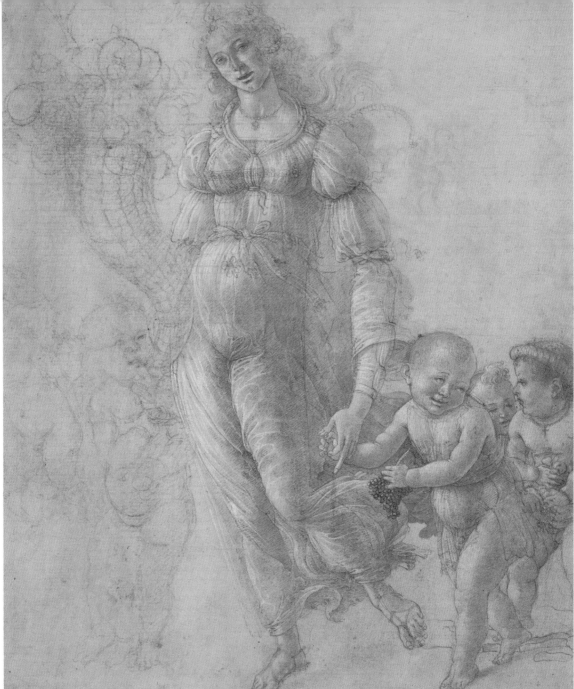

Allegory of Abundance or Autumn by Sandro Botticelli (1445–1510), British Museum

The basic volumes suggested for each element of the body can be changed to suit the personal preference of the artist and the emotions being communicated. Botticelli was known for his graceful female figures in paintings like *The Birth of Venus* (page 186). His preferred volume concepts were the softer cylinder and sphere.

In the drawing above we can see how the upper arm, forearm, and legs have been shaded according to a cylindrical mass concept. Solid box forms would have given the figures a heavier appearance.

BONES OF THE LEG

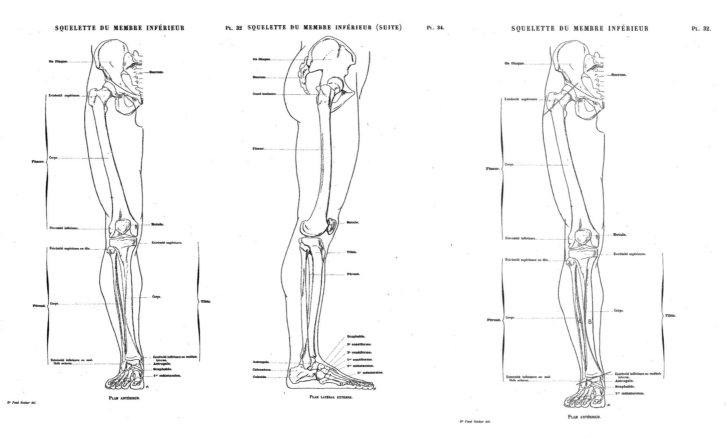

Bones of the lower limb by Dr. Paul Richer (1849–1933)

A common mistake for beginners is to draw the legs protruding straight down from the pelvis. In reality, the bone of the upper leg inserts into its socket at an angle of around 45 degrees. If the legs were attached to the base of the pelvis it'd be extremely awkward to walk, as our legs would rub against each other and we'd be restricted in raising our knees forward or out to the side.

Note the slight curvature of the bone of the upper leg in the side view, which echoes the curving contour of the thigh.

The ankle joint is composed of the topmost part of the foot (the talus) and the bones of the lower leg, the fibula (A) and tibia (B). The bumps that we commonly associate with the ankle are the ends of the fibula and tibia protruding out on either side of the leg. Note that the rounded bump of the tibia sits higher up than the bump of the fibula on the opposite side.

The tibia (B) appears to be fairly straight but the knife-like edge that is visible as a skeletal landmark on the surface of the shin is actually curved.

From a side view, the protruding kneecap creates an upward-facing plane across its top while the front plane points slightly downward.

In the front view, notice how the outside plane of the knee joint is flat, which is mirrored in the surface contours. The inside contour is more rounded because of muscle forms that wrap around the knee.

The midpoint of the figure is at the top of the great trochanter, which is the outermost part of the femur and is shaped like a bulb. This bulb is visible as a dimple on the side plane of the figure.

SKELETAL LANDMARKS OF THE LEG

LEFT *The Four Witches* by Albrecht Dürer

Dürer has beautifully rendered the flesh of these females with a wonderful sense of their soft and supple forms while ensuring that important skeletal landmarks, particularly in the legs, are also indicated to communicate a sense of solidity.

The topmost skeletal landmark of the leg is the great trochanter, which is the bulb shape at the top of the femur. The bony protrusion creates a dimple (A) on the surface of the skin because of muscles that radiate around it.

Farther down you'll find the skeletal prominence of the kneecap (B), which sits above the knee joint. The bump located just below the kneecap is the combined mass of the head of the tibia and a fatty pad (C) that protects the knee.

A barely perceptible bump (D) below the knee's midline represents the head of the fibula, visible on the side plane of the knee. This skeletal landmark becomes more pronounced when the knee is bent. The outside ankle (E) marks the lower end of the fibula, connecting the two points much like a splint. From here on down toward the ankle you can see the curved edge of the tibia—the larger of the two bones of the lower leg—highlighted in blue.

Dürer has expertly suggested the head of the tibia (F), feeling its arched form across the top of the foot. The vertical plane of the leg has been modeled in shadow, and the upward-facing plane of the foot is in light.

MASTER QUICK STUDY OF THE LEG

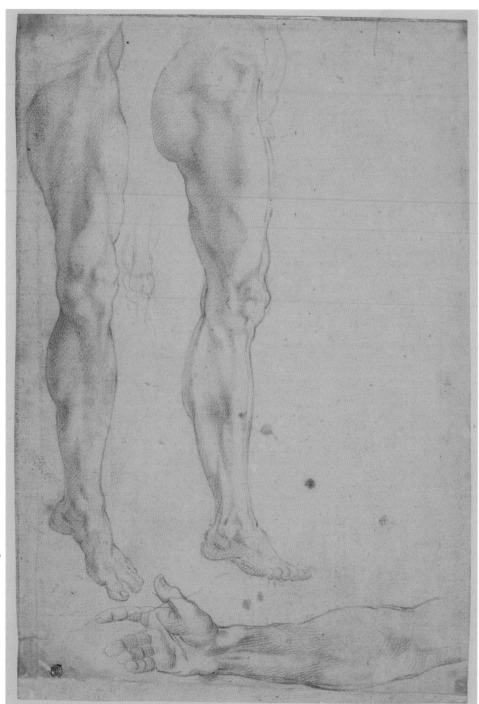

Studies of two legs and a right arm by Michelangelo (1475–1564), British Museum

Michelangelo had knowledge of the human form like few other artists in history, which he gained from performing his own dissections. Luckily you won't need to perform any dissections to draw figures with the same sense of solidity as Michelangelo's figures because it is largely his expressive use of light to model forms that gives his figures the illusion of strength.

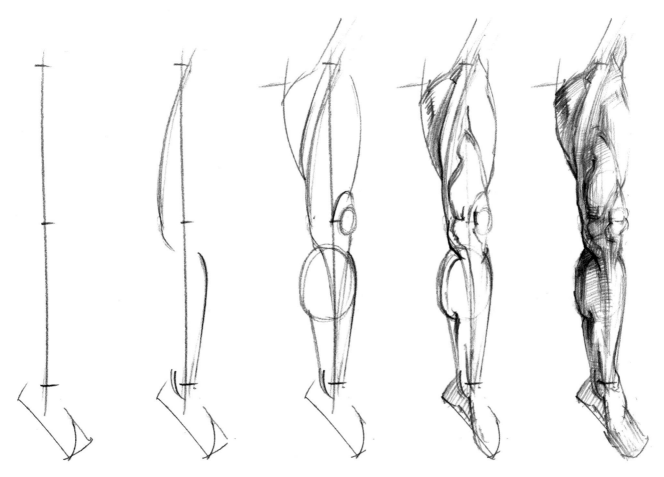

Despite the complexity of Michelangelo's study, you can use the massing concept (page 84) to temporarily ignore details and block in the leg on the left in no time at all.

The core shadow is the boundary between the light- and shadow-facing planes. Squinting at the subject helps reduce the complexity of light and shadow masses so that you can see the core shadow more clearly, drawing its tangled path as it describes the forms of the leg. With only the core shadow indicated, you've already created a sense of light.

What remains is to refine the contours, ensuring that lines overlap correctly, depending on which form is in the foreground.

The final layer of shading should be descriptive of the form: curved lines for rounded forms and straight lines for flat planes.

Michelangelo's leg study offers the opportunity to study the different shapes of the calf muscle when it's resting or flexed. The human body isn't an entirely efficient machine. With the masses of the body stacked up one on top of the other, the feet and ankle joints do an inordinate amount of work to keep the figure upright. The flexed calf on the left has a more defined shape than the relaxed calf muscle on the right.

Try the massing process on the other leg featured in the study, noting how the mass of the leg inserts into the downward-facing plane of the pelvis.

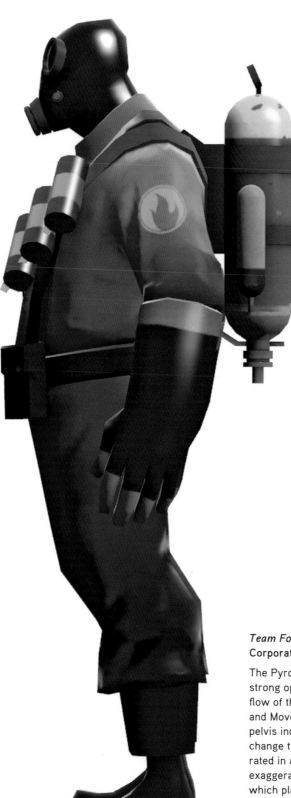

Team Fortress 2: Pyro (Artwork courtesy of Valve Corporation)

The Pyro character from *Team Fortress 2* illustrates the strong opposing curves of the leg that are created by the flow of the antigravity muscles that you studied in Gravity and Movement (page 61). Also note the forward tilt of the pelvis indicated by the character's beltline and the plane change that occurs at the knee, which has been incorporated in an exaggerated manner. Consider featuring such exaggerations in your designs, because the resolution at which players may eventually view your characters may mean that nuances will be too subtle to notice.

THE PELVIS

The pelvis is the body's second largest form—the ribcage is the largest—and should therefore be indicated at the beginning of a drawing, along with the ribcage and head, before details are added. The pelvis features prominent skeletal landmarks that wrap around the body in a 360-degree sweep and that give a strong visual indication for the orientation and direction of the pelvis.

MASSING OF THE PELVIS

B

A

C

The pelvis can be conceptualized as a tapered box form (**A**). The bones of the upper leg insert in the middle of the side planes of this box. Note that the volume of the pelvis is angled forward at around 45 degrees. Refine the box form with the contour of the iliac crest, the curved ridge that defines the top of the pelvis, and the downward sweep of the pubis on the front plane (**B**). The upward-facing plane on the rear side of the box form features a triangle along its center line that represents the sacrum (**C**), which marks the base of the spine.

Without this simple mass concept, it would be extremely difficult to re-create the form from imagination. But because you've been practicing drawing boxes freehand you can turn the form around any way you wish.

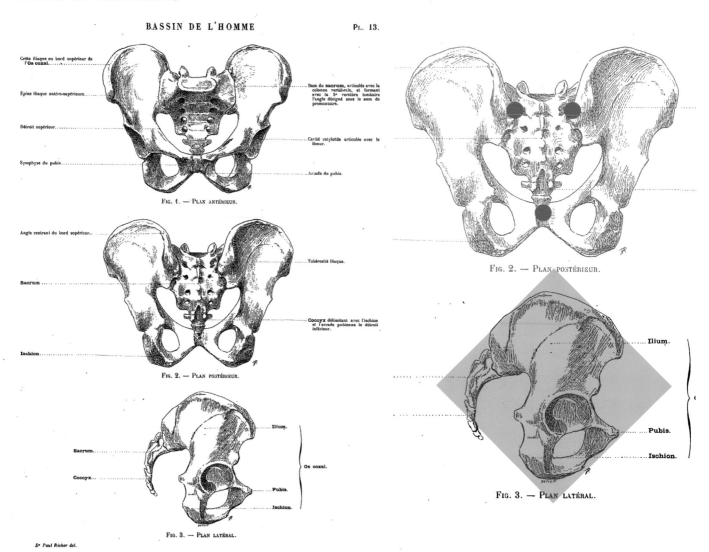

Dr Paul Richer del.

Pelvic bone illustrations from *Artistic Anatomy* by Dr. Paul Richer (1849–1933)

When you look at these anatomical illustrations by Dr. Paul Richer, it's easy to see why the pelvis is generally conceptualized as a tapered box form. The front view illustrates how the sides of the pelvis taper inward between the curved ridge that defines the top of the pelvis and its base. The anterior superior iliac crests are the two prominent skeletal landmarks that you can feel if you trace your fingers across your hips, roughly above the front pockets of your trousers.

The socket into which the upper leg fits is visible in its central position in the side view. It faces out to the sides of the figure, not down.

The thin ridges along the top of the pelvis are prominent skeletal landmarks that will help you position the pelvis. You can see in the side view how they define the forward tilt of the pelvis, turning at an angle of 90 degrees to form the back plane of the pelvis.

The sacrum triangle is the curved tail shape at the base of the spine. The three highlighted points are visible as landmarks on the surface of the body and likewise give us a strong indication of the pelvis's orientation in space.

SKELETAL LANDMARKS OF THE PELVIS

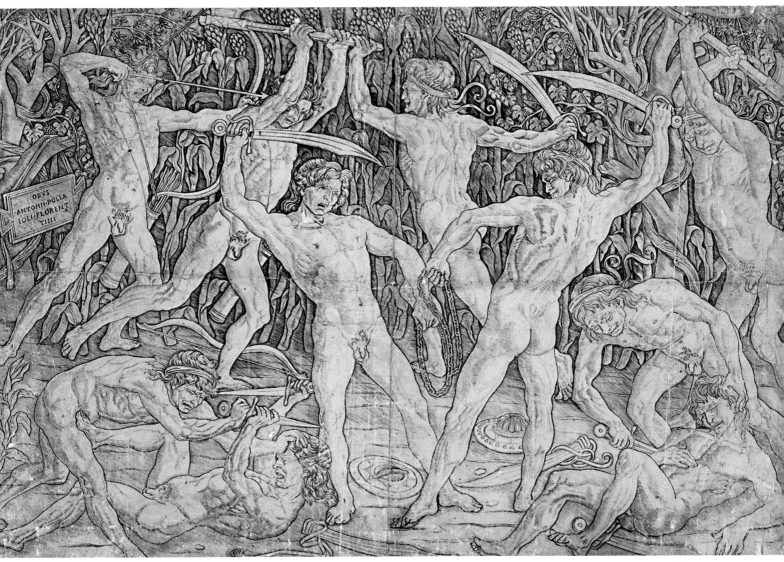

Battle of the Naked Men (1465–1475) by Antonio del Pollaiuolo

The iliac crest wraps around the side planes of the pelvis from the back, marking the top of the form where many muscles from the ribcage and leg converge. These landmarks are easy to see in the annotated detail of the artwork (page 94).

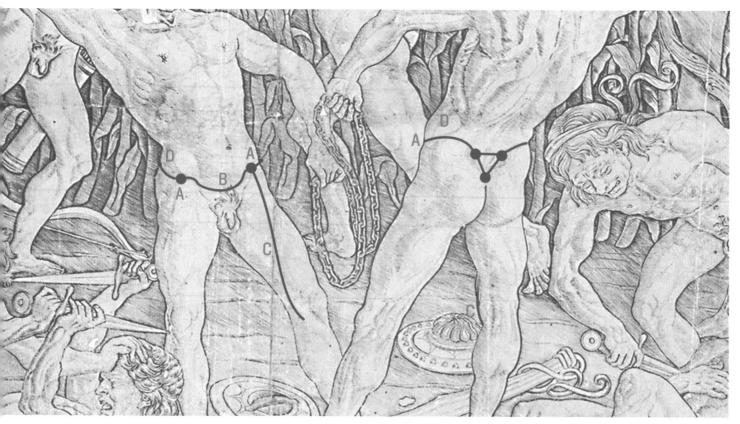

Detail and overlay of *Battle of the Naked Men* by Antonio del Pollaiuolo

The anterior superior iliac spine (**A**) is a skeletal landmark located on the front plane of the pelvis at the end of the iliac crest. You can feel the anterior superior iliac spine on either side of your hips as hard points below the surface of the skin. The skeletal landmark of the pubis (**B**) sweeps down and across the front plane of the pelvis between the two points of the anterior superior iliac spine (**A**). The sartorius muscle (**C**) is attached to the bony ridge of the anterior superior iliac spine (**A**), from where it continues down across the front plane of the leg to attach on the inside of the leg below the knee.

The great thing about these skeletal landmarks is that they are not covered by muscle or significant layers of fat, and so are identifiable points of navigation on all body types.

Following the iliac crest around the waste to the back of the figure we find the sacral triangle, which is also known as the "devil's tail." It has a curved shape when viewed from the side. You can triangulate its position using its base and the top two points, which indicate the attachment of the strong muscles of the back. The sacrum is an important skeletal landmark because it clearly indicates the orientation of the pelvis.

The bulging form of the external oblique muscle (**D**) attaches along much of the length of the iliac crest and is responsible for the upward-facing plane at the waist in opposition to the downward-facing place of the ribcage.

THE PELVIS IN GAMES

Vanquish: Sam Gideon wearing the Augmented Reaction Suit

Function creates form. Human anatomy has evolved to its current state due to functional requirements, such as the system of opposing curves of the antigravity muscles. Considering function will likewise dictate the forms you design for your own characters or creatures.

This is true of Sam Gideon's Augmented Reaction Suit (ARS). The forward tilt of the pelvis is visible here in relation to the backward tilt of the shoulder girdle, showing the balancing relationship between the pelvis and ribcage that we explored in Gravity and Movement (page 62).

Enslaved: Odyssey to the West: Trip

The relatively hard-edged iliac crest and the downward sweep of the pubis can be seen in contrast to the softer muscular form around Trip's abdomen.

The female pelvis is comparatively larger and wider than the male pelvis. The female body also tends to store more fat *across* the pelvis around the gluteus and sides of the upper leg, which softens the form of the pelvis and accounts for Trip's rounded silhouette. The male body stores more fat *above* the pelvis, around the external oblique and abdomen, thus exposing more of its angular form.

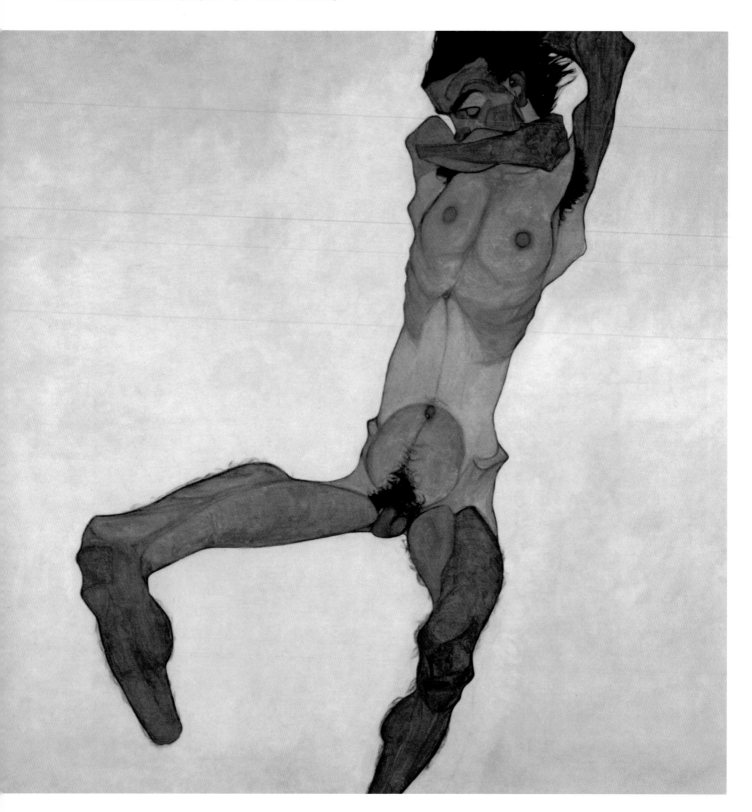

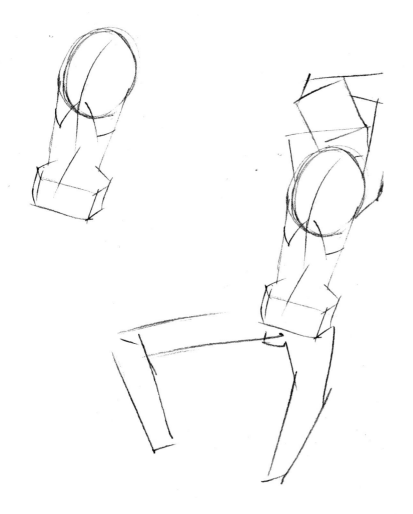

OPPOSITE *Seated Male Nude* by Egon Schiele (1890–1918)

Although this is a very stylized interpretation of the figure, Egon Schiele's classical training and strong anatomical knowledge are evident in the solidity of the skeletal forms. Schiele has almost entirely ignored the muscles of the abdomen to emphasize the hard-edged pelvis. The artistic effect creates a strong sense of vulnerability and discomfort. Our center of interest here is the pelvis, the box shape of which has been clearly defined by the prominent upward-facing planes of the iliac crest that wrap around the figure's waist.

When drawing the human figure, the starting point is always the biggest forms. Because the head is obscured by the figure's arm, start with the biggest form in the body: the ribcage. Indicate the ribcage's spatial orientation with axis lines. The vertical line travels down the length of the abdomen to meet the pelvis. As you draw this line, closely observe the relative height of the ribcage in relation to the abdomen to establish good proportions.

Follow along by drawing the pelvis, head, and legs, using simple lines. Your eye should be on the extremities, making sure the alignment of the ribcage and pelvis is correct. You can add the guidelines to the drawing for accuracy.

Schiele has explicitly conceptualized several other forms of the body as simple shapes, which make the figure easier to draw. These include the circular shapes of the chest and lower abdomen, the latter defining the downward sweeping curve of the pubis. The remaining forms are easy to fill in once the dominant volumes are established. You can add simple layers of shading to match Schiele's strongly silhouetted figure.

THE SPINE AND RIBCAGE

The ribcage is the largest mass of the body and therefore the most important. Artistic anatomy is more concerned with the volume that best describes the overall form of the ribcage than it is with anatomical accuracy and the exact number of ribs on the ribcage. When drawing the ribcage you have to also think about the spine, which supports the weight of the ribcage and connects it to the pelvis and head.

MASSING OF THE SPINE AND RIBCAGE

The basic shape of the ribcage is egg-like. It helps to draw a central axis onto this basic egg-form to indicate its orientation (A). You can also add an oval to the top of this volume to position the base of the neck.

Refine the volume of the ribcage by drawing the soft inverted V-shape (B) that describes the base of the ribs and that continues around the form to the spine at the back.

As you make further refinements, note that the volume of the ribcage is flatter in back and rounder in front, where it accommodates the lungs (C). The two lines traveling downward and outward from the base of the neck define the front plane of the ribcage.

The cylindrical column of the spine attaches to the ribcage along an S-curve, ending with a tail at its base to form the sacrum triangle (D).

BONES OF THE SPINE AND RIBCAGE

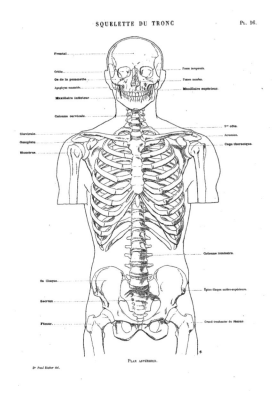

SQUELETTE DU TRONC Pl. 16.

PLAN ANTÉRIEUR.

Dr Paul Richer del.

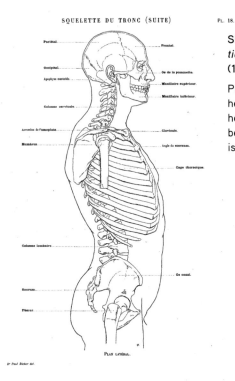

SQUELETTE DU TRONC (SUITE) Pl. 18.

PLAN LATÉRAL.

Dr Paul Richer del.

Skeleton of the trunk from *Artistic Anatomy* by Dr. Paul Richer (1849–1933)

Proportionally the ribcage is two heads high, two heads wide, and one head deep. The sternum, located between the ribs on the front plane, is one head in height.

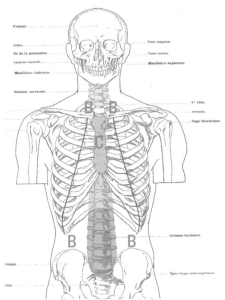

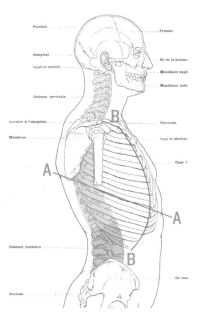

The relative angle between the apex at the back and front of the ribcage is indicated by line (**A**). The dominant plane break is indicated along (**B**). Notice the overall orientation of the ribcage, which is tipped backward in opposition to the forward tilt of the pelvis.

The sternum (**C**) is a useful skeletal landmark that defines the central line of the ribcage. Another useful skeletal landmark is the inverted V-shaped opening at the front of the ribcage.

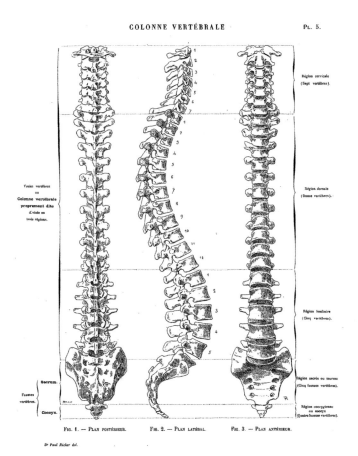

Région cervicale
(Sept vertèbres).

Région dorsale
(Douze vertèbres).

Région lombaire
(Cinq vertèbres).

Région sacrée ou sacrum
(Cinq fausses vertèbres).

Région coccygienne
ou coccyx
(Quatre fausses vertèbres).

Vraies vertèbres
ou
Colonne vertébrale
proprement dite
d'visde en
trois régions.

Sacrum.

Fausses
vertèbres.

Coccyx.

Fig. 1. — Plan postérieur. Fig. 2. — Plan latéral. Fig. 3. — Plan antérieur.

Dr Paul Richer del.

Vertebral column from *Artistic Anatomy* by Dr. Paul Richer (1849–1933)

You can see here how the spine becomes steadily wider from top to bottom, where it has more weight from the upper body to support. Artists tend to exaggerate this widening at the base to communicate a stronger sense of weight. Notice how the shape of the spine dips in and under the ribcage and head at sections (**B**) and (**D**), which are the two dominant forms it supports. The spine attaches to the sacrum triangle at its base.

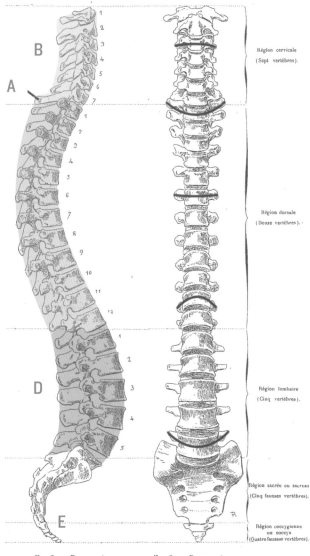

Région cervicale
(Sept vertèbres).

Région dorsale
(Douze vertèbres).

Région lombaire
(Cinq vertèbres).

Région sacrée ou sacrum
(Cinq fausses vertèbres).

Région coccygienne
ou coccyx
(Quatre fausses vertèbres).

Fig. 2. — Plan latéral. Fig. 3. — Plan antérieur.

The spine has different levels of flexibility. Its seventh cervical vertebrae (**A**) is an important skeletal landmark that marks the border between the flexible neck (**B**) and the part of the spine that attaches to the ribcage (**C**), which has the least amount of flexibility.

You can feel the difference in flexibility between (**B**) and (**C**) by placing your hand on the back of the lower neck and rotating your head and then on the middle part of your spine at the ribcage. A similar increase in flexibility occurs between the ribcage and pelvis (**D**). The tail-shaped sacral triangle (**E**) inserts into the pelvis. Its curvature and three skeletal landmarks make it a useful place to indicate the orientation of the pelvis.

St. Albert by José de Ribera (1591–1652)

In this depiction of St. Albert, José de Ribera drew the ribcage from a top-down view. He simplified the task of drawing the difficult view of the ribcage by conceptualizing it as a spherical form. It's suggested by the curved contour of the back, which is continued behind the arm and up and down the side of the figure.

To orient this spherical form and give it a direction, Ribera indicated the vertical and horizontal axis of the sternum (A) that runs down the middle of the ribcage. He also made sure to include the skeletal landmarks at (B), which mark a direction change between the front and side planes of the ribcage. The solidity of the ribcage means that the triangle connecting points (A) and (B) is fixed, no matter what action the figure is performing.

On the figure's side, the downward-facing planes of the lower ribcage meet the upward-facing plane of the external oblique muscle at point (C).

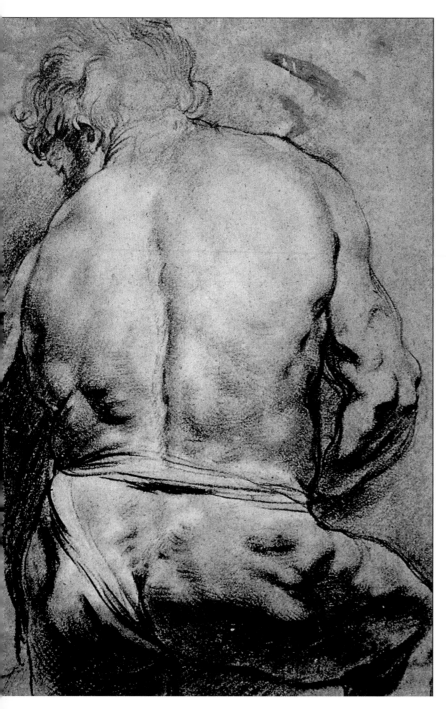

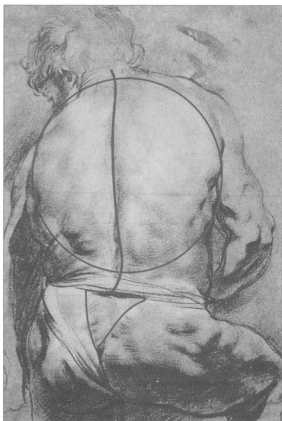

Study of a Male Figure Seen from Behind by Peter Paul Rubens

Rubens teaches us that maintaining the solidity of the ribcage is much more important than drawing its details, which should always support the bigger forms.

He created the illusion of a solid ribcage by drawing a nearly continuous line around its spherical form. The soft transition of light across the back reinforces its curved shape. He used the spine and the skeletal landmark of the sacral triangle to give the ribcage and pelvis a direction.

OPPOSING CURVES OF THE SPINE AND RIBCAGE

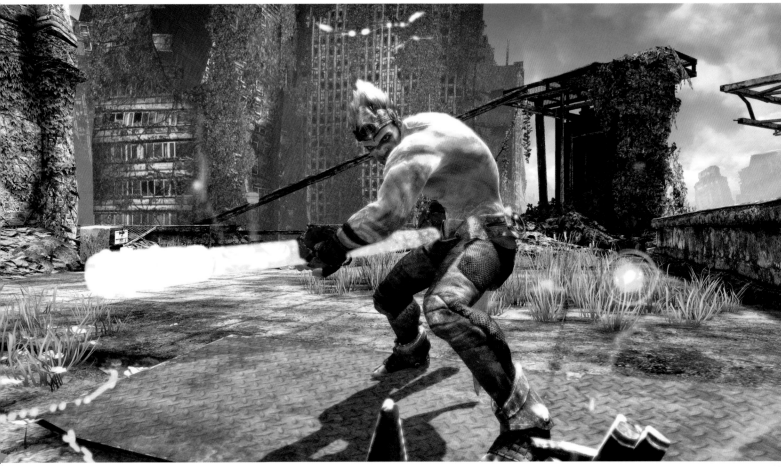

Enslaved: Odyssey to the West: Monkey

Taking time to establish a flow of opposing curves through the forms is essential to create a realistic sense of life and movement. Although the basic volume of the ribcage is fairly simple, the myriads of muscles that overlay and attach to it make the task of drawing it somewhat of a technical challenge.

The illusion of energy in Monkey's pose has a lot to do with the parallel curves of the spine and the latissimus dorsi (purple) and deltoid (blue) muscles. The latissimus dorsi is a particularly useful surface feature that can link elements of the figure together because of its large size and the way it wraps around the length of the back up to the arm.

You should take the time to study these muscles in detail once you're confident drawing the mass of the ribcage from every angle.

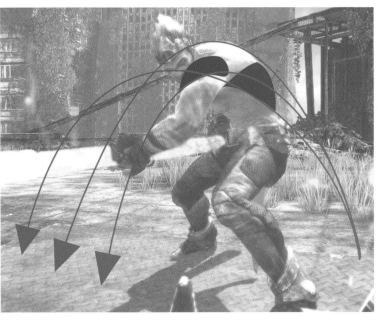

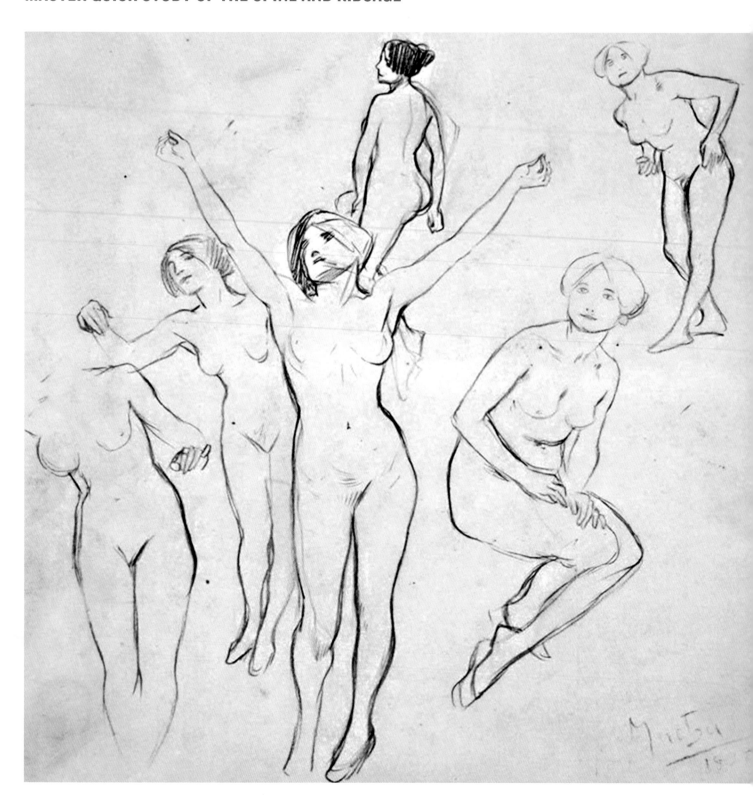

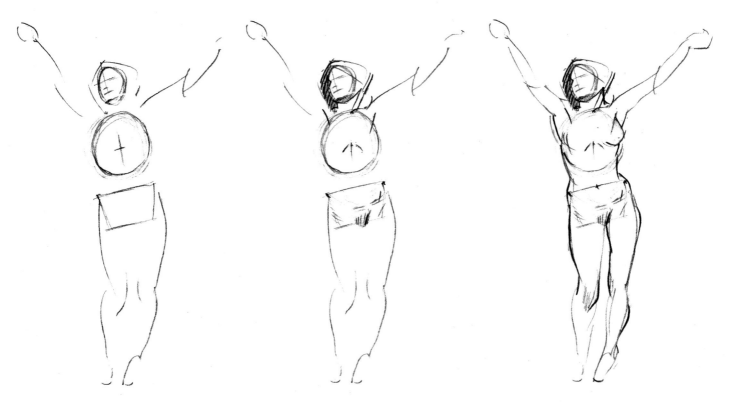

Study of the Female Nude by Alphonse Mucha
(1860–1939)

This study by Alphonse Mucha is a great example of how much you can say with just a few simple lines. Master Japanese painter and printmaker Katsushika Hokusai (1760–1849) summarized the artistic pursuit of simplicity beautifully: "At seventy-three, I learned a little about the real structure of animals, plants, birds, fishes, and insects. Consequently when I am eighty I'll have made more progress. At ninety I'll have penetrated the mystery of things. At a hundred I shall have reached something marvelous, but when I am a hundred and ten everything I do, the smallest dot, will be alive."

Mucha missed Hokusai's life goal by twenty-one years, but nonetheless achieved a level of subtlety that few artists can match.

ABOVE In your study of the central figure in Mucha's composition, first block in the head, then use it to measure out and mark the relative proportions and placement of the ribcage and pelvis, using the neck and spine as attachment points. Indicate the central axis lines of each form to establish their relative orientation to one another.

Mucha used very subtle marks to communicate skeletal and muscular landmarks: the sternomastoid muscle, which runs across the neck from below the ear to the clavicle, was suggested with two lines; the short line at the armpit represents the pectoralis muscle and travels vertically to attach to the figure's upraised arms.

Working down the figure, add the central line of the abdominal muscle and base of the ribcage followed by the contours of the pelvis between the skeletal landmarks of the anterior superior iliac spine.

Once these large skeletal forms are established you can consider the softer fleshy forms that overlay them. Most relevant to this study are the figure's breasts and external oblique muscles, which are drawn with lines that overlap our initial volumes.

The initial shapes that you put down to indicate the head, ribcage, and pelvis can be lightened or removed entirely with the eraser at any moment, but it's important that the contour lines that you put in their place echo their shapes.

THE SPINE AND RIBCAGE IN GAMES

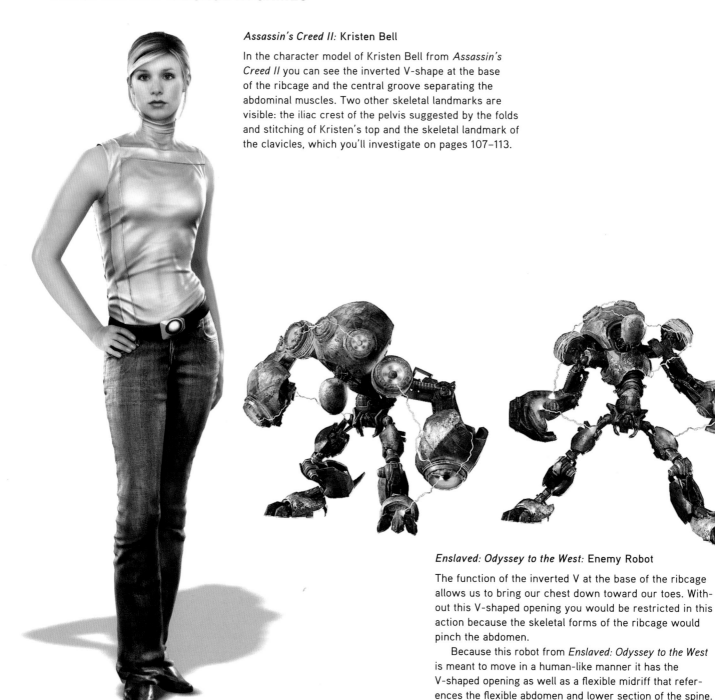

Assassin's Creed II: Kristen Bell

In the character model of Kristen Bell from *Assassin's Creed II* you can see the inverted V-shape at the base of the ribcage and the central groove separating the abdominal muscles. Two other skeletal landmarks are visible: the iliac crest of the pelvis suggested by the folds and stitching of Kristen's top and the skeletal landmark of the clavicles, which you'll investigate on pages 107–113.

Enslaved: Odyssey to the West: Enemy Robot

The function of the inverted V at the base of the ribcage allows us to bring our chest down toward our toes. Without this V-shaped opening you would be restricted in this action because the skeletal forms of the ribcage would pinch the abdomen.

Because this robot from *Enslaved: Odyssey to the West* is meant to move in a human-like manner it has the V-shaped opening as well as a flexible midriff that references the flexible abdomen and lower section of the spine.

Notice the similarity of the robot's pelvis to the human pelvis in its tapered box-shape, and the opposing curves throughout the forms of the legs. It's easy to see from this example how knowledge of human anatomy can be used to create convincing characters from imagination.

THE SHOULDER GIRDLE

The shoulder girdle is the convoluted skeletal link connecting the bones of the upper arm to the torso. It is composed of the shoulder blades, acromion process (the flat skeletal form that is located directly above the arm), and clavicles. The shoulder blades are an extension of the upper arm and follow the arm around wherever it goes. The shoulders are very expressive of emotions because of the free movement the shoulder girdle affords—pulled back to express confidence, dropped forward for protection and to express vulnerability.

MASSING OF THE SHOULDER GIRDLE

In the front view a straight horizontal line establishes the plane break between the front plane of the chest and the top plane of the shoulder girdle. This line can be continued around to the back and the shoulder blades to complete the upward-facing plane of the upper body (A). This top plane should be tilted backward to echo the backward tilt of the ribcage, in opposition to the forward tilt of the pelvis. The shoulder blades have a thin, curved form when viewed from the side as they fit snuggly over the rounded ribcage. Their basic shape is a triangle (B).

A downward-pointing triangle at the pit of the neck indicates the inside edge of the clavicles and the top of the sternum (C), which is drawn with a vertical line. The T-shape that these lines create communicates the orientation and direction of the ribcage. The shoulder girdle's primary function is to allow for free movement of the upper arm, to which the clavicles and shoulder blades are fastened. The pivot point for the shoulder is located at the inside edge of the clavicles. The clavicles move in relation to the arms, so the T-shape may turn into a Y if both arms are raised.

BONES OF THE SHOULDER GIRDLE

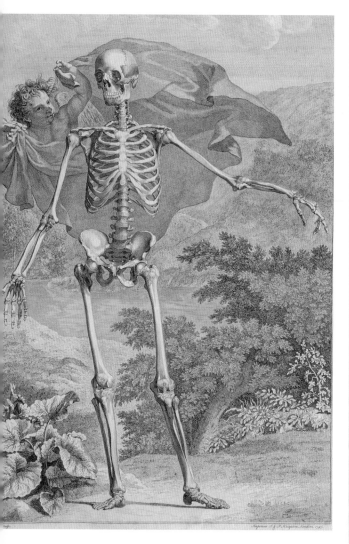

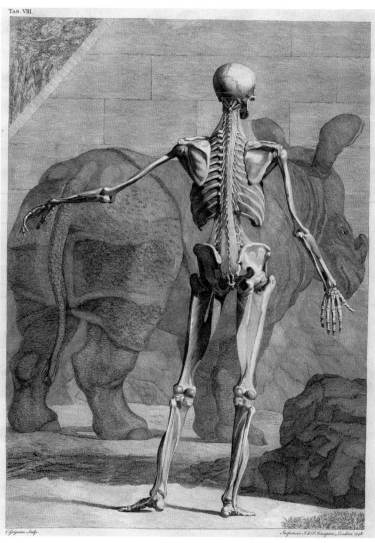

Skelatal studies by Bernhard Siegfried Albinus

Knowledge of the skeleton is extremely important because it dictates much of the outward forms of the body. Knowing the location of skeletal landmarks lets us communicate direction and structural solidity of the figure.

The construction of the shoulder girdle allows the shoulder blades to float above the ribcage, giving our arms a wide range of maneuverability. The pivot point of the shoulder girdle is located at the inside edge of the clavicles (C) and (D), where they attach to the sternum (B). The acromion process (E) is oriented at a right angle to the clavicles (A) in its position above the bone of the upper arm.

Our shoulder blades have a spine (line F to G), which is a useful skeletal landmark because it's a good indication of what the shoulders are doing beneath the surface of the skin as they follow the movements of the upper arm to which they are connected.

The base of the shoulder blades is particularly visible when the arm is pulled back, causing the shoulder blade to literally lift off the surface of the ribcage. Indicating the points (F), (G), and (H) allows you to triangulate the position of the shoulder blades.

(H) is where the teres major muscle attaches, linking the shoulder blade and the bone of the upper arm. This is just one of several connecting muscles between the two forms. To pull our arms back, we must push our shoulder blades inward. To pull our arm forward the shoulder blade must follow, moving away from the spine.

The shoulder blades are larger than most people think: approximately half the height of the ribcage. In the front view they can be seen extending out beyond the mass of the ribcage, seen as a triangular shape below points (A) and (E), to connect with the upper arm.

SKELETAL LANDMARKS OF THE SHOULDER GIRDLE

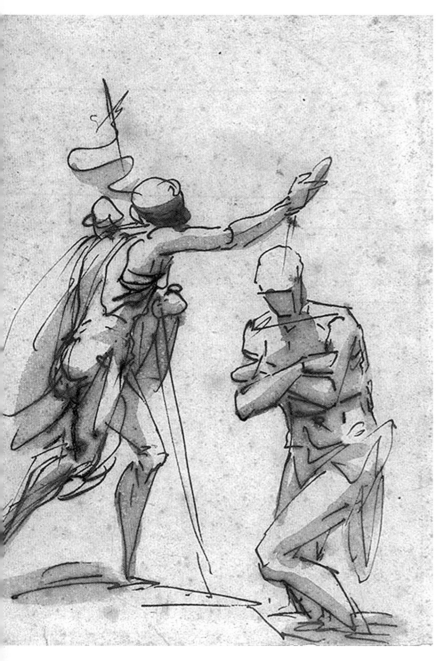

The Baptism of Christ by Luca Cambiaso

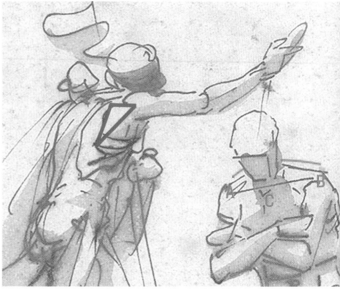

The shoulder girdle has many useful landmarks that will help you communicate the action of the arm and orientation of the ribcage. With a simple straight line between points (A) and (B) Luca Cambiaso defined the clavicles and established the upward plane of the shoulders. At (C) he drew a V and a small vertical line to indicate the inside edge of the clavicles and sternum, giving direction to the ribcage to which these forms are attached. The line that goes behind the head is the contour created by the trapezius muscle.

The figure on the left has his arm pulled forward, which correspondingly causes the shoulder blade to slide over the form of the ribcage, away from the spine in pursuit of the arm. Cambiaso has triangulated its position with a contour line and the shadow edge that continues into the arm.

THE SHOULDER GIRDLE IN GAMES

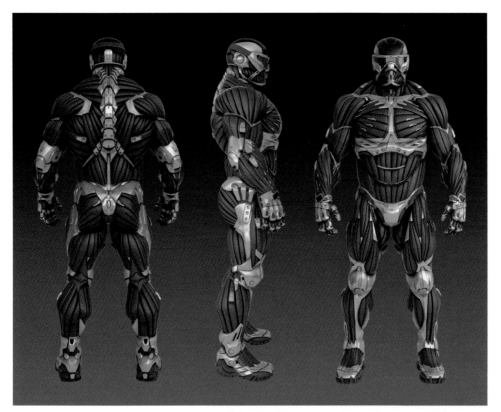

Crysis 2: Nanosuit 2

The spine of the shoulder blades (A), the acromion process (B), clavicles (C), and the sternum (D), have all been clearly incorporated here into the Nanosuit 2. Note how the plane created between these points is tilted backward in the side view, echoing the backward tilt of the ribcage.

The skeletal landmarks are instrumental in giving the suit its visual strength. Without them the character would look unstable and lack a solid structure to keep it upright.

In the front view the silhouette of the trapezius muscle travels behind the neck in an arc between points (B). The majority of aggressive characters have an overly developed trapezius because this muscle stabilizes the neck when the head is punched and adds a sense of belligerence to their appearance.

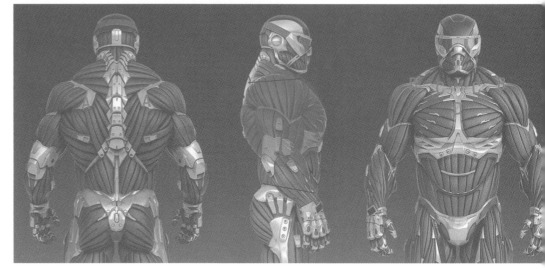

MASTER QUICK STUDY OF THE SHOULDER GIRDLE

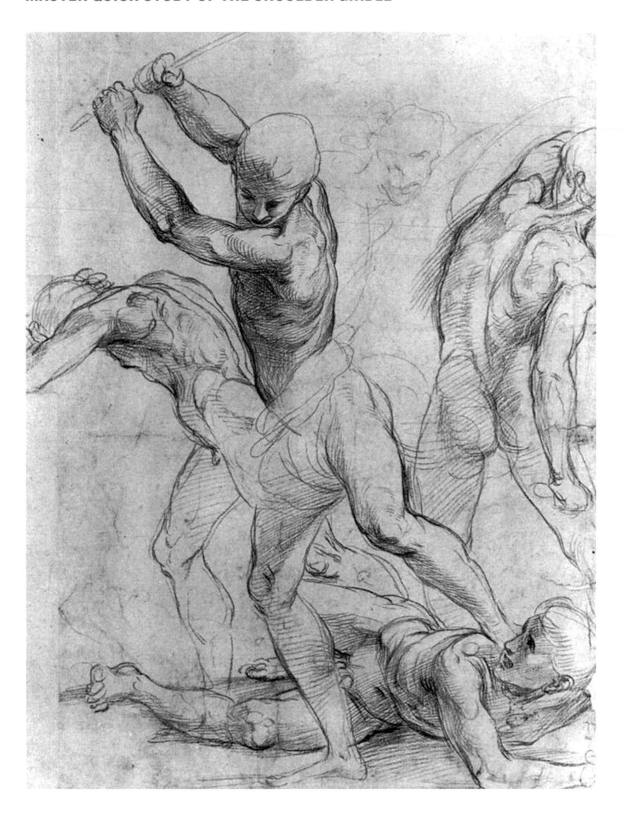

OPPOSITE *Fighting Men* by Raphael

Examples of the shoulder girdle in action are in abundance in this study by Raphael. Make a quick study of the prostrate figure in Raphael's composition, whose right arm is pulled forward and up in self-defense. Raphael would have been perfectly capable of creating this drawing from imagination, as would all the Masters featured here. You too can draw such convincing figures from imagination if you take the time to learn the proportion systems and massing concepts in this book.

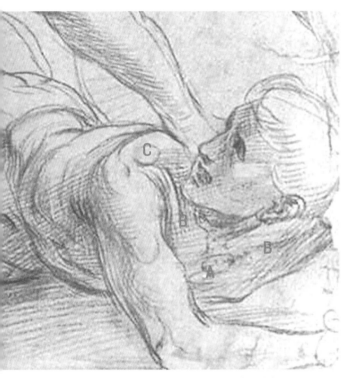

The most prominent skeletal landmarks of the prostrate figure are the sternum (**A**), clavicles (**B**), and acromion process (**C**).

After establishing the head and ribcage, note that the contour line of the acromion process and spine of the figure's right shoulder blade intersect with his face just below the nose. Raphael has used the concept of atmospheric perspective (see pages 53–54) to fade the contour line before it disappears behind the head to emphasize that the form sits further back in space in relation to the face.

The figure's right clavicle is at a steeper angle than his left, emphasizing the angle of his right shoulder's defensive position.

THE ARM

The process of drawing arms is similar to that used for legs. Both the legs and arms have interesting spiraling rhythms linking their forms. This spiraling placement of forms is essential to create movement.

MASSING OF THE ARM

A

B

C

The quickest way to mass the arm is to conceptualize it as two cylinders (**A**). Begin with simple gestural lines to indicate the direction of the lower and upper arm using various curves and cross-sections depending on the action of the arm.

A more advanced mass concept for the arm is to reduce its volumes to a series of interconnecting box and spherical forms intersecting one another at roughly 90 degrees (**B**). For the final stage, refine these basic volumes, noting the way they attach to one another (**C**). The top box represents the deltoid muscle. The base of this form tapers to insert between the muscles below. A similar tapering and insertion happens across the pit of the elbow between the box form directly above the elbow joint and the spherical form below.

BONES OF THE ARM

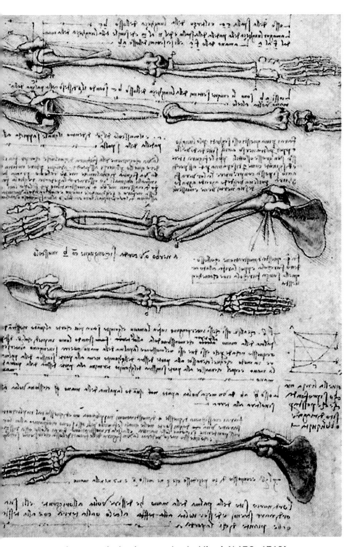

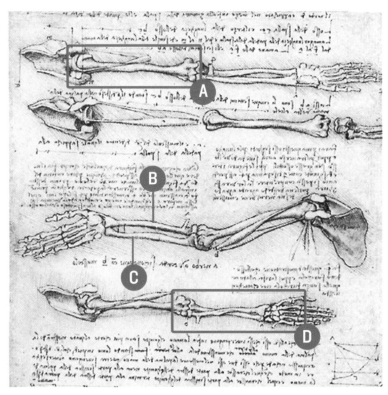

Arm study by Leonardo da Vinci (1452–1519)

In Gravity and Movement (pages 60–67) you saw how the opposing placement of antigravity muscles up and down the body is fundamental to the action of walking. This system of opposing curves penetrates down to the bones, since this is where the muscles attach. You can see this in the drawing above in the way Leonardo drew the spiraling shape of the humerus, which is the bone of the upper arm; see (**A**) in the next illustration.

Here you can see the action of the two bones of the forearm. When the palm of your hand is turned so that it faces up or forward, the radius (**B**) and ulna (**C**) sit parallel to each other.

When the wrist is twisted so that the palm faces down or backward, the two bones twist over each other to create an X-shape (**D**). This action is visible on the surface of the skin because of several skeletal landmarks that we'll study in the following drawings.

SKELETAL LANDMARKS OF THE ARM

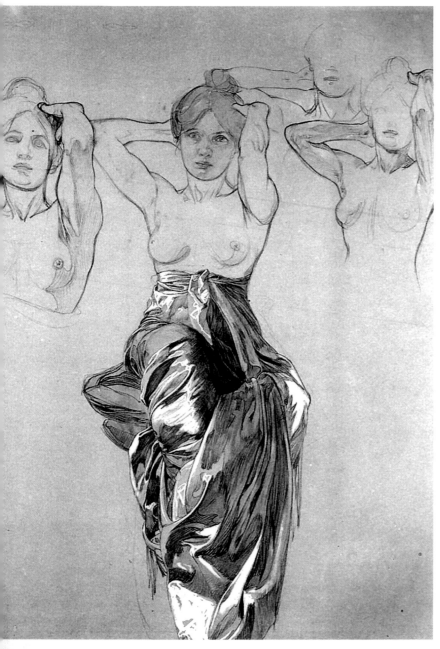

Study of Drapery by Alphonse Mucha

The skeletal landmarks of the arm concentrate around the area between the elbow and wrist. The hard skeletal form that we think of as the elbow is the large end of the ulna (A). The ulna has a second landmark, which is the skeletal bump on the top outside edge of the wrist (B). The line that links these two points together traces the path of the ulna below the surface of the skin.

Two smaller skeletal landmarks (C) and (D) indicate the extremities of the humerus bone, which hold the end of the ulna (A) in place. The edge of the ulna and the tendons of the triceps create a strong plane break along the line indicated down the back of the upper arm.

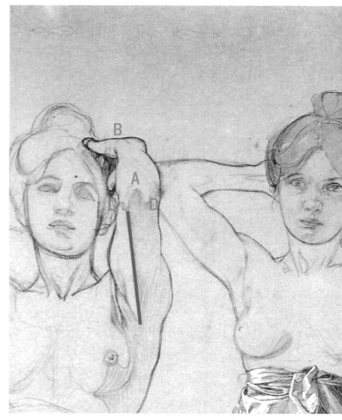

Human Skeleton by Govert Bidloo

This detail from an engraving by Govert Bidloo is included here because it shows the connection between the ulna and humerus bone. You can clearly see the ulna and its skeletal landmark where it slots into the wrench-like shape of the humerus bone. Look for these bones as skeletal landmarks at the elbows of the female figures in Mucha's drawing, below and opposite.

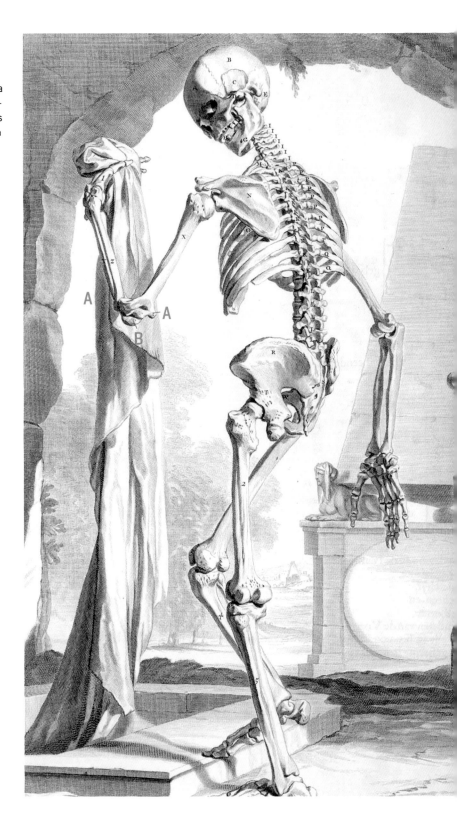

MASTER QUICK STUDY OF THE ARM

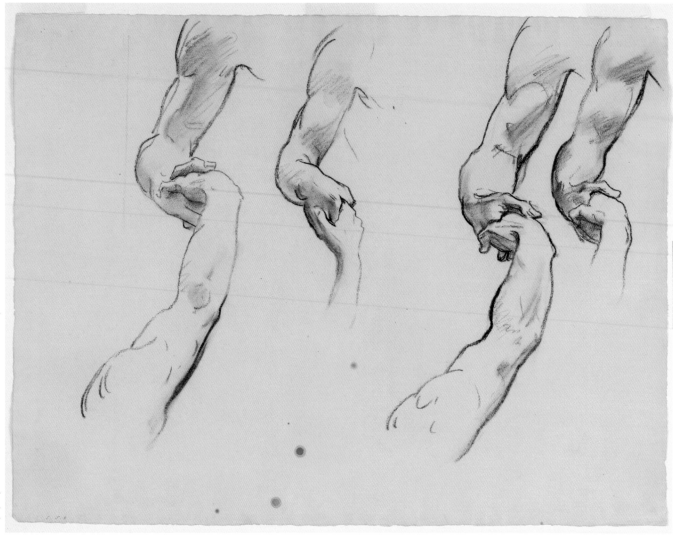

Study of Clasped Hands, for Heaven (1895–1916) by John
Singer Sargent, Boston Public Library

This drawing of arms and clasped hands by John Singer
Sargent is beautifully simple and yet it still has a power-
ful sense of strength and form. The three-step study
opposite will show you how Sargent achieved this.

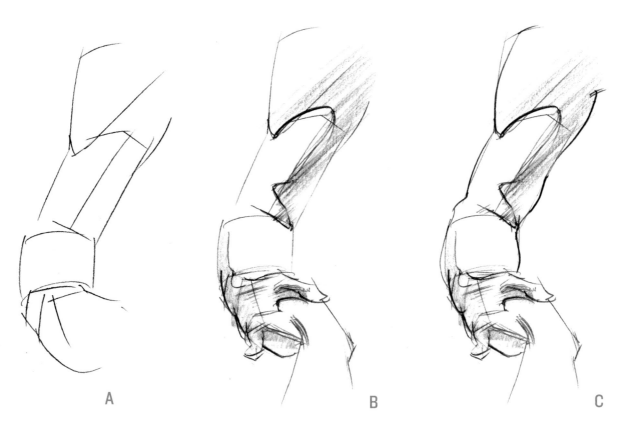

A B C

Illustration (A) demonstrates the first step of the study. Working from top to bottom, start with a tapered box for the deltoid muscle. Below this tapered box form place another box, intersecting it with the one above at an angle of approximately 90 degrees. The last set of volumes mass the lower arm, featuring cylinder and box forms, which overlap to communicate depth.

Because the muscle groups are conceptualized as separate volumes it's easier to understand why the contour of the deltoid overlaps the contour of the triceps, as the triceps sit further back in space. Further down you see additional overlap where the contour of the forearm overlaps the outside edge of the triceps to indicate that the upper arm is further back in space than the forearm. Run a line indicating the core shadow along the dominant plane breaks of the upper arm (B), as Sargent has done. This gesture alone already increases the sense of light and form, but the addition of quick, diagonal shading for the shadow planes completes the illusion. Finish by refining the contour lines and adding overlapping T-intersections that communicate a stronger sense of depth (C).

Gears of War 2: Berserker

You can clearly see the twisting action of the Berserker's forearm, caused by the orientation of the downward-facing palm. Starting at the skeletal landmarks of the elbow, these surface forms twist around the lower arm toward the wrist, suggesting the same underlying skeletal mechanism that Leonardo drew in his study of the bones of the arm on page 115.

The Berserker's design also references the anatomy of the upper arm with the 90-degree intersection between the deltoid muscle and the combined mass of the biceps and triceps below. The majority of the muscle fibers have been clearly defined, making them look like they're bursting at the seams.

Prince of Persia

Prince of Persia features excellent lighting that models the planes of the figures, much like the lighting used by the Masters. The arm in this screenshot resembles the study by Sargent on page 118.

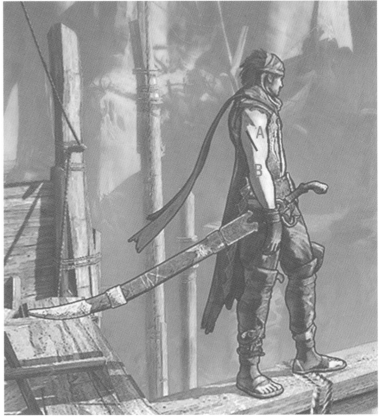

A core shadow runs down the length of the arm, defining the insertion of the deltoid in between the triceps and biceps. It then turns to wrap across the triceps before continuing down to the wrist. On its way down, it breaks at two important landmarks: the base of the lateral head of the triceps (A) and the skeletal landmarks of the humerus and ulna at the elbow (B).

The upper arm was modeled asymmetrically with the apex of the contour for the triceps on the back of the arm located higher than the apex of the biceps on the front of the arm. When the upper arm is flexed, the relative positions are reversed.

THE HAND

In comparison to the other anatomical forms we've investigated so far, the hands are a collection of very small forms, the intricacy and flexibility of which make them a very expressive feature of the human body.

MASSING OF THE HAND

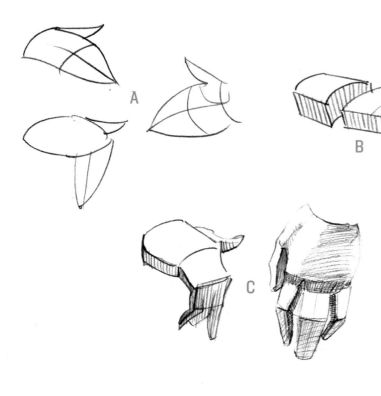

The quickest way to suggest the hand is with a petal shape (A), the tip of which is located off center to indicate the position of the long middle finger. Cut this petal shape in half with a curved line to indicate the placement of the knuckles. The form of the thumb overlaps the base of the palm at roughly a 45-degree angle.

To add volume, turn the bulk of the hand into a series of arched box forms that taper toward the fingers (B).

Keep in mind that the hands are much simpler to draw if you treat the fingers as one mass, rather than drawing each finger individually. We took the same approach in combining the toes to enhance the feeling of a coherent, solid mass. Common exceptions are the index and little fingers, which are the most maneuverable of the fingers and help communicate the expressive actions of the hand (C). Notice that fingernails have not been considered, as they are a detail that is secondary to the overall mass conception.

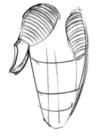

The thumb can also be conceptualized using box forms, but its base (where it attaches to the palm) is closer in shape to an elongated sphere. Another prominent form is located on the opposite side of the palm across from the thumb. When tensed, this mass of muscle and fat, together with the thumb, allows you to cup your hand.

BONES OF THE HAND

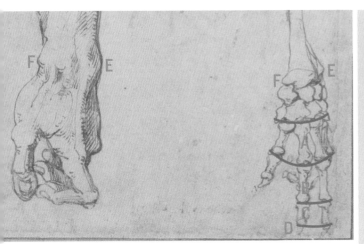

The segments of the fingers, known as the metacarpals (A) and phalanges (B), (C), and (D), are responsible for the skeletal landmarks on the surface of the hand. You can see how the bulky joints of the bones create the concertina-like shape of the fingers. Notice how the alignment of the joints describes the curved form of the hand.

Michelangelo's study also features the styloid process of the ulna (E) and the smaller skeletal landmark of the radius (F), which are useful landmarks for describing the orientation of the wrist.

We often think of classical artworks as "realistic," but in fact they were very stylized and unique to each artist. It's interesting to note that Michelangelo used a simpler mass concept for the upper arm than did Sargent (see page 118). Sargent's core shadow snakes its way down across the deltoid and biceps; Michelangelo's drops down almost uninterrupted. Also compare this mass concept for the arm to the Botticelli artwork on page 85. These are great examples of just how open representing anatomy is to artistic expression.

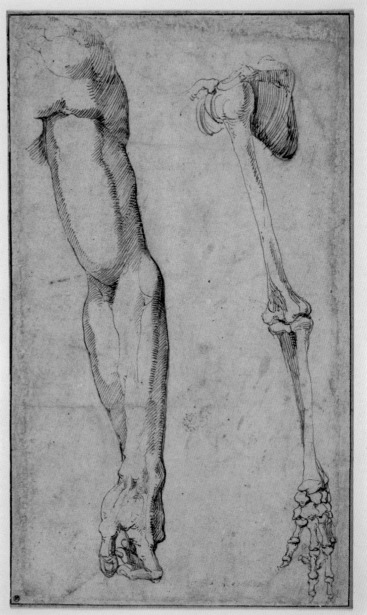

Study of a left arm and the bones of a left arm by Michelangelo, British Museum

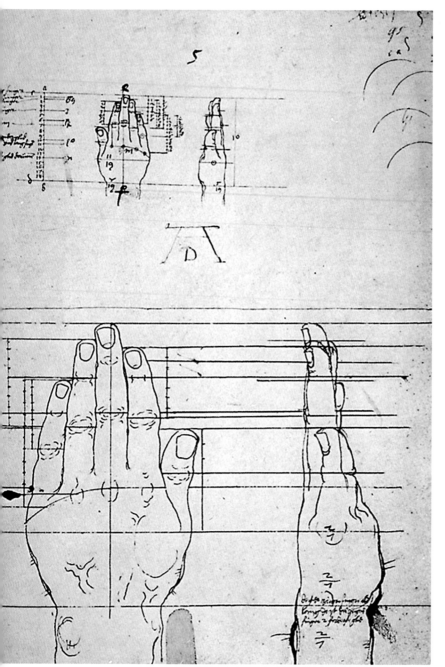

Right and left hand: outside view in profile by Albrecht Dürer, Saxon State Library, Dresden

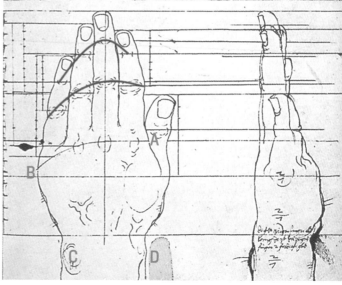

The joints of the fingers serve us perfectly in simplifying the mass of the hand if we link them together to create a larger shape, as opposed to drawing each finger individually. Here Dürer linked the skeletal landmarks of the knuckles with a curved line starting just below the joint of the thumb (A) and ending at (B). The tip of the thumb is roughly aligned to the first joint of the little finger after the knuckle.

Another landmark that you looked at already is the styloid process at the end of the ulna (C). On the opposite side of the wrist is the smaller skeletal landmark at the outside edge of the radius bone (D).

OPPOSING CURVES OF THE ARM AND HAND

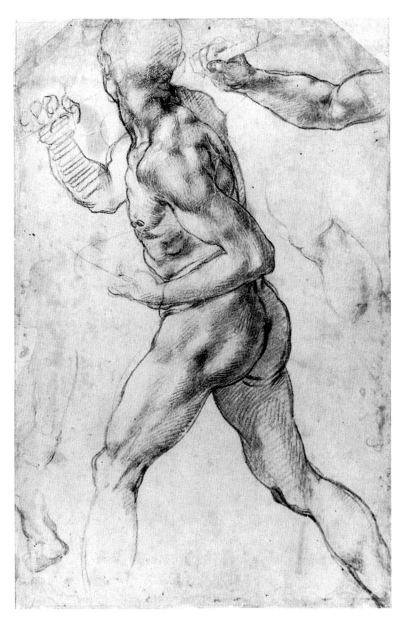

Study for the Battle of Cascina by Michelangelo

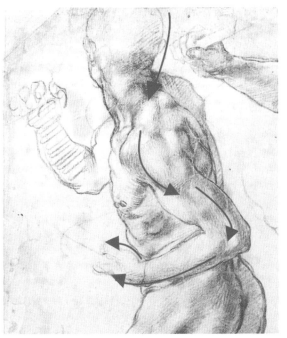

Artists sometimes use the spherical form at the base of the thumb in opposition to the curved contour of the fingers to create a flow of opposing curves, as Michelangelo has done here.

Make a quick study to find the opposing curves flowing throughout the figure, wrapping around the head, over the shoulders, and down to the legs. Note the opposing curves between the triceps and biceps.

MASTER QUICK STUDY OF THE HAND

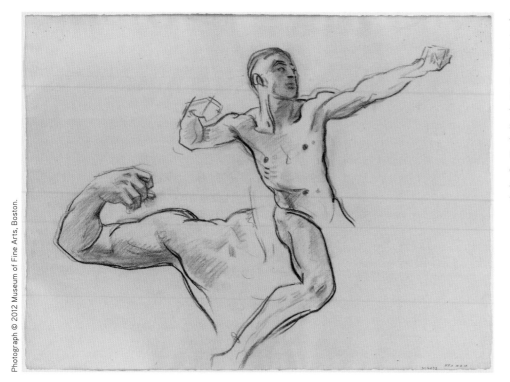

Sketch for Achilles and Chiron (MFA Rotunda), 1917–1921 by John Singer Sargent, Museum of Fine Arts, Boston

Preparatory drawings are fascinating to study because they reveal the thought process of the artist. In this study, Sargent drew two versions of the same hand. The upper drawing is less developed and reveals how he conceptualized the clenched hand as a modified box form with a top and front plane.

If you follow Sargent's lead and begin with a block in combining all the fingers into one mass, you'll see how useful this approach is in simplifying the otherwise complex elements of the hand.

Since you're not considering individual fingers but the segments between the knuckles as a whole, measuring is made easier using triangulation and positive shapes.

Lighting such a simple mass is straightforward since the planes that face toward and away from the light are clearly defined. Once you have the general mass of the fingers blocked in and shaded appropriately, the fingers should fall nicely into place. Beginners often forget to draw a side plane for the fingers, which makes the fingers look two-dimensional.

THE HAND IN GAMES

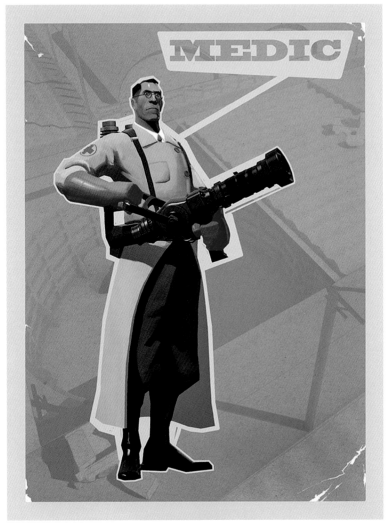

Team Fortress 2: Medic (Artwork courtesy of Valve Corporation)

Team Fortress 2 features some of the best lighting in the business when it comes to modeling form. Individual planes that face in the same general direction, such as the fingers, are shaded with the same value, which subdues individual contours and groups them into one unified plane.

The proportions of the hands, like the feet, can be enlarged to add a greater sense of weight, as here with the Medic.

BELOW *Fable 3,* ©Microsoft Game Studios, 2010

In these concept sketches for *Fable 3* you can see just how expressive the hands are in communicating much of the personality of the character to which they belong. From left to right, the characters' hands communicate determination, strength, authority, stubbornness, and snobbish refinement.

THE HEAD AND NECK

The head is the third largest form of the body, after the ribcage and pelvis. Its overall shape should be your primary concern in establishing the solid skeletal form of the skull that it represents. The facial features are of secondary interest and allow you to fine-tune the emotions that have already been established in the broader concepts of the pose and larger volumes of your characters.

MASSING THE HEAD AND NECK

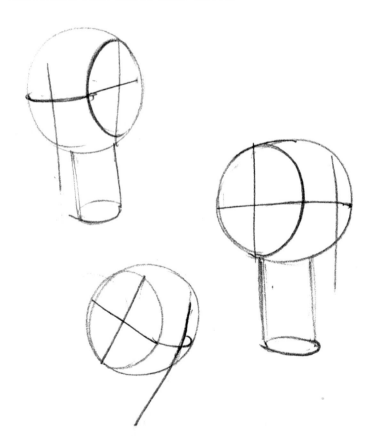

The best approximation of the head's form is a sphere that represents the back of the head. Further refine this mass concept by slicing off the sides of the sphere to define the side planes of the head. Draw a crosshair across the front plane of the face to indicate the direction that the head is facing. The vertical line indicates the central axis of the face, and the horizontal line indicates the brow. Deciding whether the brow line curves up or down is very important, as this communicates whether you're looking at the head from above or below. This combined mass can be placed atop the cylindrical volume of the neck.

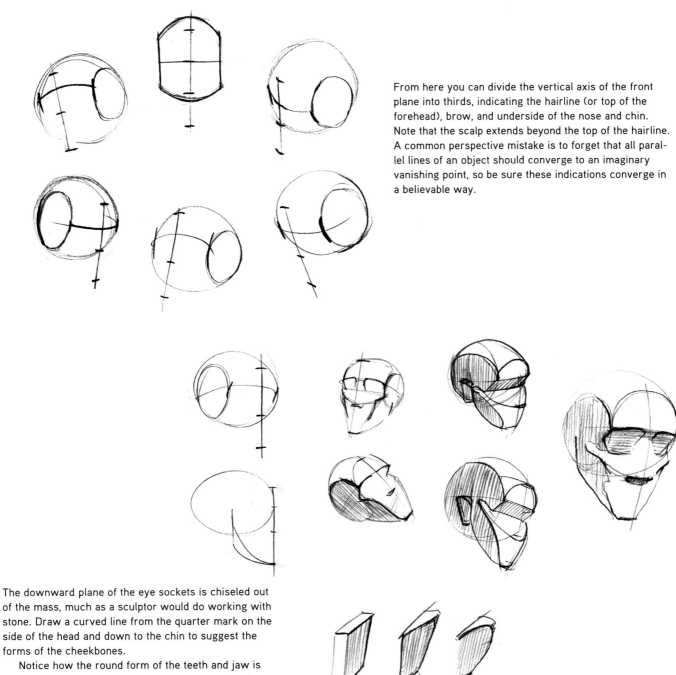

From here you can divide the vertical axis of the front plane into thirds, indicating the hairline (or top of the forehead), brow, and underside of the nose and chin. Note that the scalp extends beyond the top of the hairline. A common perspective mistake is to forget that all parallel lines of an object should converge to an imaginary vanishing point, so be sure these indications converge in a believable way.

The downward plane of the eye sockets is chiseled out of the mass, much as a sculptor would do working with stone. Draw a curved line from the quarter mark on the side of the head and down to the chin to suggest the forms of the cheekbones.

Notice how the round form of the teeth and jaw is suggested simply by connecting the cheekbones with a curved line. A curved line likewise defines the forehead, linking the temples on either side of the front plane.

This volume is the first thing to consider when drawing the head because all facial features overlay this dominant mass. Practice the above process repeatedly, drawing the head in every possible orientation, and you'll soon find yourself drawing heads from imagination.

Complete this massing stage by attaching the ears, which can be conceptualized as tapered box forms attached behind the vertical center line of the head on the side planes.

MASSING THE EYES, MOUTH, AND NOSE

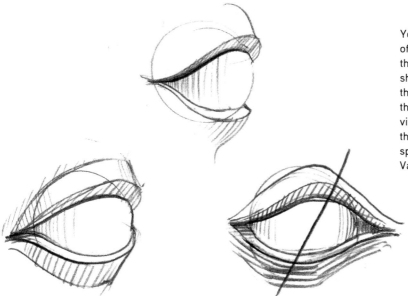

You should always be conscious of the spherical form of the eyeball when drawing the eyelids. Eyelids have a thickness to them that causes the upper eyelid to cast a shadow onto the sphere of the eyeball as it wraps around the form. Beginners often have the idea that the *whites* of the eyes are indeed white and automatically ignore any visible shadows cast by the eyelids. It's better to think of the eyeball as a colorless sphere and shade it just like the spherical form that we studied in Advanced Lighting and Values on page 46.

Keep in mind that the lips overlay the cylindrical mass of the teeth. As Andrew Loomis wrote in *Drawing the Head and Hands*, "To impress upon yourself what the roundness of this area is like, take a bite out of a piece of bread and study it. You will probably never draw lips flatly again."

Note that the outside corners of the mouth are drawn softly to reflect the curved forms on either side of the lips. The bottom lip can be described as an upward, light-facing plane. Rather than draw an ugly and unrealistic contour line around the bottom lip, suggest the shadow below it. The lower lip magically appears without being explicitly defined.

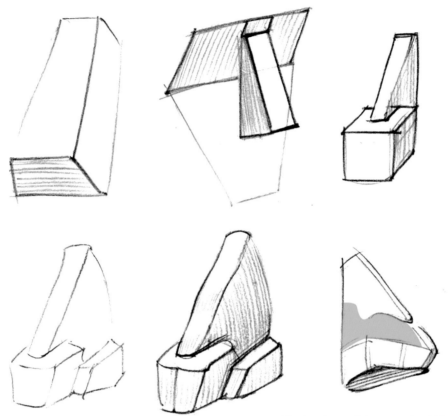

The box form of the nose should be placed along the central vertical axis of the face. The top plane of the nose changes from hard skeletal forms to softer masses at the base. These changes can be described by varying the weight of the line that describes the contour.

A feature of the nose that is greatly overlooked is that of the nasalis muscle (highlighted in red), which sits just above the outward forms of the nostrils. This muscle is emphasized when a person is snarling. The nasalis muscle and the intersections between forms break the otherwise straight contour of the nose.

Key to making the nose appear as if it is protruding is the core shadow that travels around the edges at the base of the nose, creating the effect of reflected light for the downward-facing plane.

PLATE V.

Fig. 1.

Fig. 2.

Drawn & Engraved by W. Miller.

Published by W. Blackwood Edinburgh.

PLATE V.

Fig. 1.

Fig. 2.

Drawn & Engraved by W. Miller.

Engraving of the human skull by William Miller (1818–1871)

The hardness or softness of the line (A) that defines the front and side planes of the head varies along its length depending on whether it is describing bone or softer fleshy forms.

The most abrupt transitions between light and shadow are always where the bone is nearest the surface at skeletal landmarks. On the skull these are found along the edge of the nose (D), the temples (E), the cheekbone (F), the mastoid process behind the ear canal (G), and the temporal line (H).

The nasal bridge, or glabella (C), is loosely defined by the top of the nasal bone and the inside corners of the eyebrows on the surface of the skin. You can see in the side view that this plane is downward-facing and therefore often in shadow.

The angle of the cheekbone (B), which wraps around the eye sockets, varies wildly between people and ethnicities.

The cylindrical volume of the teeth and overlaying muscles define the shape of the muzzle (indicated as a blue oval). It's difficult to fully appreciate the exact volumes of the head based on these two-dimensional etchings, which is why it's important to find yourself a model of a skull to study firsthand (a very popular source of anatomy models for artists is www.anatomytools.com).

SKELETAL LANDMARKS OF THE HEAD AND NECK

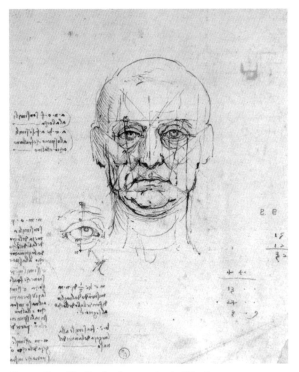

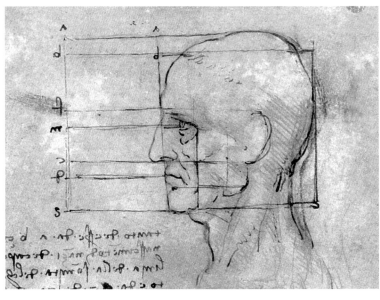

Proportion Studies by Leonardo da Vinci

Every classical artist had their own system of proportions, which gave them the ability to create figures from imagination. The sketchbooks of the Old Masters are filled with studies like the one above, where Leonardo noted the general alignment of various landmarks to make memorizing them easier.

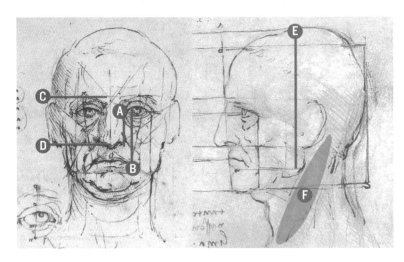

As you learned in the massing exercises on pages 128–129, the face, or front plane of the head, can be divided vertically into thirds using the hairline, brow, nose, and chin as landmarks. You can also see here that Leonardo drew a line from the inside corner of the eye (A) to the outermost edge of the nose as a way to remember the relative alignment between these two features. Another vertical line links the left edge of the iris with the outside corners of the mouth (B). The ears align with the brow line (C) and the tip of the nose (D).

On the side of the head, Leonardo aligned the ear behind the centerline of the head (E).

The sternomastoid muscle (F) emerges from behind the ear, wraps around the cylinder of the neck, and attaches to the inside edge of the clavicles. The sternomastoid muscles can be thought of as rubber bands that connect the head to the torso so that we can move our head from side to side and tilt it forward.

OPPOSING CURVES OF THE HEAD AND NECK

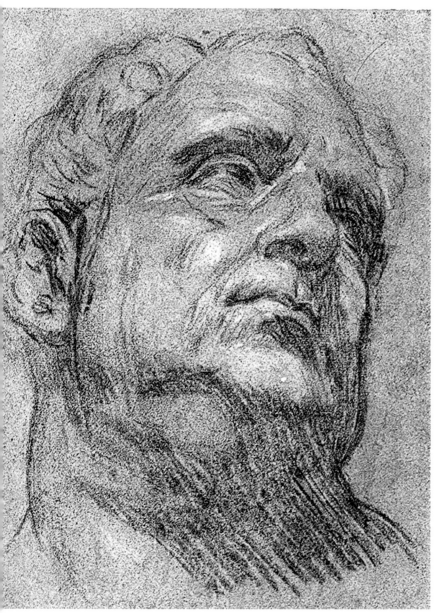

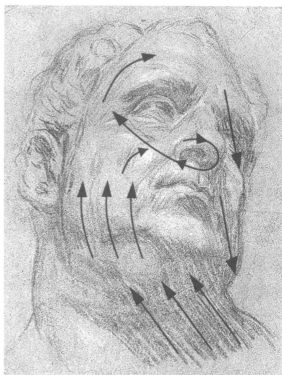

Study of a Bust of Vitellius by Tintoretto (1518–1594)

One of the great exercises to build confidence in drawing the head and its rhythms is to make copies of ancient Greek and Roman sculptures. Tintoretto did many such drawings of the Roman Emperor Vitellius (AD 15–69) because he had a copy of a classical sculpture depicting the emperor's head in his studio.

Because the general mass of the head is such a compact form, you'd think that there is little room for creating a flow of opposing curves. But you can see here how Tintoretto expertly selected and emphasized lines that would help guide a viewer's eye around the form.

MASTER QUICK STUDY OF THE MALE HEAD

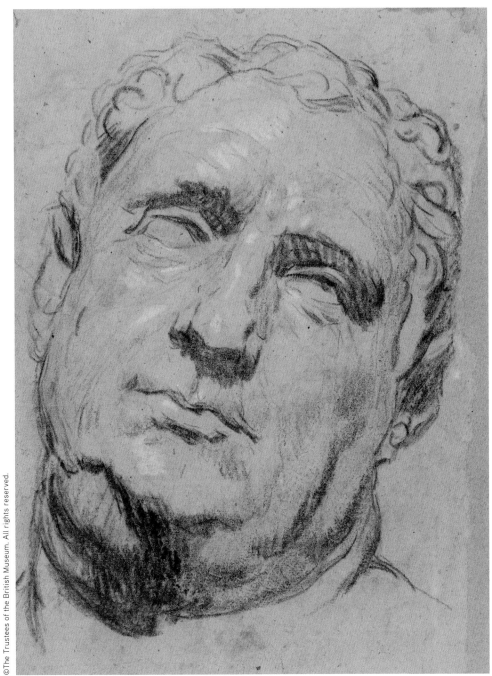

Study of a Bust of Vitellius by Tintoretto (1518–1594), British Museum

Practice your massing concept for the head by studying this second drawing of Emperor Vitellius by Tintoretto.

Six-Stage Gesture Process for Tintoretto's Head

01 The start of every drawing is the most important because it is the foundation for successive steps. The first oval indicating the general shape of the head should be observed accurately and drawn with precision. Does the head have a tall, narrow oval shape? Or is it more angular and square? Step back and consider the head's overall shape to avoid distraction from details. You'll be surprised at the variety of head shapes once you look more closely.

02 Tintoretto's head is tilted to the right and has a slightly boxy shape, so draw your first shape with these two observations in mind. Then divide the head with a center axis cut into thirds, noting that the top third, representing the forehead, is smaller on our subject than either of the two thirds below.

Locate the position of the ears, which should sit between the brow and the base of the nose. Because we're looking slightly up at the figure, the ears appear lower down. Don't refrain from drawing guidelines. The Old Masters used them to align facial features, as you can see in many of their drawings.

03 The goal of this stage is to establish the largest planes of the head. Tintoretto fixed the light source from the upper left of the drawing, placing the figure's left and downward-facing planes in shadow.

A common beginner's mistake is to create spotty patches of shadow isolated within the dominant light-facing planes. Strongly define the light-facing front plane of the face from the sides of the head by shading the sides lightly with an even tone to reinforce your volumetric concept. Make a habit of modeling the mass of the head in this way in all your drawings to create a strong sense of three dimensions, even if such form-defining light is not clearly visible on the model.

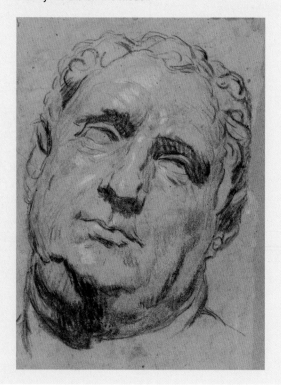

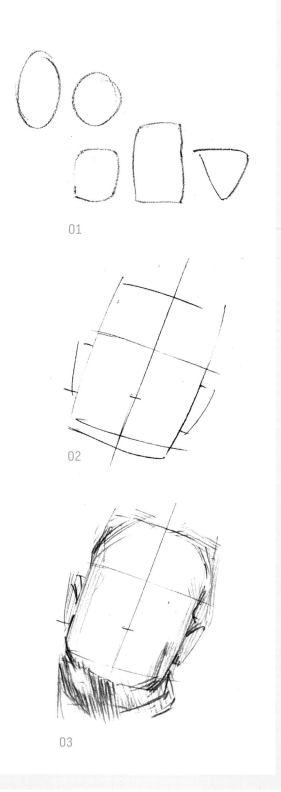

01

02

03

04

05

06

04 Our next step is to block in the second largest set of shadow planes, which includes the arches of the eyes, the base of the nose, the upper lip, and the underside of the lower lip. Work lightly and make adjustments to your drawing as you progress. Block in the eye socket by using shadow shapes and useful landmarks, such as the inside and outside corners of the eye. Rather than drawing curved lines to block in the shapes, break down contours into a series of straight lines, which are easier to triangulate.

Core shadows are especially useful in defining the various shapes that make up the head. Varying the pressure of the pencil to create darker or lighter lines is a great shortcut in suggesting hard and soft plane breaks, which are the points where the form turns away from the light.

Every line put down is mirrored on both sides of the central axis. Use your measuring tools to check that the placement of each line is as accurate as possible. The most useful tool that trumps all others is squinting because it helps simplify the subtler modulations of shadow and light into bigger, unified shapes.

05 Once the facial features are blocked in, begin refining your drawing by selecting an anchor point—the center of interest—like an eye. Here, go with the left eye.

Develop the eye socket, making sure that every line you place to indicate the eyelids describes the spherical form of the eyeball.

Work the shadow mass of the left eye until you feel it's correct, as it will be your anchor point against which all other shapes and volumes of the head will be judged. When you're satisfied with the accuracy of your anchor point, tentatively work on an adjacent area on the face, such as the nose or glabella, using the spiraling process (page 39).

The glabella, the downward-facing plane between the eyes, is extremely important in getting a likeness of the figure. Draw this shape incorrectly—too wide or too thin, for instance—and the person's face takes on a completely different character.

06 Notice how important the core shadow is to giving the feeling that the brow and nose protrude. If you merely suggest the core shadow with a darker line or shadow mass, then the remaining shadow area automatically begins to look like it receives reflected light, making the facial features pop forward.

The hair should be conceptualized in the same way as the eyeballs: as a colorless volume. It doesn't matter, for instance, if your model's hair is black. The hair is an extension of the mass of the head, so should therefore be shaded to describe the head's major volumes.

Finish by adding some accents of two or three sharp, dark lines concentrated around whichever area you want viewers to focus on in a portrait. In Western figurative art the center of interest was traditionally the left eye because those of us who read from left to right will usually "read" it as the dominant eye. Avoid giving equal importance to both eyes to give viewers a single eye to focus on, as people naturally do during conversation.

MASTER QUICK STUDY OF THE FEMALE HEAD

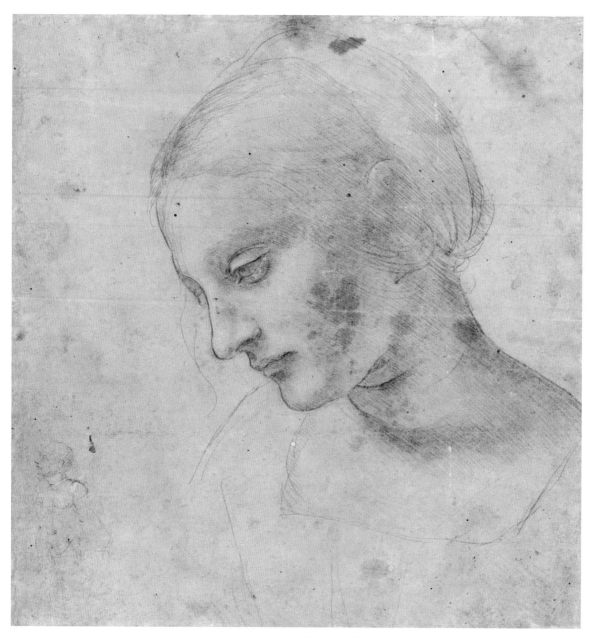

Study of a Woman's Head by Leonardo da Vinci

Have a go at copying this beautifully subtle drawing by
Leonardo da Vinci. Use the same process you did for the
male head (pages 136–137), although it's worth noting
the way in which Leonardo has rendered the female head
with softer and more rounded features in contrast to
Tintoretto's relatively angular male head.

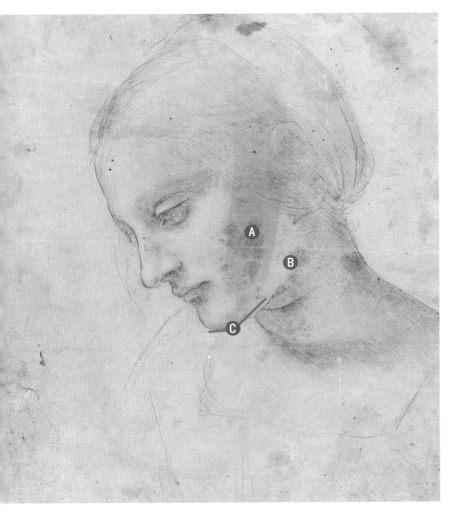

The head in Leonardo's drawing is more spherical than the boxy male head by Tintoretto. Leonardo described the head's volume with a core shadow that runs almost vertically across the cheek (**A**) and the reflected light on the underside of the chin (**B**).

The ear was shaded to conform to the head's overall shape, with only the light-facing top plane indicated. This has an added effect of maintaining focus on the facial features, which are the center of interest.

Rounder features are a general characteristic of female heads. The chin, for instance, tends to be more curved in females, although it's still important to define the front and side planes of the head with a change in direction at (**C**). The female figure also tends to have a longer neck, which is a feature that can be exaggerated for a swanlike effect. Leonardo did not draw the sternomastoid muscles on either side of the neck, which gives it a more delicate appearance. In the eyes, Leonardo offset the placement of the pupil within the iris to indicate perspective.

What makes this drawing so delicate is that the value contrasts are subdued. The model would likely have had at least a few wrinkles on her face, especially the lines that run down on either side of the nostrils to the corners of the mouth. Emphasizing wrinkles often makes figures look much older than they are, so ignore labial folds and eye crinkles altogether when drawing children.

Uncharted 2: Elena Fisher (Artwork courtesy of SCE)

Although the shape of Elena's head is rounded, the front and side planes are defined with light and shadow to give the face a strong sense of three dimensions. You can see the plane break between front and side plane by following the shadow line that runs along the edge of the forehead, along the cheek, and down toward the chin. This line is mirrored on either side of the face.

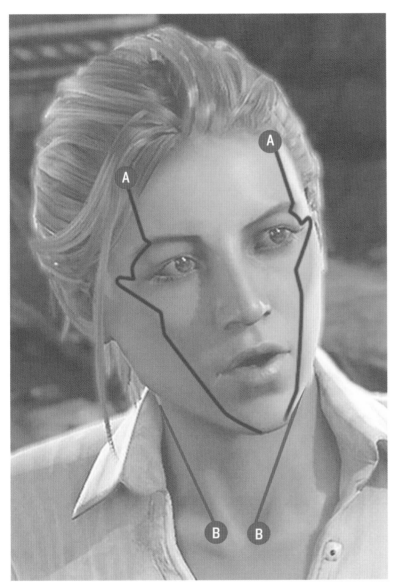

The front plane of the face starts at the hairline (A), down each side of forehead, running around the eye sockets, over the cheekbones, and down to the chin. The sternomastoid muscles on either side of Elena's neck are indicated by the lines starting at the inside edge of the clavicles (B) to which they connect. Even though you can't see the ribcage in this close-up view, the orientation of the head in relation to the torso is made clear due to the alignment of the head and chin in relation to the clavicles (B).

Team Fortress 2: Concept art for Medic

In contrast to Elena's head, the Medic from *Team Fortress 2* is much more angular, particularly at the chin. The excellent "classical" lighting of the game was evidently considered in the concept art stage and defines the front and side planes of the head much like the study by Tintoretto (page 136).

FACIAL EXPRESSIONS

The human face has the highest concentration of muscles of any animal, which allows us to articulate a wide and subtle range of emotions. But a character's ability to express the whole range of basic emotions relies on a minimum of four specific areas of the face: the forehead, the eyebrows, the eyes, and mouth.

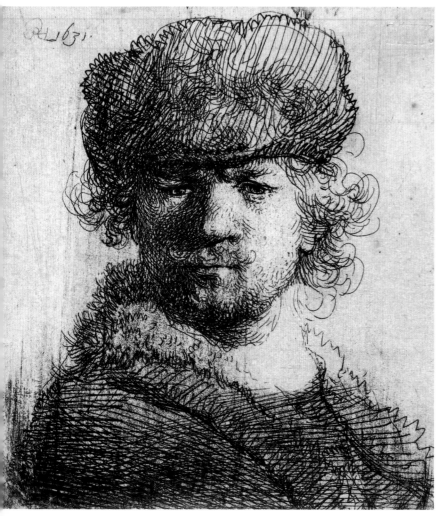

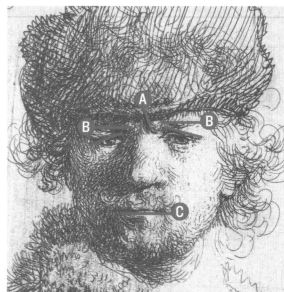

Self Portrait, Frowning by Rembrandt van Rijn (1606–1669)

Rembrandt was a master in creating subtle facial expressions thanks to his many self-portraits. Note that several important lines are key to communicating the emotion of anger in this expression: vertical frown folds (**A**), a flat brow (**B**), the downward slope of the upper eyelid, wrinkling and widening of the nose, and flat, pursed lips (**C**).

Rembrandt would have created this study by observing himself in a mirror. Modern-day artists and animators always have a mirror on hand and continually use it for reference.

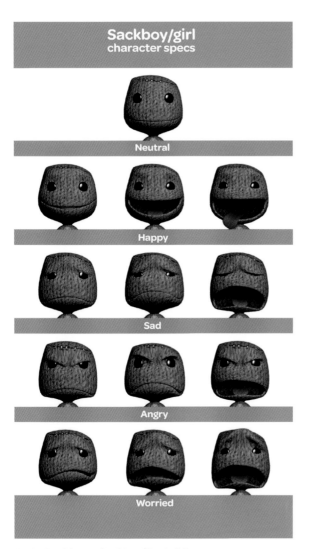

Sackboy/girl
character specs

Neutral

Happy

Sad

Angry

Worried

Little Big Planet: Sackboy/Sackgirl

Sackboy/Sackgirl in *Little Big Planet* doesn't even have a nose or eyelids but is still capable of expressing a wide range of emotions because the character has variable frown and brow lines. Different mouth shapes also express emotion, as does the shape of each eye.

Make some sketches of Sackboy, using as few lines as possible to create the various emotions. (See Goldfinger's facial expressions on page 144). Learning to tweak facial expressions to express emotions will enhance your ability to draw characters from imagination. Note that Sackboy has a proportionally big head and face, making his expressions more visible. Consider exaggerating anatomical features to emphasize important aspects of your character even if you're designing realistic humans.

HAPPINESS SADNESS SURPRISE

FEAR ANGER DISGUST

Facial expressions from *Human Anatomy for Artists* by Eliot Goldfinger

On pages 142–143, you practiced four facial features that express emotion: brow and frown lines, the mouth, and eyes. Goldfinger adds two more facial features: the crease of the nasolabial folds (also known as "laugh lines") and the horizontal wrinkles of the forehead. The elements used to control expressions are fairly simple if you think of them as abstract lines and shapes as in Goldfinger's illustration.

LEVEL UP!

Human anatomy is the heaviest topic in the book, so you should be proud of yourself for completing all the exercises in Level 4. You now have specialized knowledge that even some in the art world don't have, and most of the tools you'll ever need to create figures with a convincing presence and sense of weight and movement just like the Old Masters.

The next level explores select elements of design, giving you a comprehensive set of tools to design your characters, environments, and interactive experiences with specific emotions that you want players to feel.

LEVEL 05 | ELEMENTS OF DESIGN

WE SAW IN GRAVITY AND MOVEMENT how manipulating the shape of a line can create a sense of weight and movement. Classical artists also used line as a foundation for arranging elements in an image, which is known as *composition*.

These abstract approaches to design use the basic elements of visual grammar and have powerful implications for the way we design video games, from logos and user interfaces to environments, characters, and animations.

Although there are only five elements of visual grammar to consider—lines, shapes, volumes, value, and color—there are an infinite number of ways that we can manipulate them using classical design concepts to create complex emotions and player experiences, as we'll see when we take a closer look at the various ways in which they've been applied to video games.

Detail of *Children's Games* by Peter Bruegel the Elder (1525–1569)

FRAME

A first step in translating classical art principles to video games is to consider the in-game camera and whether it's set to frame the action using a *close-up*, *medium*, or *long shot*.

There are many practical considerations when deciding on a camera shot. For example, the player must be able to see enough of the playing area to make decisions on how to act within the game, so gameplay often dictates the choice of camera shot. But the final decision on how to frame in-game objects is not just a technical one; the frame's artistic intent will affect the emotional experience of the player as well. The ideal is to have the gameplay and artistic intent inform the camera shot unanimously, changing dynamically to fit changing situations in-game.

INTIMATE ◀————————▶ **DISTANT**

The viewer's perceived proximity to characters in an image either creates an intimate feeling, as in a portrait (left) or still-life painting, or a more detached, distant relationship, as in a typical landscape painting (right).

Video games have a significant advantage over traditional media because the proximity device that influences the emotional connection between player and characters can be adjusted dynamically depending on the situation. A close-up shot creates an intimate connection with the playable character, but as the camera shifts away, the landscape becomes more prominent and the player-character connection more detached.

Heavy Rain (Artwork courtesy of Quantic Dream)

A game like *Heavy Rain* uses the close-up shot a great deal so players experience an intimate connection with subjects on-screen. The close-up shot is a translation of the composition conventions of classical portrait and still-life painting, where the subject takes up much of the visible frame.

Journey (medium shot)

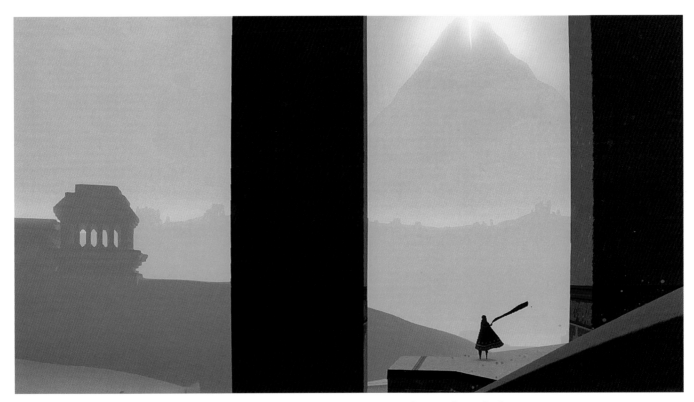

Journey (long shot)

Journey generally employs a *medium shot,* which establishes a relationship between player, characters, and environment that fits somewhere between close-up and long shots for a more balanced effect. But the game's camera constantly shifts the frame, zooming out to take in more of the landscape or zooming in to frame the character depending on the situation.

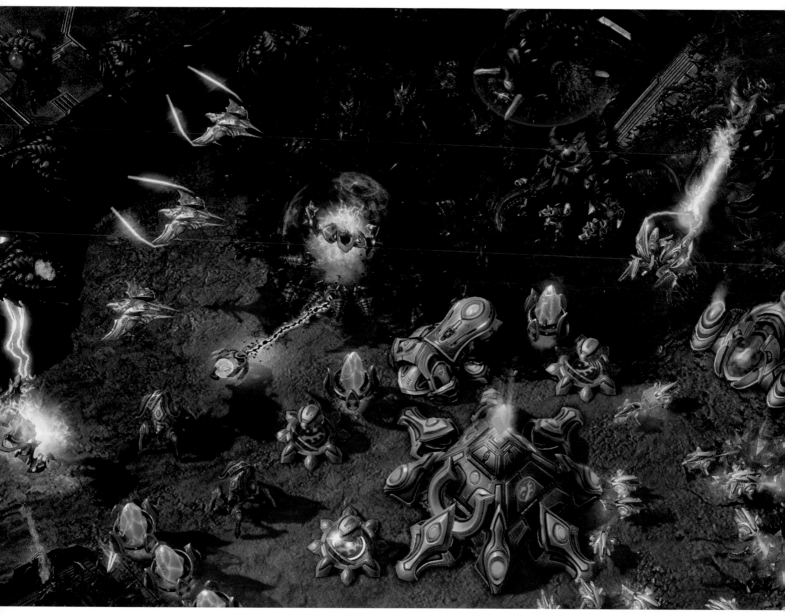

StarCraft II: Wings of Liberty **(Artwork courtesy of Bliz-
zard Entertainment)**

The in-game camera in *StarCraft II: Wings of Liberty*
frames the action with a *long shot*. The long shot is
perfectly suited to the genre of real-time strategy games
as it gives players a commanding view of the action. The
distance and number of on-screen objects depicted in
this battle scene make it difficult for players to feel an
intimate connection with any one element. Instead the
player's attention is spread across many elements that
are generally grouped by function for simplicity.

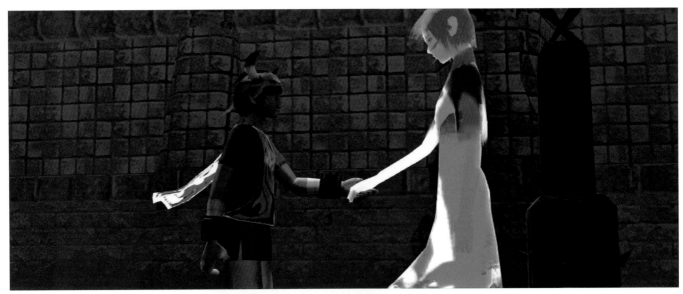

ICO

The interactive element of video games causes players to emotionally identify with their playable character as if it genuinely represented them. So in addition to directing the proximity of the camera to on-screen objects, an equally important design consideration is the proximity of the playable character to other characters in the game.

The game mechanics of *ICO* repeatedly bring characters together then separate them to create emotions of closeness and intimacy contrasted with loneliness and detachment, which makes the moments when Ico and Yorda are connected all the more powerful.

CAMERA ANGLE

We briefly examined the significance of horizon line placement in Basic Perspective (pages 24–26), but now we'll take a closer look at this design tool and how the horizon line's position in relation to the camera is used in games to affect the player's feelings.

EAGLE VISION
GENTLE PUSH
FAST WALK

1856 f

162

Assassin's Creed II

Assassin's Creed II allows players to scale buildings to reach the city's rooftops, which places the horizon line high up in the frame, giving players a commanding and empowering view of their surroundings.

Avoid placing the horizon line in the exact middle of the frame because the equal balance between the top and bottom half of the frame creates a very neutral and static composition (unless that is the effect that you're after).

EAGLE VISION
GENTLE PUSH
FAST WALK

326197 *f*

162

Assassin's Creed II

The same character placed at ground level creates a more natural perspective with the horizon closer to the middle of the screen. The contrast between a high and middle horizon line in this game makes the player feel more exposed and vulnerable at ground level.

Shadow of the Colossus

Shadow of the Colossus from Team Ico effectively uses a *low-angle* shot to create a sense of vulnerability in the face of massive scale. Placing the camera near the ground, behind the playable character Wander, means the player is often looking up at the colossi that he must scale.

Uncharted 3

Tilt the horizon line diagonally and you get a dynamic effect.

Uncharted 3 uses a tilted perspective throughout the game to create an added sense of tension and disorientation for the player, particularly when the playable character of Nathan Drake is drugged or during the Sink or Swim level featured here.

Superbrothers: Sword & Sworcery EP (Artwork courtesy of Superbrothers Inc.)

Superbrothers: Sword & Sworcery EP employs a centrally placed horizon line, which creates a neutral effect. Moving the horizon line further up or down would create a more dynamic composition that would be less appropriate for the relatively tranquil atmosphere of the game.

Players feel a lot of empathy toward their playable character, as if they were experiencing the situations themselves. Even though the placement of the horizon line is neutral, a powerful tension is created in this scene by the position of the playable character relative to the Trigon enemy (which references the camera angle in *Shadow of the Colossus* on page 154).

Bumpy Road (Artwork courtesy of Simogo)

The emotional effect of low-angle, eye-level, or high-angle shots, relating to the position of the horizon line in the vertical axis, can also be applied to the placement of objects along the horizontal axis—when deciding whether to place characters to the left, middle, or right of the frame. *Bumpy Road* from Simogo illustrates the dynamic possibilities of creating tension with this effect. A balanced feeling is created when the car is positioned centrally. Placing the car further left or right within the frame creates more dynamic energy.

SCALE

Closely related to horizon line placement and perspective is the scale of characters in relation to other characters and to their environment. The relative size of the character can make the player feel either vulnerable or empowered.

Alice: Madness Returns

American McGee's *Alice: Madness Returns* takes full advantage of the video game medium's ability to dynamically change elements on the fly by scaling Alice's character throughout the game to create different emotional experiences. When Alice is small she can explore more of the environment, but she also becomes more vulnerable. When Alice grows to a larger size the player feels more powerful.

GROUPING

Three is the magic number in design. If you have more than three on-screen elements (or grouped elements) at any one time, it becomes increasingly difficult for players to orient themselves amid the visual noise. One way to maintain simplicity and keep the number of on-screen elements to a minimum is through *grouping*.

Pikmin

In the series of *Pikmin* games, the player can control up to 100 on-screen characters at any one time. That's an incredible amount of information to take in. The reason the player doesn't get overwhelmed by all the visual noise is that the characters are grouped into larger masses, sorted by function and color. The grouping helps players orient themselves within the action, as they only have to consider a few large masses rather than 100 individual elements.

Empire: Total War

Empire: Total War features hundreds of soldiers fighting in battle, all of whom the player must control. Arranging the soldiers into large groups reduces the visual noise.

Note the rectangular group arrangement before battle (left) and the dagger-like shape that emerges incidentally during this particular charge (right).

As a game designer you have an infinite number of possibilities to use this concept and dynamically adjust the shape of groups to create different emotional effects (which we'll explore in more detail in Shapes on pages 176–183).

Children's Games by Peter Bruegel the Elder

Another method to reduce noise is to align elements along composition lines, as Peter Bruegel did in *Children's Games*. Even though there is a tremendous amount of information in this painting, it's not overwhelming because there is order even where there appears to be none.

Bruegel exactingly placed figures along composition lines to dictate how viewers experience the image by offering them visual paths to read the scene.

LIGHTING

The *value key* is the proportion of lights to darks in an image. The majority of artwork is designed around a fairly equal distribution of values, similar to the natural balance of values that we see in reality during the daytime. Shifting the values so that either the lights or darks become dominant is an effective way to create a special atmosphere within the gaming environment.

Journey

Journey employs a *high-key* in this desert scene to create a light and positive feeling for players traversing the environment. The majority of objects in the landscape are at the lighter end of the value scale, while select objects, such as the figures and important landmarks, are made prominent with darker values.

Animal Crossing: City Folk

Animal Crossing: City Folk virtually does away with shadows altogether. Soft-lighting and shadowless environments are common in children's games because it creates a safe and surreal feeling. The flip side of removing shadows is that objects appear flatter and the spatial relationship between elements becomes difficult to judge (see Advanced Lighting and Values, page 44, for more detail).

Get to Cauldron Lake

verizon

18

3

[E] Drive

Alan Wake

The nighttime scenes in *Alan Wake* feature *low-key* lighting, with values mainly located at the darker end of the value scale. Points of light highlight key areas of interest, while other areas are shrouded in ominous shadow. The threatening emotions created by this lighting are amplified by the contrast to the *mid-key* lighting (for day scenes) which provides a fairly equal distribution of light and dark values.

LINE

We've practiced many of the fundamentals of drawing: techniques for holding a pencil, how to create various qualities of line, and how each line quality—thick or thin, light or dark, curved or straight or zigzag—communicates quite specific emotional responses to the artwork. But because of its interactivity, the viewer/player of a video game is actively involved in shaping the artwork, in affecting the screen visuals. In this section you'll see how to design elements of a game so that players experience the same physical actions and sensations that artists experience in designing with line.

Diana and Her Companions by Johannes Vermeer (1632–1675)

Basing compositions on a system of lines allowed classical artists to control the viewer's overall experience of an image by offering visual pathways along which a viewer's eye would travel. Classical artists like Vermeer sought to make their compositional lines invisible to the untrained eye so that their subtlety could have a greater subconscious emotional effect. Vermeer exactingly designed each figure's pose, aligning limbs and drapery along the frame of his compositional lines. This painting communicates a tranquil emotion largely because it's constructed on a composition of gentle, curved lines.

Massacre of the Innocents (c. 1610) by Peter Paul
Rubens

In stark contrast to Vermeer's *Diana* (opposite), the
dominant compositional lines in *Massacre of the Innocents*
by Peter Paul Rubens are two opposing triangles. Rubens
aligned the figures to a network of straight, angular lines
that communicate the aggressive, explosive force of the
figures clashing together.

What made a composition like this possible was
Rubens's ability to create figures from imagination. He
could compose the figures in any way he wished. Notice
that the composition's lower left triangle exclusively fea-
tures female figures who are being trampled by the male
figures in the upper right triangle. Make a simple study of
this painting. See if you can find other lines that form its
compositional framework.

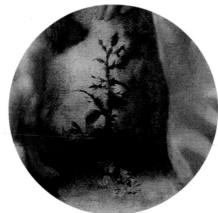

Detail from *Massacre of the Innocents* by Peter Paul Rubens

Detail from *Diana and Her Companions* by Johannes Vermeer

Take a second look at the Vermeer and Rubens paintings and imagine substituting the lines of one for the other. You'll find that it's not details that communicate each painting's particular emotion, but the larger compositional framework. If you were to switch the composition lines from one painting to the other, it would completely undermine the artists' intended messages. The overarching design relies very little on detail elements like the sword in Rubens's painting and the plant in Vermeer's, which have very similar abstract shapes.

How can you translate the concepts of classical composition to video games to design powerful emotional experiences? By conceptualizing classical composition in a new way. Don't think of compositional lines purely as visual pathways on a static medium; conceptualize them as an interactive virtual map whose pathways can be actively experienced by players.

Race the Lost crew to the A.O.D. clubhouse.

INFERNUS
THE MEAT QUARTER

Grand Theft Auto IV

Consider the anticipation and action players experience driving through a slow-sweeping curve versus hitting the breaks around an angular corner in *Grand Theft Auto IV*. The curved street creates a gentle driving experience for the player while the angular corner creates a more aggressive emotional experience through the corresponding physical actions that they must perform.

In visual and interactive terms, the curved line of the road is like the composition of Vermeer's *Diana and Her Companions* (page 164). The angular pathway that the player takes in navigating corners is like the aggressive composition of Rubens's *Massacre of the Innocents* (page 165). Simply by conceptualizing the pathways within an environment as curved or straight lines you can design the players' emotional experience as they travel through the interactive spaces.

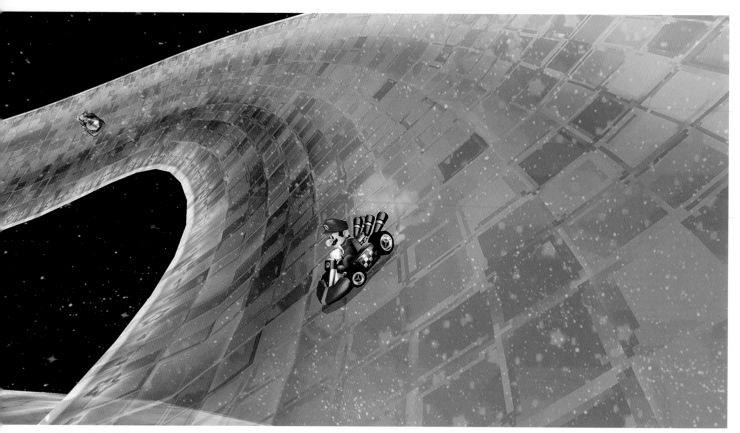

Mario Kart Wii

Reading about video games is like reading a description of a song. It's impossible to appreciate a song without hearing it for yourself because reading and listening appeal to different senses. Just as you visit museums to study classical artworks, to understand the full significance of video game art and design you must play a wide variety of games and reap the benefits of firsthand experience.

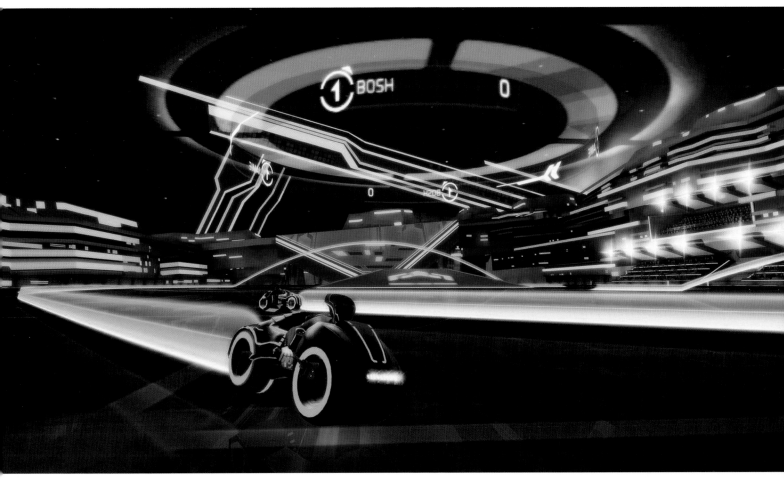

Tron: Evolution

The tracks in *Mario Kart Wii* (opposite) predominantly feature sweeping curves and vehicles have a softer handling. In contrast, the Light Cycles in *Tron: Evolution* (above) change direction in an angular manner, and players have to steer using more abrupt physical actions.

Video games that use motion controllers allow players to physically experience sensations of moving along lines in a virtual three-dimensional space, as if they were taking part in the act of creating the compositions they see. As with classical art, in video games it's the composition, not the details, that has the strongest effect on the players' emotions.

Apply your accumulated knowledge about concepts like gravity and movement to design the emotional experiences of the players on a macro level and the pathways that you make possible for them to navigate through your game environment. In another design approach, you could remove predefined pathways altogether (as in *Journey*'s desert landscape), leaving players free to "draw" their own path through the environment.

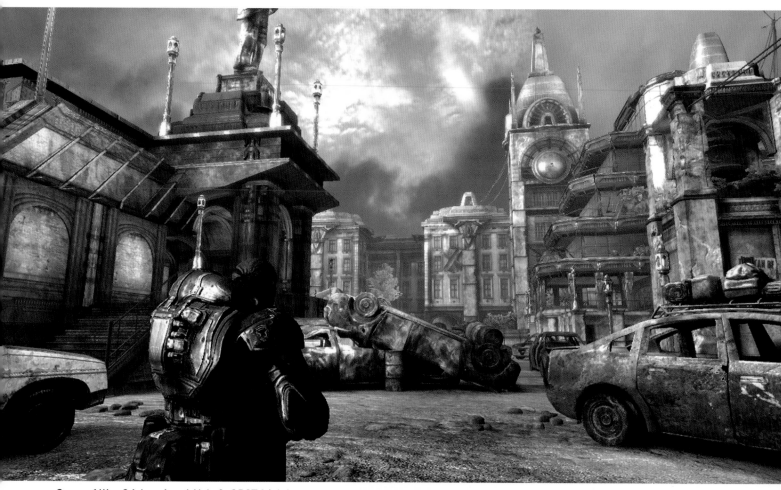

Gears of War 2 (above) and *Halo 3: ODST* (right)

The concept of designing an overarching emotional experience based on either curved or angular composition lines is present in first- and third-person shooter franchises like *Halo* and *Gears of War*.

Compare the graceful jump arcs, fluid movements, and pathways taken by Master Chief in *Halo* against the grounded and angular theme of *Gears of War* and its relatively angular forms and character animations. Although the gameplay conditions are very similar in terms of character actions and abilities, *Gears of War* feels more brutal due to its angular overarching concept.

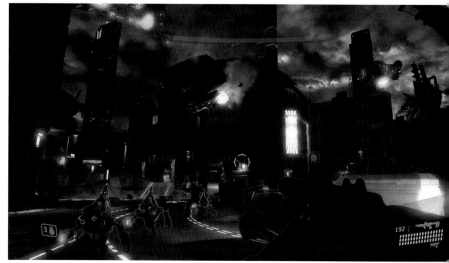

Superbrothers: Swords & Sworcery EP

Superbrothers: Swords & Sworcery EP is an example of line-based level design that sits between curved and angular concepts. The level restricts the Scythian's movement to navigating horizontal and vertical pathways.

The game pathways affect players in the same way as traditional composition in that players are presented with an environment background that is constructed with an abstract series of lines. What video games add to the traditional theory of composition is that the game's background image is an interactive environment through which players can move; the playable character dynamically traces the abstract lines of the composition. The visual and interactive components of the experience combine to create a type of emotional engagement that is not possible with traditional media.

The predominance of straight horizontal and vertical lines created by the 1-point perspective in these screens from *Superbrothers: Swords & Sworcery EP* creates a still and tranquil backdrop for the game. If *Superbrothers'* art director, Craig Adams, had used diagonal lines (which evoke dynamic and energetic emotions) the resulting player experience would be at odds with the overall concept of the game.

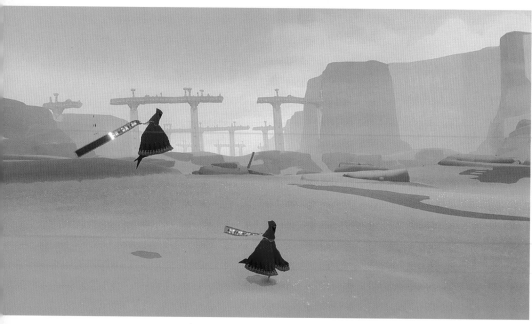

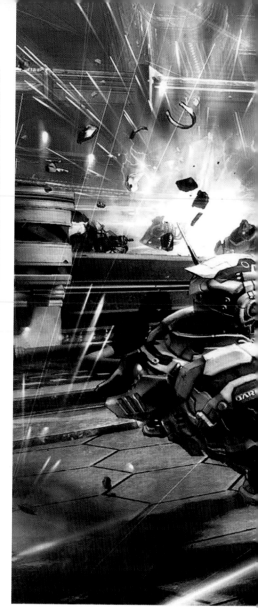

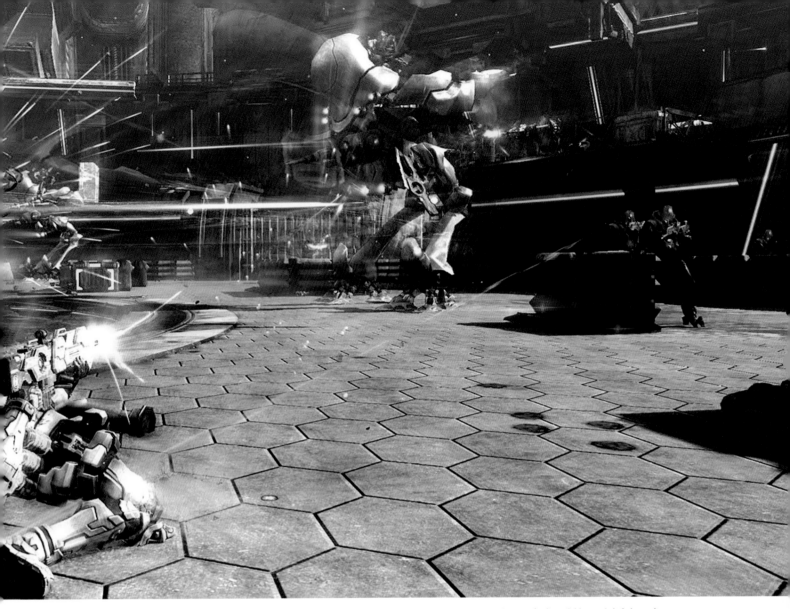

Journey (opposite) and _Vanquish_ (above)

You can also direct the players' emotional experience by applying line concepts to character animations. The characters in _Journey_ (opposite) move and jump gracefully across the desert landscape, which the player traces across the screen with the push of a button. The gentle, curved movements in _Journey_, emphasized by the character's flowing scarf, are in stark contrast to the violent zigzag movements of Sam Gideon in _Vanquish_ (above). The different movement styles of each character can be likened to two distinct musical melodies: one is gentle and flowing, and the other abrupt and jagged.

StarCraft II: Wings of Liberty: Protoss units attacking from the bottom; Terran units defending on the top (Artworks courtesy of Blizzard Entertainment)

StarCraft II: Wings of Liberty illustrates just how important distinct animations are in such a fast action video game, which presents a significant amount of visual information for players to assimilate. So much happens on-screen in a typical game of *StarCraft II* that it'd be near impossible for players to comprehend and manage events without distinguishing animations and shapes for the various character species and unit types.

StarCraft II: Wings of Liberty: Probe

StarCraft II: Wings of Liberty: Immortal

In *StarCraft II* the nonaggressive Probes that gather resources travel across the screen in gentle, back-and-forth, straight lines. In contrast, Immortal attack units travel with fast, aggressive movements along angular lines. In the middle of the action there simply isn't time to take in all of the game's rich visual detail, so it's largely the distinguishing lines implied by the animations that allow players to subliminally recognize aggressive and nonaggressive units. Unique shapes for each species reinforce these visual distinctions.

SHAPES

Line dominated the theory of composition for the majority of art history, until some 150 years ago when artists began experimenting with photography. An evolution happened around this time, much like the evolution that video games are driving. Artists such as Edgar Degas started thinking not in terms of lines, but in terms of *shapes*. The reason for this is that they were exploring the way in which the photographic camera, and our eyes, records reality as light and shadow shapes. This was a revolutionary approach to painting at the time. In Degas's artwork, below, and the paintings by Vermeer and Rubens on pages 164 and 165, we'll find a common theme of rounded versus angular elements.

Volkswagen Beetle (left), Range Rover (middle), Lamborghini Gallardo (right)

Abstract communication with shapes is surprisingly universal, appearing in visual design in every artistic discipline. From left to right: the Volkswagen Beetle is designed around the circular concept to communicate that it's fun and friendly; the square shape of the Range Rover communicates confidence, stability, and safety; while the Lamborghini's triangular shape communicates aggressive speed.

OPPOSITE *Waiting* by Edgar Degas, J. Paul Getty Museum

Degas was a grudging member of the Impressionist movement, which marked the crossroads between classical and modern art. Degas was a great admirer of the master Jean-Auguste-Dominique Ingres who advised the younger Degas to "draw lines, young man, and still more lines, both from life and from memory, and you will become a good artist." Degas did indeed draw many lines—until the arrival of photography, which changed the way Degas conceptualized his images from lines to shapes.

Although we can't fully see the face of either figure in this pastel by Degas, an emotional tension is created by the contrast of a circle and a triangle shape. Degas further heightened the effect with a value contrast of black and white.

The Lord of the Rings (film trilogy): Hobbits and Sauron

You can see how primary shapes communicate emotions in these stills from *The Lord of the Rings*. At one end of the emotional spectrum are the good-natured Hobbits (left). A circular concept echoes through every level of detail, from the curl of their hair, rounded shirt buttons and shoulders, to the rounded buildings of Hobbiton and even the landscape itself.

On the other side of the emotional spectrum is the evil Sauron (above) whose menacing triangular shape runs throughout the design, from the sharp fingertips of his glove to the volcano on the landscape.

You can tell the entire *Lord of the Rings* story in shapes, with the good, circular Hobbits traveling from a safe, circular landscape to a dangerous triangular environment and back again. Appropriate colors and textures reinforce the emotional concept of each character.

UNIQUE SHAPES = UNIQUE EMOTIONS

Designing with shape was once considered a radical departure from classical theory. But the two elements are very closely bound: circles relate to curved lines; the square relates to straight vertical and horizontal lines; and the triangle relates to diagonal and angular lines. Surprisingly, the ability for basic shapes and lines to communicate emotions is rooted in reality, as we'll now see.

Where do these concepts of soft rounded forms versus angular shapes originate? All around us in nature! Things that we deem safe tend to have rounded forms, while we're naturally cautious in the company of sharp, pointy triangles. Our instinctive reactions to these objects are based on the tactile sense of *touch*. In visual art this physical sensation is missing, though viewers react to these shapes based on their real-life experiences.

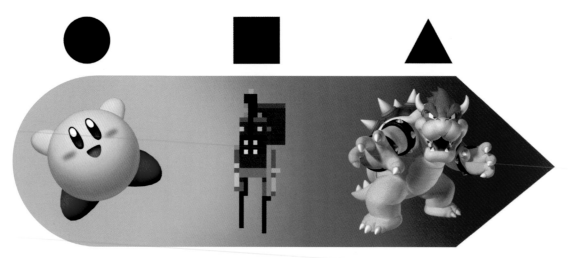

You can order the three basic shapes into a scale of emotions. From left to right: positivity and youthful energy (circles); strength and stability (squares); aggressive and threatening (triangles). Traditionally the circle and curved lines have also been used to communicate femininity and square or angular lines, masculinity.

Note how the well-known "good" characters on the left are designed around circular concepts, while the enemy characters in the right column are based on a dominant triangular concept. The silhouettes underscore the importance of designing characters around larger shape concepts and not details.

Mario

Even details should echo the character's overall design concept and the emotion you want players to feel once the silhouette of a character has been established. Practically every element of Mario has been designed around a friendly circular concept, including his mustache (two overlapping circles and a series of smaller round shapes). His torso too is modeled on a sphere, the three-dimensional representation of the circle.

Wario (left), Goomba (above)

If Mario was designed around a triangular concept instead of a circular one, he'd no longer be Mario, he'd be Wario (left)! By little more than sharpening a few lines the artists at Nintendo transformed a friendly character into a villain. Although the Goomba characters (above right), Mario's enemies, are designed around an aggressive triangular concept, their edges have been rounded to fit the overall friendly theme of the Mario universe. These three characters are an example of *style consistency*.

Frieze of Dancers by Edgar Degas

Repetition of shapes and echoing of movement can create a sense of *harmony*. Take a look at these beautiful ballerina renderings by Edgar Degas in which the artist drew the same figure from different angles, changing elements only slightly to create a feeling of harmonious movement.

OPPOSITE *Flower*

Soft, rounded shapes are the obvious choice for design-
ing an environment of natural, organic beauty. But you
need an element against which to measure this beauty in
order for players to fully appreciate the positive feelings
of the environment. *Flower* contrasts somber weather,
hard-edged rock, and manmade structures against
colorful fields, sunlight, and rolling hills to emphasize the
latter's natural beauty.

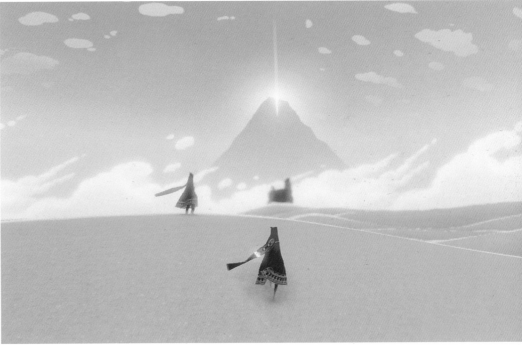

Journey

A sense of harmony similar to that in Degas's *Frieze of
Dancers* is evident in this screenshot from *Journey*, since
the playable character is nearly identical for every player.
A delicate harmony is created when this uniform design
is coupled with the character's graceful movement.

SUBVERTING CONVENTIONS

We can think of the primary shapes—circle, square, and triangle—as conventions that communicate common notions of good and evil, passivity and aggression, dynamic and static energy. These conventions are useful tools in game design, where it's often necessary that players understand the significance of their gaming environment as quickly as possible.

There are many instances, however, where players are afforded more time to become familiar with gameplay elements or when designers wish to surprise players with the unexpected. If players expect circular forms to be friendly and sharp shapes to be threatening, then designing a game where the opposite is true can create a sense of mystery, surprise, and depth. The video games featured below are among the most distinguished of all time because they went against design clichés to offer new and unconventional emotional experiences.

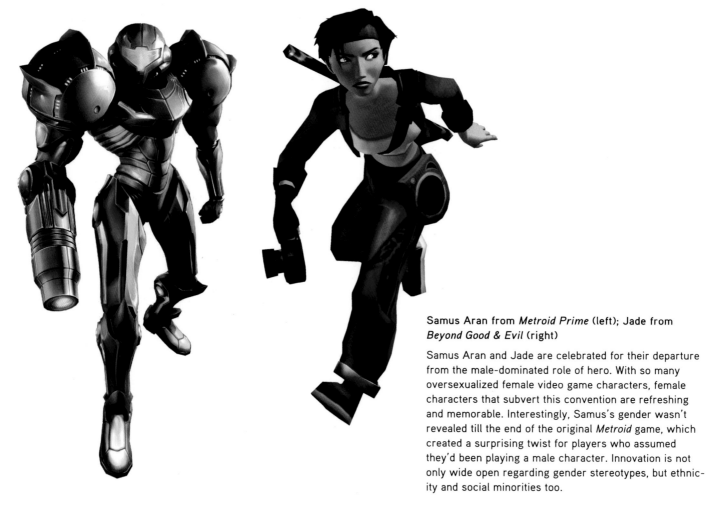

Samus Aran from *Metroid Prime* (left); Jade from *Beyond Good & Evil* (right)

Samus Aran and Jade are celebrated for their departure from the male-dominated role of hero. With so many oversexualized female video game characters, female characters that subvert this convention are refreshing and memorable. Interestingly, Samus's gender wasn't revealed till the end of the original *Metroid* game, which created a surprising twist for players who assumed they'd been playing a male character. Innovation is not only wide open regarding gender stereotypes, but ethnicity and social minorities too.

The Last Guardian (above and below)

The main protagonists in *The Last Guardian* are a young boy (see bottom left in the above illustration) and a strange mongrel creature. The friendship between the two characters is made visually ambiguous because of the creature's impressive size and aggressive-looking claws and beak. But, as in reality, not everything that appears ugly or aggressive is necessarily unfriendly or dangerous.

Rather than attempt to soften the threatening emotions created by the angular shapes of the mongrel creature, the designers expressly challenge player conceptions of good and bad. For example, there are instances in the game when the creature must aid the boy's progress through the environment by lifting him with its mouth.

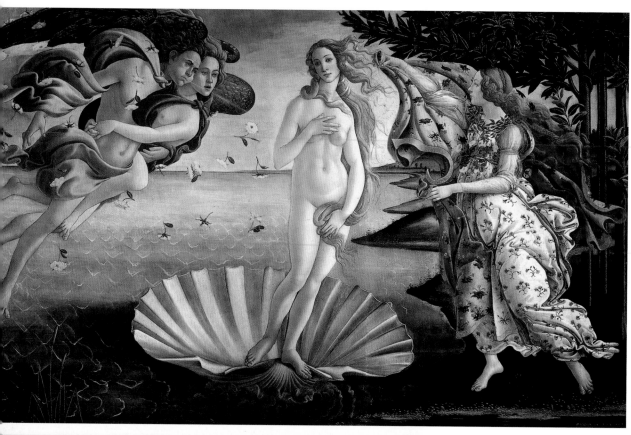

ABOVE *The Birth of Venus* by Sandro Botticelli, Uffizi, Florence

LEFT *Portal 2*

The villain in *Portal 2* is a great example of subverting conventions. Rather than sticking to the stereotypes of villainy in the form of an aggressive male character, the art team at Valve Software took inspiration from Sandro Botticelli's *The Birth of Venus* when designing the character of GLaDOS. The opposing curves that run gracefully down the length of Venus's body have been translated to the inverted mechanical body of GLaDOS, turning the Renaissance icon of feminine beauty on its head, both literally and metaphorically, to create one of the most memorable and emotionally complex video game characters to date.

BioShock: Rapture (Artwork courtesy of Irrational Games)

The character designs in *BioShock* incorporate an interesting play on conventions. The Gatherers, who are the innocent-looking girls inhabiting the dangerous dystopia of Rapture, are at odds with what players would likely expect to encounter in such an environment. The young gatherers create a visceral contrast to the violence featured in the game.

LEVEL UP!

The design concepts discussed in this chapter are essentials every artist should be familiar with. There are many more design concepts to learn, and the bibliography at the back of this book is a great place to start. But having now completed Level 5, you are sufficiently armed to create your own characters and environments. Artistic theory can only take you so far; for the rest you must learn to use imagination and your own unique artistic expression with the help of the techniques in the following level.

LEVEL 06 [CHARACTER DESIGN

IT IS OFTEN ASSUMED THAT CREATIVITY IS SOMETHING that you're born with: either you have it or you don't. Although some people may be more naturally gifted than others, creativity and exercising your imagination can also be learned and developed. This level will give you a reliable process for creativity so that you need never be lost for ideas when designing characters (this same process can be applied to environment design, game design, and, for that matter, to creation in any artistic discipline). The structured process of defining your design goals before researching and character development will also ensure that you can visually engineer your designs to express specific ideas and emotions.

World of Warcraft (Artwork courtesy of Blizzard Entertainment)

GOOD STUDIO PRACTICE

Some triple-A development teams consist of more than a hundred developers, including programmers, marketing teams, producers, and artists, each with their own unique take on the game being developed. That's a lot of ideas and egos to balance! So before we begin looking at the creative process, here are a few suggestions for good studio practice to consider:

01 Develop cross-sections of the game rather than focusing on one aspect. This means developing the whole range of characters and environments in unison, rather than finishing one character or environment at a time. The quicker you can block in one entire cross-section of the game, such as a playable demo level, the easier it'll be to judge the full scope of your game and make comparative decisions.

02 Present your work daily to members of your team. Artists often find daily presentations an uncomfortable chore because few want to show work they deem unfinished. But daily presentations are good because the key concepts can be refined through quick iterations and team feedback before precious time is spent on details and polish.

03 Make your inspiration and artwork visible. Never assume at the end of a discussion that everybody is thinking along the same lines. Draw it! Hang your latest work on the wall, so that everyone can visualize the product they're working on as soon as it's realized.

Media Molecule, the studio behind *Little Big Planet,* goes one step further and dedicates a corner of the studio to artwork created by its fans and quirky furniture that echoes the franchise's handmade concept. (Image courtesy of Media Molecule)

BRAINSTORMING AND CHARACTER CONCEPT

This section will provide you with tools to be creative on demand. Make these tools an instinctive part of your design process and you'll likely never be lost for ideas.

The first question you or your team should ask is not What game should we build or How do we build a game? The lead question of any creative endeavor is *What is the emotional experience we want our audience to feel?* The *high concept* serves this purpose.

The high concept is a simple paragraph that defines your design goals clearly and concisely. You can think of it as the game summary that you'd find written on the back of a video game box. Who defines the high concept varies:

A game publisher may submit a high concept outline to a development team

The development team may create its own high concept

A high concept may be derived from an existing story, such as a book, a film franchise, or a real-life event or experience

Whatever the scale and premise of your project, make a habit of developing a high concept before commencing work so that you can design with intent. Once a high concept is established for the entire game, take the time to develop similar concepts for each character, group or race, and environment to be featured in the game.

A high concept is assembled from *keywords* generated during a *brainstorming* session. Keywords are a small selection of adjectives that together summarize an entire concept.

To help structure the brainstorming session, write out the following checklist of key design concepts for you or your team to consider and come up with keywords for each:

Emotion

Color

Shape

Texture

Line

Speed

Size

Opposing concept

Let's say that your task is to create a character for a hypothetical game about exploring a fantasy landscape populated with fantastic creatures and vegetation. The types of questions you should ask are: What emotion should the character communicate? What colors do we associate with such a character or environment? What shapes are invoked in our imagination when we think of fantastic creatures and vegetation? And so on, through all the concepts. Any association that comes to mind gets written down, whether it's a memory from an exotic holiday in the tropics or a plant from the backyard.

Keywords should be adjectives, not nouns, because adjectives, like *friendly*, *strange*, or *dangerous,* describe emotions. Using keywords like these as search terms for visual research will return a broader and unexpected set of results than searching for specific objects.

Include keywords that are conceptually in opposition to your main theme. As we saw in Subverting Conventions (pages 184–187) you'll add a greater element of depth and interest to your design if you include visual contrast.

Once you and your team have exhausted the idea process, formulate your keywords into a concise high concept that summarizes the character(s) and environment(s) you want to produce. Highlight the selected keywords, as in the following example, which we'll use as a launch pad for gathering visual research.

CHARACTER CONCEPT FOR [Character name]

The [...] is a race of creatures whose lines, shapes, and colors mirror their lofty home of strange, natural beauty. These creatures are delicate, gentle, and quiet in contrast to the dark and aggressive [...] creatures that live nearby.

SUPPORTING KEYWORDS
OPPOSING KEYWORDS

Developing up from a high concept and a series of character and environment concepts provides the entire team with common reference points against which to judge the suitability of design decisions. Only once you've defined your goal are you ready to begin the character development process. But before we begin the first stage of development, which is research, we need to understand what the process of transforming words from our high concept into images actually involves. And this is done through *visual metaphors*.

VISUAL METAPHORS

We are all aware of metaphors in literature. Metaphors like "icy stare" and "beaming smile" are used to imbue objects or actions with greater emotional significance. Visual artists can use metaphors in much the same way, sometimes taking inspiration from the most unlikely places. All the images you find in the research stage can be turned into visual metaphors.

Every day you encounter many attention-grabbing visuals, and every one of them has the potential to be developed into a video game character or environment, whether it's the *gravity-defying height, solidity,* and *scale* of a skyscraper or a *creepy, shriveled* dead spider.

When you see anything that piques your interest, make a habit of drawing quick black-and-white *thumbnail* sketches of it in your sketchbook, spending just enough time to capture the primary element of interest, as in the sketches to the left.

Reducing objects to black and white silhouettes masks their original identity. Once you have a shape that captures the abstract qualities of the original source it becomes easier to imagine it as something else entirely.

The abstract shape of the dead spider above can be turned into a creepy, arachnid-shaped hairstyle and the skyscraper into a sturdy and imposing character. Viewers may not recognize the underlying visual references but they will likely get a sense of their associated emotions.

Though the spider and skyscraper can both be used as abstract shapes for a character, they don't fit our character concept that features keywords *natural beauty* and *light,* which the spider and skyscraper do not embody. So put these drawings aside for a more appropriate future project.

MIND-MAP, RESEARCH, AND MOOD BOARD

Thorough research is one of the key factors that distinguish professional artwork. Your aim is to become an expert on a given subject so you can create believable characters and environments with a sense of authenticity. If you have the time to do firsthand research—sketching on location, life drawing sessions, etc.—then be sure to take full advantage of the opportunity.

Once you know what emotions you want players to feel, begin researching images that abstractly embody these feelings in the form of visual metaphors. Creating a *mind-map* will help you research diverse concepts and images, so you can avoid drawing the first, most obvious thing that comes to mind.

While the character concept is based on adjectives that describe desired emotions and feelings, the mind-map looks for nouns that reflect the character concept's emotions. Let's go through the research and development process for our character together.

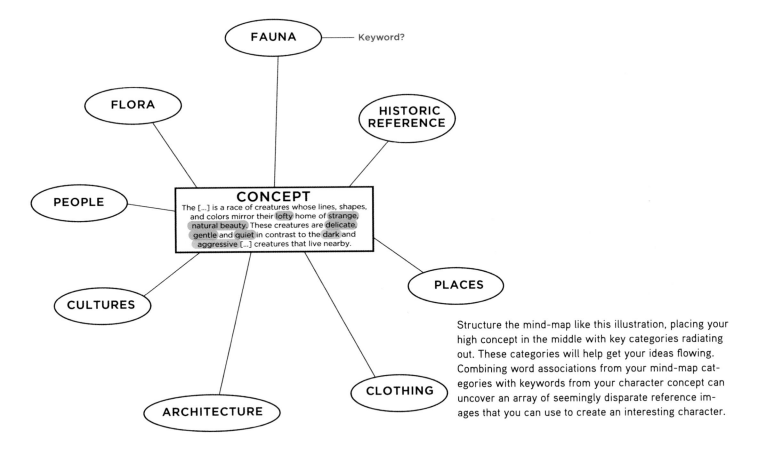

Structure the mind-map like this illustration, placing your high concept in the middle with key categories radiating out. These categories will help get your ideas flowing. Combining word associations from your mind-map categories with keywords from your character concept can uncover an array of seemingly disparate reference images that you can use to create an interesting character.

If you're drawing several thumb-nails on one page, it's a good idea to place a clean sheet of paper under the heel of your hand to avoid smudging your work as you move across the page.

The character keywords *delicate* and *natural beauty* produced the visual research results of flora, leaves, and trees. When you make a study of each research image, draw it as a simple silhouette without details. You're looking for a design that abstractly communicates the keywords in the character concept.

By drawing every photographic image that interests you, you'll begin to get a feeling for the lines and shapes that will eventually be incorporated into the character design. Usually the character begins to evolve naturally through this repeated process of researching and sketching.

OPEN SPACES.

SIMPLE SHAPES.

VERTICALS
+
HORIZONTALS

BALANCE

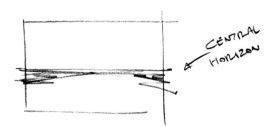

CENTRAL
HORIZON

Research into the character keyword *silence* yielded images with sparse and simple composition elements composed of vertical and horizontal lines. Therefore, the goal for this particular character design is to avoid using too many diagonal or curved lines and noisy details. Feel free to annotate your drawings to highlight the key design features that you'll want to incorporate into your final character design.

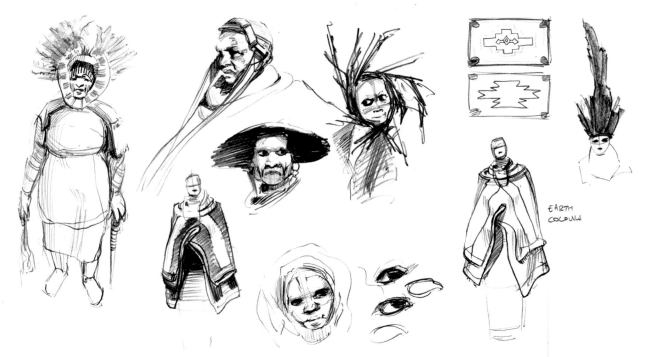

When it comes to your characters' clothing, think about the resources and textiles available in their environment. In this example, the nature references in the character concept led to research of African tribal groups, although you might choose different ethnic or geographic avenues of research.

Often you just stumble upon interesting and suitable reference images by chance. In this case it was the garments of the Ndebele tribe of South Africa. They have simple design patterns and silhouettes that will be helpful in designing a simple character shape, which is the goal here.

After making these sketches, save your original source images in a folder on your computer so you can refer to them in future. (And you'll be able to use them for the exercises in Level 8.)

Visual metaphors for the keyword *delicate* were found in "dry, dying leaves," some of which resembled a poncho, which was then likewise researched. Keep in mind that the quality of these research sketches doesn't have to be great, as they're primarily to be used as your own personal library of reference images. Draw only as long as it takes to visually note the main element of interest and ignore or suggest the rest.

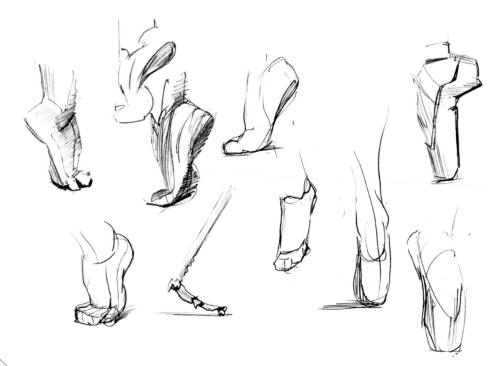

Display your most inspiring research drawings, character concepts, and images around your workspace to create a *mood board* that can serve as a shared reference for the entire team.

Keywords *light* and *gentle* also influenced research for the character's feet, starting with the search term "tiptoe." This didn't seem light enough, so further research was made into "ballet feet" and there was even a brief investigation of "grasshopper leg." You can never predict when and where you'll discover suitable visual metaphors, so it's worth exploring everything that comes to mind for the chance that it'll take the design in an unexpected and exciting direction.

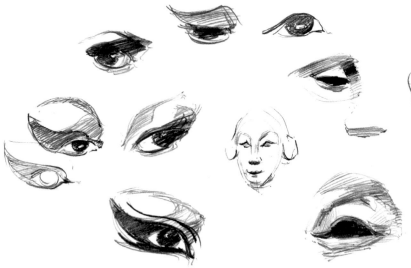

Research for the character's eyes began with sketches of images from a great book called *Decorated Skin: A World Survey of Body Art,* by Karl Gröning (Thames & Hudson). But the eyes appeared too alive and visually noisy for the keywords in the character concept, so the search term "quiet face" was researched, which uncovered images of "ancient Chinese sculpture" that featured more suitable eyes. Notice how even the eyes echo the leaf concept of the character.

THUMBNAIL DEVELOPMENT

Because researching images on the Internet and thumbnail sketching is so quick, it's easy to explore several visual ideas in the space of just a few minutes. When you combine these tools with your innate ability to recognize meaningful shapes in random objects (apophenia), you'll arrive at a process that is fast-paced and excitingly unpredictable. There's a great wealth of fascinating visual information to be discovered, and your task is to select the appropriate inspirations and then marry diverse visual concepts together to create a coherent character design, a process called *thumbnail development*.

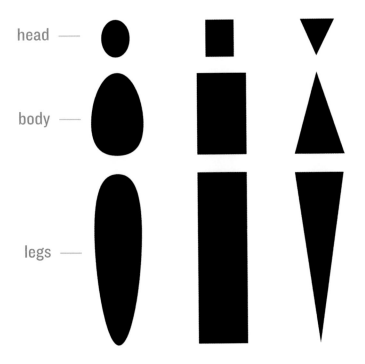

head

body

legs

To determine a body shape for your character, review and assess your sketches from the visual research produced by your keywords and mind-map. Select shapes that most closely match the character concept.

A first step to developing an abstract shape into a character is to decide where to place the head, body, and legs. This process of personification need not be complex. Primary shapes—the circle, square, and triangle—play a key role in communicating emotions, so even at this early stage it's worth considering which shapes best fit your high concept. Try to echo the overall shape from your thumbnail sketch in the body parts.

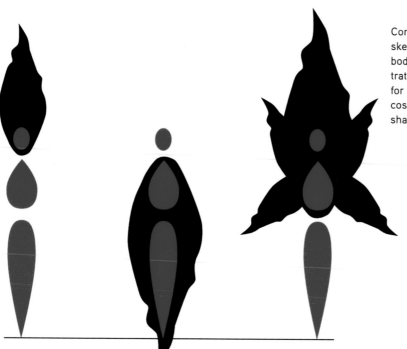

Combine the basic body shape with the thumbnail sketches of leaves from page 194. Play around with the body's placement within the shape of each leaf, as illustrated here. From left to right: the leaf becomes headgear for our character; scaling it up it turns into a full-length costume; rotating, flipping, and mirroring our abstract shape creates even more possibilities.

Steadily begin combining the personified abstract shape with elements of your research, starting with very simple lines and shapes. By keeping your drawing simple for as long as possible, you'll be less reluctant to make bold changes and more inclined to experiment with proportions than if you were to start out with detailed drawings.

Here you can see how the base shape of a simple leaf is combined with various research sketches (pages 194–197) including Ndebele tribal clothing, dead leaves, faces from ancient Chinese sculpture, and a poncho.

Think of the composite sketch as a mannequin over which you can loosely try out different visual ideas.

Talk yourself through the design, challenging each decision in reference to the character concept. How can you communicate keywords like *lofty* and *strange* featured in the character concept? Here an impressive proportion of 10 heads goes some way to convey both keywords.

What is the character's anatomy and underlying structure over which its flesh and clothing is draped? How would the character move? Aim to incorporate a system of opposing curves throughout your character designs for a believable sense of energy and life. As noted in Gravity and Movement (page 60), without opposing curves movement would not be possible. Return to research as often as necessary. Gestures for the hands were investigated using the search term "delicate hands."

It's time to assess how well the character silhouette is working as an abstract shape. Trace or copy it onto a new sheet of paper and block it in with a single value of shading. Do the elements of the character remain distinguishable when you stand back from the drawing? Does the silhouette sufficiently communicate the keywords in the character concept?

Angle changes that are too subtle tend to disappear entirely when viewed at a small resolution. Therefore, it's important to exaggerate elements of the silhouette for the purposes of visual interest and clarity. For instance, where you have two overlapping elements it is often a good idea to exaggerate the angles between the two elements so as to define them as separate (highlighted in red).

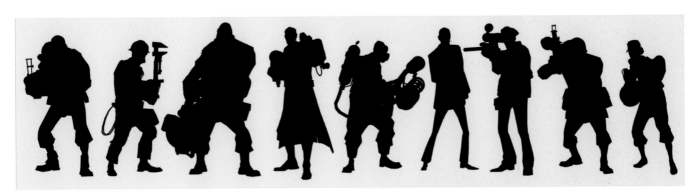

Team Fortress 2 (Artwork courtesy of Valve Corporation)

The art team at Valve that developed the cast of *Team Fortress 2* did a great job creating characters with silhouettes that are easily distinguishable and have a strong suggestion of personality without the need for supporting details. Notice how angles between elements of each figure are often acute—such as the transitions from boots to trouser cuffs—adding visual clarity, even when characters are viewed at a small scale.

FINAL CHARACTER DRAWING AND MODEL SHEET

With the thumbnail stage complete, we've tackled the hardest part of character design—communicating a character's concept through its silhouette. At this point, you might want to switch to developing other characters and environment silhouettes so you and your team can begin to get a good visual overview of the game, and make visual comparisons, which may influence your character's final design.

In Elements of Design (page 145) we saw several examples of games that successfully echo the high concept at every level of detail. The character being developed in this chapter has now evolved to visually communicate its concept keywords, including *nature, silence, delicate,* and *light,* through its silhouette. Details like body parts, decorations, and textures should also echo the character's overarching concepts or enhance them through contrast.

It's important to keep in mind that any details you add in subsequent stages should not disrupt the form that has been designed so far. Details should assimilate into the design and not change it altogether.

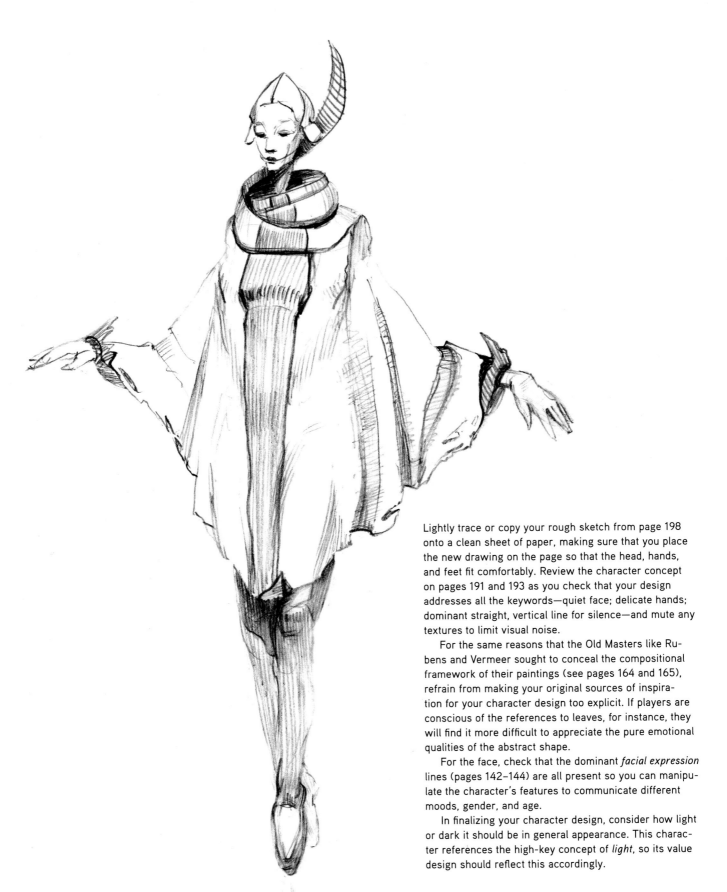

Lightly trace or copy your rough sketch from page 198 onto a clean sheet of paper, making sure that you place the new drawing on the page so that the head, hands, and feet fit comfortably. Review the character concept on pages 191 and 193 as you check that your design addresses all the keywords—quiet face; delicate hands; dominant straight, vertical line for silence—and mute any textures to limit visual noise.

For the same reasons that the Old Masters like Rubens and Vermeer sought to conceal the compositional framework of their paintings (see pages 164 and 165), refrain from making your original sources of inspiration for your character design too explicit. If players are conscious of the references to leaves, for instance, they will find it more difficult to appreciate the pure emotional qualities of the abstract shape.

For the face, check that the dominant *facial expression* lines (pages 142–144) are all present so you can manipulate the character's features to communicate different moods, gender, and age.

In finalizing your character design, consider how light or dark it should be in general appearance. This character references the high-key concept of *light*, so its value design should reflect this accordingly.

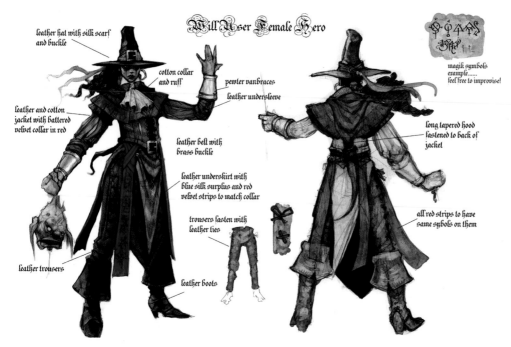

leather hat with silk scarf and buckle

cotton collar and ruff

pewter vanbraces

leather undersleeve

leather and cotton jacket with battered velvet collar in red

leather belt with brass buckle

leather underskirt with blue silk surplus and red velvet strips to match collar

trousers fasten with leather ties

leather trousers

leather boots

Will User Female Hero

magik symbols example...... feel free to improvise!

long tapered hood fastened to back of jacket

all red strips to have same symbols on them

Model sheet from *Fable 3*, ©Microsoft Game Studios, 2010

The approved final drawing should be combined in a *model sheet* that will be used as the key reference document by other members of the team. Here is an example of a model sheet for the game *Fable 3*. The model sheet gives you an opportunity to annotate your designs with information that may be useful to other members of the team, including references to fabrics and textures. Cut-away drawings have been included for elements that are obscured by overlapping details.

LEVEL UP!

Collecting reference images is relatively easy. Combining them to create just the right character may take hours, days, weeks, or even months. Whatever your schedule you'll *always* wish you had more time to develop your design further, but it's better to present your concepts to the team sooner rather than later. The team may either like your character design, ask for a revision of certain details, or turn down the concept altogether if the design is found to be unworkable for technical or other reasons. Luckily, you now have a fast process for researching and developing designs, so any suggestions or feedback can be quickly explored before your team commits to the timely and costly process of turning your drawing into a working 3D model for the game.

Repeat the four steps of character development—selecting a concept, researching the concept and keywords, developing the thumbnails, and refining the character—until they are instinctive; then you'll always have the design tools to be creative on demand and to be inspired in new and unpredictable ways.

LEVEL 07 [ENVIRONMENT DESIGN

THE PROCESS OF CREATING ENVIRONMENTS AND PROPS is very much the same as the process for character design. The concepts for all your game's assets (characters, animations, environments, props, game menus, cover art) should derive from the same high concept and mind-map if there is to be unity between characters and the imagined environments they inhabit. As with characters, the shapes you choose for your environment design have a huge influence on whether it feels welcoming, threatening, or neutral. In fact, it helps to think of buildings, in particular, as living objects rather than lifeless inanimate structures, as they have much in common with characters when it comes to affecting the player's feelings while engaged in a game.

ICO

CHARACTER/ENVIRONMENT SHAPES

Which character/environment shape combination is best suited to your particular game depends on the high concept and the emotions that you want players to feel when they take control of a playable character. The character/environment relationship may even change dynamically over the course of the game to create different emotions as the player progresses, much like the journey of Frodo and Samwise Gamgee in the *Lord of the Rings* trilogy (page 178).

HARMONY

DISSONANCE

DISSONANCE

HARMONY

The shapes in the illustrations (left) represent characters and the environment. When you design an environment that echoes the shapes of its inhabitants, you create a sense of *harmony* between the characters and the environment. If you relocate the very same characters to an environment with opposing shapes, you create a sense of *dissonance* between them.

It's interesting to see how the top left and bottom right examples are both instances of harmony, yet create very different emotional feelings due to the primary shapes used. The top left example communicates a sense of dynamic and positive energy while the triangular environment at bottom right feels more threatening.

The two examples of dissonance likewise create two distinct emotions. In the top right example, the circular character appears vulnerable in the triangular environment, while in the bottom left example the triangular shape of the character is the aggressor in a passive landscape.

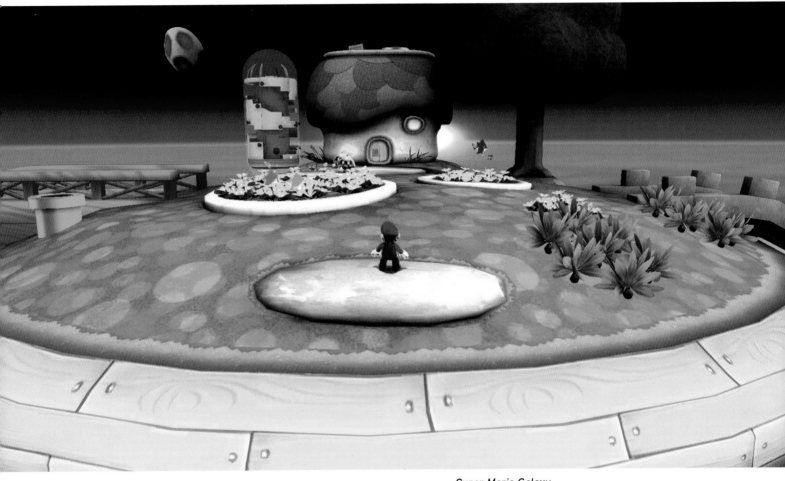

Super Mario Galaxy

An example of a harmonious character/environment re-
lationship is found in many of the worlds from the Mario
franchise. Conceptually, you can think of Mario's task as
being to restore harmony by ridding his circular world of
aggressive triangular characters.

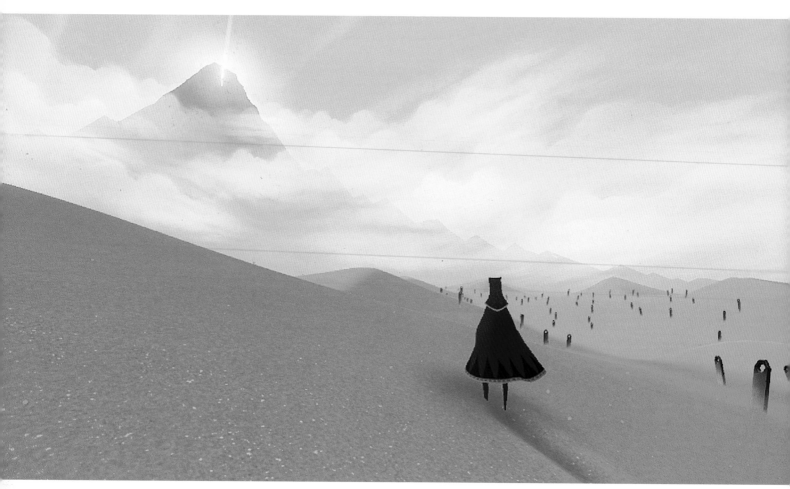

Journey

The game *Journey* has a triangular character within a triangular environment, another example of a harmonious character/environment relationship. But the feeling generated by the *Journey* environment is very different from that of Mario's due to the different underlying shapes.

MORF

Morf

The browser-based game *Morf* features both harmonious and dissonant shape combinations to explore the influence that shapes alone have on player emotions. You can play the game by visiting www.solarskistudio.com.

BUILDING CONSTRUCTION

Computers make it very easy to create digital objects that are mathematically perfect. There's a seductive quality to snapping a building into place using automated alignment tools. But much of what distinguishes reality from digital space is *imperfection*. With increasing age houses begin to sag, the roof tilts, and nature begins to reclaim the environment.

It's this sagging and sense of weight that is very interesting to game artists. When an actual person stands in front of a real building they can reach out and touch it to test its solidity. They can even go inside and walk around to experience the ins and outs of its structure. With video games, players experience dislocation of the senses since what they see cannot be physically experienced.

Therefore, it's the artist's job to enhance the feelings of weight and solidity in video game environments using visual cues established by their experiences and observations through firsthand research and the concepts of gravity explored in Gravity and Movement (pages 60–67).

If you're drawing a particularly complex landscape, a series of buildings, or an interior, you may want to use a 3D digital modeling program—such as Google's SketchUp: http://sketchup.google.com—to help visualize difficult perspective. Quickly block in the scene in 3D using basic volumes (paying no attention to lighting or textures) before printing out a screenshot and lightly tracing the 3D scene onto a new sheet of paper. Continue to refine your ideas freehand. Be sure such shortcuts don't become a substitute for sound knowledge of perspective!

TAVERN

FABLE 2

Fable 2: Tavern, ©Microsoft Game Studios, 2008

For character design we did an extensive study of anatomy, in part to understand the all-important skeletal structure that holds the figure together. In creating environments the artist must make a similar effort to understand the skeletal structure of buildings and the forces involved in keeping them upright.

Historical buildings naturally lend themselves to emphasizing the prolonged effects of gravity and wear. The structure, or anatomy, of the tavern from *Fable 2* can be clearly seen, with asymmetry and sagging between supportive elements being the key to creating a believable sense of weight and age.

LEFT **Doric columns in the temple of Hera, Paestum, Greece**

Greek columns in the Doric style were not designed to be perfectly straight. The columns are in fact bowed, creating a feeling of tension under weight, like that of upraised arms with muscles bulging in support of the temple roof.

BELOW Wherever possible, it's advisable to suggest the underlying structure of a building so that you can better consider how the structure would remain upright against the forces of gravity.

Don't be afraid to deform the structure to communicate an imagined weight, even if you're creating an environment based on reality. Otherwise your buildings may look like weightless virtual boxes without mass.

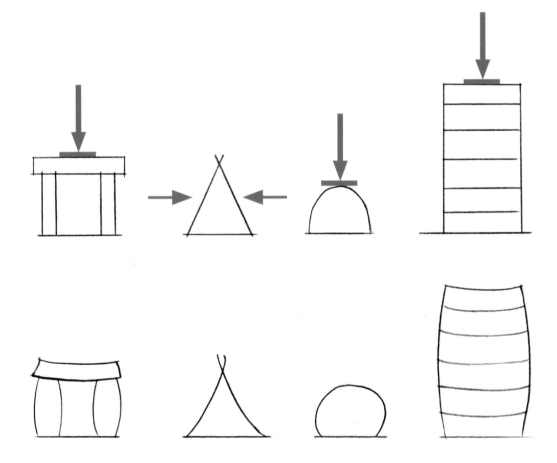

The connection of the base of a building with the ground is very important, particularly when designing high-rises. Architects understand that people experience a psychological discomfort if the bases of these massive structures don't have features that communicate a sense of solidity.

In classical Greek and Roman architecture this visual problem was solved with the base or steps of the building creating a gradual transition to the ground. In modern design, architects sometimes use the surrounding environment to visually blend the building's connection with the ground and to create the illusion that the weight of the building is somehow affecting its surroundings.

Mirror's Edge

Another consideration for environment design is to give buildings a sense of life because you want the buildings to look inhabited. Consider what external features might give clues as to who or what lives inside.

Mirror's Edge is a great example of how the internal functions of buildings can be suggested externally. The flat skyscraper roofs where much of the action takes place are filled with things like air-conditioning units, elevator shafts, and cables. Think of buildings as living organisms that must be brought to life in the same way as a character.

Make a pencil study of this scene, noting how the view's high vantage point and the scale of the buildings requires the use of three-point perspective (pages 24–25 and 41–43). Once you've blocked in the simple box form that represents each building, it'll become easy to gradually break it down into smaller forms and add details.

CHARACTER-CENTRIC ENVIRONMENT DESIGN

There are two possible approaches to environment design commonly used in games, and each is practical depending on whether you're adding a new environment to an existing world or creating an environment from scratch.

In the character-centric approach, you assume that the game visuals have already been defined and your task is to create new environments that fit into this imagined world. For this approach, begin by creating a character using the process explored in Level 6, Character Design (page 188–202) before working up to designing the environment and bigger elements. This may seem counterintuitive but it's based on the assumption that the inhabitants of an environment influence its shape.

Fable 3: Concept art for Auroran female and Auroran dwellings, ©Microsoft Game Studios, 2010

This character and building concept art from *Fable 3* demonstrates how a home environment can be designed to echo the character's concept. Once the characteristic design of the Auroran people was established, buildings were designed by combining decorative elements from their clothing. The buildings' architectural forms were influenced by the rocky landscape in which they live.

World of Warcraft: Blood Elves (Artworks courtesy of Blizzard Entertainment)

The art team responsible for ongoing development of *World of Warcraft* (*WoW*) has the task of adding new character races to the existing franchise. This process begins with a new character design that is compared to existing characters and environments to ensure that each new race has a distinct motif echoed in its environments and props. Once the new character design has been defined, props and environments are designed that echo the character's visual signature.

The race of Blood Elves features a motif that visually references the organic forms of spiraling branches with leaves in red, gold, and turquoise colors. The visual iconography that these characters embody is visually summarized in the race's shield and echoed in the props and environments that the characters inhabit.

OPPOSITE *World of Warcraft*: Troll Race (Artworks courtesy of Blizzard Entertainment)

The forms and colors unique to the Troll race make them easily distinguishable from Blood Elves and other races in the *WoW* universe.

The Troll race features a motif referencing elongated tusks and tooth-like wooden forms in purples and reds. The characters also feature relatively more negative space within their silhouettes than do the Blood Elves. This negative space correspondingly influences the forms of the environments they inhabit.

BELOW *The Legend of Zelda: Twilight Prince*: Link's house

Any abstract shape or form can be turned into a building in much the same way that you went about applying a head, body, and legs to your abstract shape in Character Design (page 198).

With buildings, however, you consider elements that represent a generic house: *doorway*, *windows*, *roof*, *pathway*, and possibly *levels* or stories. It's not always necessary to include every element, as a building can be suggested with little more than a path leading up to a doorway. But the design of a doorway should not be arbitrary as doorways carry a lot of symbolic value, communicating something about the character of who or what is to be found inside.

TOP-DOWN ENVIRONMENT DESIGN

If you're designing a brand-new game, then the top-down approach is the most appropriate because it ensures that the entire experience of the game is considered as a whole before individual components are designed. Begin with a high concept, adapting the process on pages 190–191 to consider your entire game, thus defining the overarching design goals that will influence every artistic decision.

As well as defining your design goals with a paragraph of text, you can also begin your project by identifying a visual source of inspiration that summarizes the emotions that you'd like players to experience. Keep in mind that it will still be necessary to communicate your visual source of inspiration textually, so that significant elements of its design can be communicated to members of the team working in nonartistic disciplines. This section features two games whose designers successfully translated both high concepts and visual inspirations to create acclaimed gaming experiences.

Whichever emotions you decide to create in your game, find or create an image that summarizes those emotions. The mood board serves this function, but so can a classical painting or even a piece of music. Now that you're at Level 7 you should have no trouble deconstructing your source of inspiration so that it can be translated to your video game.

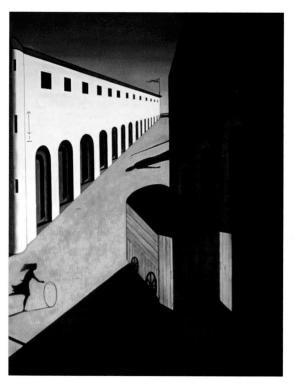

OPShTE AND ABOVE (left to right): *Mystery and Melancholy of a Street* (1914) by Giorgio de Chirico (1888–1978); *ICO* (2001) cover art and in-game graphics.

The top-down process begins with a question: What emotions do you want players to experience? Fumito Ueda, the director and lead designer of the critically acclaimed game *ICO*, was inspired by the artwork of Giorgio de Chirico and paintings like *Mystery and Melancholy of a Street*.

In terms of visual grammar, you can read the significance of elements in de Chirico's painting in the following way. The clearly defined edges between objects and the high walls create a feeling of disconnected spaces frozen in time. Solitary figures and objects hidden from view give the image a threatening melancholy, as do the deep shadows and triangular forms defined by an eerie light.

Although *ICO*'s visuals don't accurately mirror the aesthetics of de Chirico's artwork, Ueda has successfully translated the emotions of the painting by using a combination of visual abstraction and gameplay mechanics.

The lone girl seen playing in *Mystery and Melancholy of a Street* is now being guided by the game's main protagonist (also called Ico), symbolizing that the game's interactivity empowers players to help figures escape de Chirico's eerily desolate paintings. De Chirico's ominous shadows become *ICO*'s shadowy apparitions, threatening to snatch the girl, Yorda, away from the player at every step. The visual trappings of the painting translate to the confines of the prison castle and its static, vertical forms.

These visual elements work on an abstract level to shape the emotional experience for viewers and players, so understanding their function is paramount to creating powerful game experiences.

ABOVE *Journey* concept art by Jenova Chen

OPPOSITE *Journey* screen shot

After speaking to a NASA astronaut about his experiences seeing the Earth from space, Jenova Chen, thatgamecompany's cofounder and creative director, wanted to create this same sense of the sublime for *Journey* players. The sublime experience is often typified by feelings of insignificance in the face of massive scale and nature's perceived power.

Chen gave shape to his idea by creating concept sketches like the one at top, in which the visual ingredients convey the sense of the sublime he wanted to communicate in the game environment. Both the concept sketch and the finished game feature giant, vertical falls that create a sense of awe as the player moves through the environment.

GAMEPLAY MAP

The gameplay map is the representation of an environment from the top-down view. It features annotated points of interest, much like a fictional treasure map.

The gameplay map is the closest comparison we can make to classical compositions. Look at the painting by Rubens on page 165 where the composition features a network of two-dimensional paths for the viewer's eye to follow. This is what the gameplay map does for the game player. But a gameplay map also represents the potential routes the players can experience in three-dimensional space when they take control of a character. The way you shape the paths—whether with curved, straight, or angled lines—will greatly influence the emotions players experience as they move through the environment.

Gears of War: Gameplay map and logo

Gears of War is an excellent example of fractal design, where the overarching concept of the game is echoed at every level of detail from the logo to characters and map design.

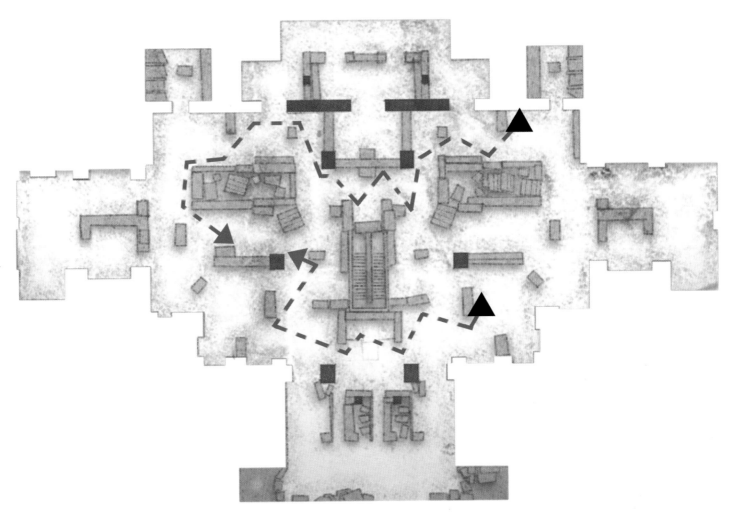

Gears of War: Map detail with overlay

The *Gears of War* franchise features whole maps based around the skull motif that is the centerpiece of the *Gears of War* logo. Although players may not be conscious of such overarching designs during gameplay, the shape of pathways along which they travel will nevertheless emotionally influence them. Because every element in *Gears of War* was designed with a coherent theme in mind, the game creates an exceptionally immersive emotional experience for players.

In addition to pathways, elements to consider annotating in a gameplay map include: exit and entrance points, districts or zones, landmarks, and special items and events.

Super Mario Galaxy 2

The top-down environment design process and gameplay map allow you to stand back from specific details of the game, so that you can contemplate the overarching emotions that you want to create for players.

The more you pull back, taking in the entire universe if possible, the easier it'll be to make all the details fit into place.

LEVEL UP!

The four elements of visual grammar studied throughout this book—value, line, shape, and volume—constitute our visual language. Their simplicity allows us to reduce emotions to their visual component parts, giving us the tools to design with intent and create heightened emotional experiences.

The one element of visual grammar that we haven't yet explored is color, which we'll turn to now. But before we do, take a moment to congratulate yourself on having completed Levels 1 to 7. Great work!

LEVEL 08 [COLOR AND DIGITAL TOOLS

UNTIL NOW, WE'VE FOCUSED ON DRAWING, as this is the foundation of all the arts. An additional part of every game artist's professional repertoire is to demonstrate an understanding of color and the ability to use digital tools, such as Adobe Photoshop and Corel Painter. Once you have the whole set of skills you'll be a very versatile artist indeed.

The following Color section will give you an overview of basic color concepts, including an introduction to the color wheel, color temperature, and color concepts for harmony and contrast. These lessons will give you confidence in your color selection and the application of color to your character and environment designs.

The Digital Tools section will show you a very simple process for adding color to your sketches using the layer features in Photoshop and Painter.

COLOR

Color can communicate emotions in a very primal way. Although the symbolism of colors varies between cultures, there are constants to be found in color practice that will help you significantly enhance the emotional messages of your designs.

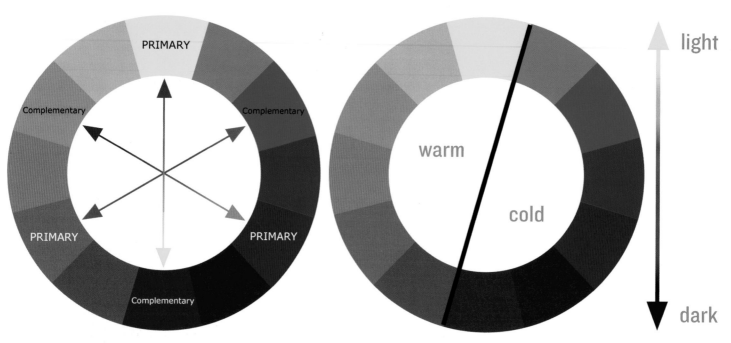

One of the primary functions of the *color wheel* is to order colors in a circle so that primary colors (red, yellow, and blue) sit opposite their complementary colors—the secondary colors green, purple, and orange.

You can also think in terms of temperature and split the color wheel into two halves, one side featuring *warm* colors and the other *cool* colors, dominated by either the warm orange or the cold blue.

A third way to use the color wheel is as a value scale, from the lightest color, yellow, to the darkest, purple, with all values in between being gradients of midrange values. This latter concept was a favorite of the Impressionists, who avoided using a black pigment, preferring to describe light and shadow with color.

YELLOW + RED = ORANGE

PRIMARY PRIMARY SECONDARY

The significance of the primary colors is that, in theory, every color in the spectrum can be mixed using just these three hues. Secondary colors are the result of mixing two primary colors together. Yellow and red, for instance, create the secondary color orange.

Complementary colors have a curious visual relationship to each other in that placing them side by side increases the intensity of each. Notice how the orange tile against a complementary blue background appears more intense and brighter than the tile of the same color against a red background. Complementary colors can be used to attract the viewer's eye to important items, as they create an eye-catching contrast that can be likened to black against white.

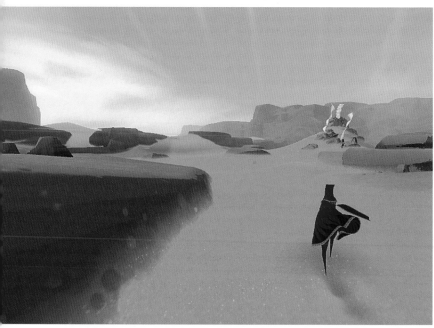

Journey

LEFT *Journey* takes advantage of color contrasts to create subtle emotional effects. In the opening desert section, the environment and character feature warm colors that sit very close to each other on the color wheel. The emotional effect of such closely related colors is one of harmony.

Journey

BELOW To create situations with more tension and unease in *Journey*, the red and orange colors of the character are contrasted with their complementary colors of green and blue in the background. In addition, the value key is shifted from high-key to low-key.

You must consider not only the color of objects but also the color of light. Light has different colors depending on its wavelength. The sun radiates warm colors in the range of red, orange, and yellow, which makes the color of illuminated objects appear warmer. If a cloud passes in front of the sun, then the blue light of the sky (which is the second brightest light source in a landscape) becomes the dominant light source and the very same objects take on a cooler hue. Therefore, it's the dominant light source that dictates the *temperature* of colors within a scene. When we speak of *color harmony*, what we're referring to is the overall temperature that unifies all the colors in an image.

As you get deeper into color, you'll find that there are even more subtleties to be discovered in terms of temperature. It's possible to have a *cool* red, or a *warm* blue. The two blues, for instance, sit very close to each other on the color wheel but the one on the right is positioned closer to the reds and oranges, making it warmer, just as the red on the left is cooler, because it's positioned closer to blue on the wheel.

Selecting which combination of colors to use depends on the overall light temperature in your scene.

Gustave Courbet's fascination with the phenomenon of light temperature is exemplified by these two paintings. Each has a distinct color temperature, even though they were both painted in the same region of the Jura Mountains. The painting on the left is cooler than the one below. What Courbet recorded are two different lighting situations, caused by atmospheric conditions and times of day or season, that have affected the colors within the landscape. Objects bathed in direct sunlight have a warmer hue (below) while a cloudy day makes the color of objects appear cooler and grayer (left).

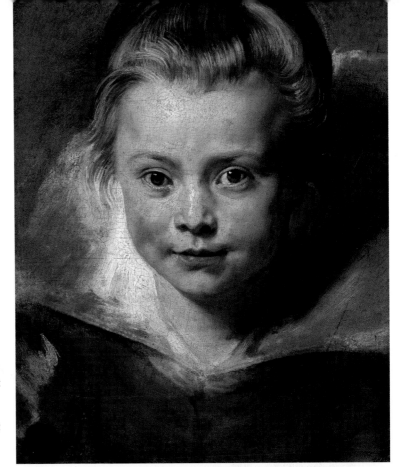

RIGHT *Portrait of Clara Serena* (ca. 1616) by Peter Paul Rubens

BELOW *Praying Hands* (ca. 1600) by Peter Paul Rubens

In figurative painting, the concept of warm and cool colors gives figures a sense of life and living warmth. These two paintings by Rubens illustrate the areas of the figure that are conventionally painted with reds to suggest warmth, indicating the parts of the body where blood vessels are closest to the surface of the skin: cheeks, nose, ears, fingers, knees, and feet. Cooler colors suggest skeletal landmarks. Note also that the "whites" of the eyes have a cool color temperature.

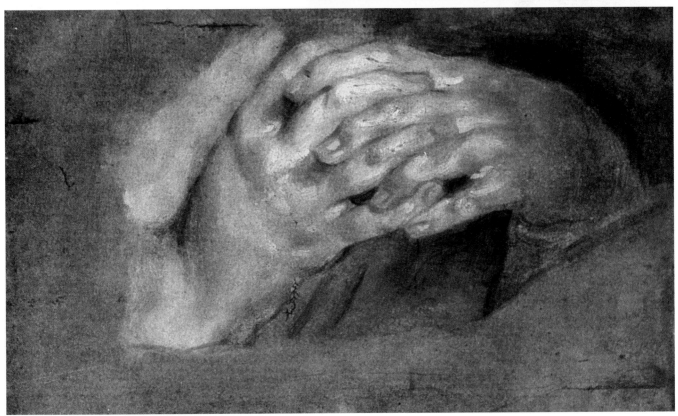

ADDING COLOR WITH DIGITAL TOOLS

Adobe's Photoshop and Corel's Painter are industry standard tools for digital 2D art. They both have fantastic features that allow you to experiment with and add color to your drawings.

I recommend that you invest in a graphics drawing tablet and pen, which is the best alternative to drawing traditionally. A computer mouse doesn't allow for the same level of dexterity.

One of the main advantages of Photoshop and Painter is their *layer* feature. The layer feature allows you to separate the stages of an image into more manageable steps, in fact mirroring the stages of creating a classical painting: a finished drawing followed by a black-and-white tonal painting over which glazes of color are added.

We will use Photoshop to illustrate the powerful features of layers for adding color. If you follow this process you'll have no trouble using the same process in Painter. Both programs are available on Mac and PC platforms and therefore share the same shortcuts. Here in the keyboard shortcuts *Ctrl/Cmd*, *Ctrl* refers to the PC platform and *Cmd* to the Mac.

The following steps assume you have a basic knowledge of Photoshop. Please refer to the Help menu within the program if you're unsure about some of the settings discussed.

Both Photoshop and Painter are excellent programs for digital painting. Some artists use both programs, taking advantage of their respective strengths, while others work exclusively in one program. Although Corel's Painter is somewhat limited in terms of photo editing capabilities, which are Photoshop's particular strengths, it surpasses Photoshop when it comes to mimicking traditional media. Different media will give your character and environment silhouettes different edge effects that may be more suitable for your style of game, such as a soft watercolor brush or the harder-edged round-tip pen.

A workflow that makes the program's tools transparent is as much essential in Painter as it is in Photoshop. Memorizing keyboard shortcuts for the most common tools will allow you to spend more time engaged with your artwork and less time navigating menus to switch between tools.

The great thing about Painter and Photoshop is that there's no single correct way of doing things. By experimenting you'll be sure to develop a personal workflow.

You can use the character you created, copied, and saved in Level 6 (pages 188–201) for your digital color practice exercises and lessons in the pages that follow.

Thirteen Most Commonly Used Photoshop Shortcuts

Cycle screen modes (F)

Cycle images (Ctrl/Cmd + Tab)

Step backward/Undo (Ctrl/Cmd + Alt + tap Z)

Hide selection (Ctrl/Cmd + H)

Brush Tool (B)

Toggle foreground/background color (X)

Restore default foreground/background color (D)

Sample color while Brush Tool is active (Hold Alt + LMB)

Zoom in (Ctrl/Cmd + Space + LMB)

Zoom out (Alt + Space + LMB)

Pan (Space + click and drag LMB)

Scale brush size ([to scale down,] to scale up)

Change brush opacity (0, 1, 2, 3 . . . 7, 8, 9)

Ten Most Commonly Used Painter Shortcuts

Eraser Tool (N)

Zoom in (Ctrl/Cmd + Space + LMB)

Zoom out (Alt + Space + LMB)

Pan (Space + click and drag LMB)

Rotate canvas (E)

Restore canvas (Hold E + LMB)

Scale brush size ([to scale down,] to scale up)

Change brush opacity (0, 1, 2, 3 . . . 7, 8, 9)

Straight lines (Hold Shift + click and drag LMB)

Toggle between main and additional colors (Shift + X)

If you want to experience the same freedom in digital painting that you have drawing with pencil on paper, you need to familiarize yourself with *shortcut keys*. Memorizing shortcut keys allows you to concentrate on creating your artwork without having to constantly look down at the keyboard or navigate to a menu.

Here is a list of the top thirteen most commonly used Photoshop shortcuts that will make the painting process easier. Shortcuts in Painter are very similar. Notice that the cursor changes to reflect the currently selected tool or action.

LMB refers to *left mouse button*. If you're working with a graphics drawing tablet, tapping the pen on the tablet will perform the same action as clicking LMB.

PHOTOSHOP DIGITAL PAINTING EXERCISE

Use the drawing from Character Design (page 201) for this exercise. Scan your drawing at a high resolution of 300 DPI, open it in Photoshop, and save it as a Photoshop file, with a PSD extension.

BLENDING MODES

Normal

Multiply

Color

Normal

Normal

You will create five layers in the Layers palette. Each layer should be set to a unique blending mode to perform its designated function. To change a blending mode, click the highlighted drop-down menu while the respective layer is selected. Notice that the Mask layer has been made invisible and that the Mask and Drawing layers have been locked.

It's worth naming each layer to keep your file organized and to make sure that the layers are ordered *exactly* as above. **Remember to click (Ctrl/Cmd + S) at regular intervals to save your work in case your computer should unexpectedly crash.**

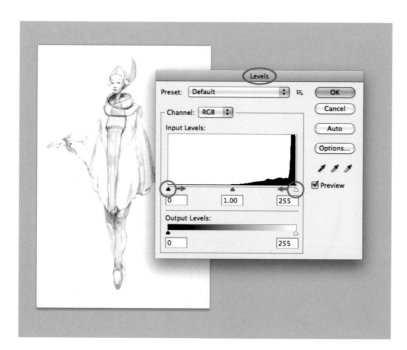

DRAWING LAYER It's fairly self-explanatory that the layer named Drawing is where you paste your scanned character sketch. Change the blending mode of the layer from Normal to Multiply.

It's essential in this layer that you remove any visible textures from the paper so that the background is pure white. You can do this by adjusting the image's contrasts using the Levels (Ctrl/Cmd + L) or Curves tool (Ctrl/Cmd + M). Finish by clicking on the Lock All icon to ensure you don't accidentally paint onto this layer.

MASK LAYER (LEFT), ACTIVE SELECTION (RIGHT)

On the layer named Mask you use your drawing as a guide to paint a black silhouette (left), making sure to keep the negative area detail-free. Fill in the silhouette using the Brush Tool (B) with a hard-edged brush, and finish by making the layer invisible.

The Mask layer will allow you to create a mask so you can paint within the contours of the character without worrying about accidentally painting over the edges. To activate the Mask, hold down (Ctrl/Cmd) and click on the layer's thumbnail in the Layers palette. The activated selection will be indicated by "marching ants" (right). Your paintable area is now restricted to the region within this selection. You can make this active selection less distracting by hiding it with the shortcut (Ctrl/Cmd + H).

When you want to paint outside this region, you have to deactivate the selection with the Deselect shortcut (Ctrl/Cmd + D).

Consider creating masks for individual elements, such as the head, legs, and hands, to make selection easier.

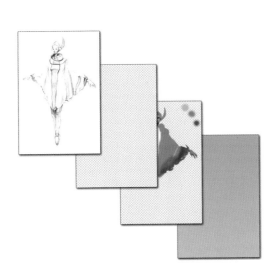

COMPOSITE To take the edge off the daunting white canvas, you can use the gradient tool (G) to create a mid-toned background on the layer named Background. Activate the Mask selection, choose the layer named Color, and you're set to begin painting!

The reason you set the layer named Drawing to a Multiply blending mode becomes evident as you begin painting. As illustrated in the composite image, the Multiply blending mode turns white areas transparent, so only the pencil lines are visible as an overlay. You can therefore experiment with color on the layer below without affecting the original drawing.

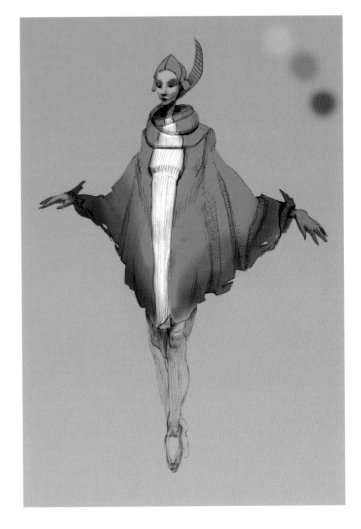

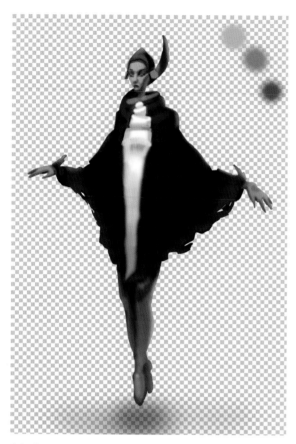

COLOR LAYER On the layer named Color, it's best to use a soft-edged brush set to the biggest size the area you're working in can manage, so that you can lay down more color in less time. Smaller, harder-edged brushes should be used for the finishing details.

Paint fairly monochromatically so that you can concentrate on establishing the lighting to create the illusion of form with core shadows and reflected light.

The three daubs of color in the top right-hand corner represent the three values used to paint the skin texture. (Three values are sufficient to model a form, as you saw in Advanced Lighting and Values [page 46]).

You can quickly sample colors from your image with the Brush Tool (B) selected by hovering the cursor over a color that you wish to use while holding down (Alt) and clicking (LMB). The color is automatically set as your brush color and you can continue painting. The colors you choose should reference the colors in your research mood board. You may even wish to sample colors directly from your reference images and apply them to your character.

GLAZE LAYER For the finishing touches you can add subtle variations of color by painting on the layer named Glaze without affecting the values that you laid down in the previous stage.

Set your brush to a low opacity of around 10–20 percent and use a warm red to add reddish tints to areas such as the nose, ears, and hands to give your character a sense of living warmth. You can also add cooler tints of color to create an interesting temperature contrast.

Finish by adding some overlap of color between neighboring objects so that they appear to reflect each other. This effect is called *color bleeding*.

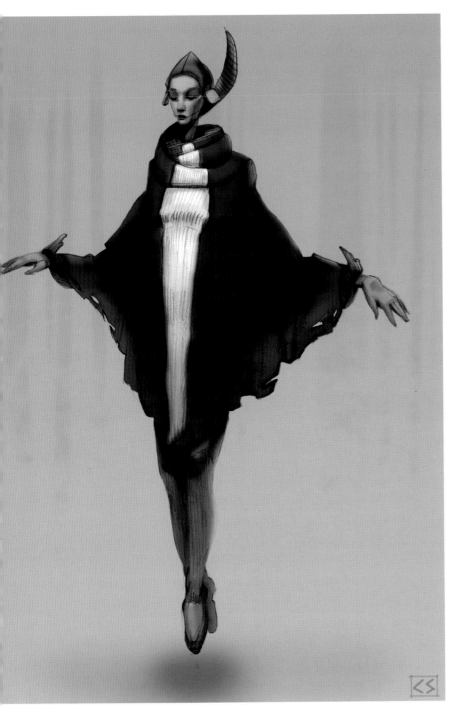

FINAL COMPOSITE The final composite consisting of a drawing overlaying a gradient background, a color layer, and color glazes.

LEVEL UP!

Great work finishing Level 8, which completes the technical chapters of this book! You now have a well-rounded set of skills that gives you freedom to add more and more emotional richness to your drawings and game designs. Continue practicing all the lessons from Levels 1 through 8, as mastery will only come once you've applied each lesson several hundred times. Very quickly you'll be able to visualize and create anything your imagination thinks up.

PROFESSIONAL PORTFOLIO AND GETTING WORK

Traditional drawing portfolios are still highly prized in the digital content industry. A portfolio demonstrating strong drawing and design skills is likely to stand out amid other portfolios that feature digital artwork exclusively. Some studios pay particular attention to gesture drawings (rapid drawing studies of live models in action, people in public, or animals, created in a very short time—as little as 10–30 seconds per sketch) because the practice of drawing from life demonstrates the true abilities of the artist. It is much easier to conceal any deficiencies of skills in a highly rendered drawing that may have taken several weeks to complete.

The following section will give you advice on how best to go about getting a job in game development, including portfolio preparation, self-promotion, tips for finding job vacancies and applications, and how to busy yourself artistically while searching for work. The tips will give you a comprehensive guide for getting your first exciting job in games.

LANDING GAME JOBS

If you're just coming to the end of your studies, the thought of looking for and finding a job might seem daunting. Don't despair; there is work to be found making games!

Think of finding work as your last level. Being professional and organized is essential. It's easy to slip into unproductivity if you're working outside of the industry or not yet employed, since there's nobody to define a schedule on your behalf. Set yourself milestones and daily schedules specifying the times at which you'll start and finish work each day and what you intend to achieve. Demonstrating that you can manage your own schedule and stay productive will ensure that you continue learning and will make you a more attractive candidate to prospective employers. Updating job placement agencies with new work on a monthly basis will give them a reason to take notice.

You may decide to start a project with friends from your studies or find collaborators through professional groups such as the local chapter of the International Game Developers Association (IGDA). IGDA's website offers a useful resource for breaking into the industry: www.igda.org/breakingin.

Essential Elements for Your Job Search

Before approaching a studio or job placement agency you'll need to prepare the following items:

PORTFOLIO OF IMAGES. Don't include every piece of work you ever created. Be selective and limit your choice to around ten images that demonstrate your abilities in terms of quality, attention to detail, and versatility. These images should be in both a simple digital format, saved as JPGs (or similar), and in a printed format (which you'll need for interviews).

If you're registered with a job placement agency then you may wish to contact your consultant to ask for their advice in tailoring your portfolio to specific jobs. It's in their best interest to give you good advice if they're to succeed in finding you work. It also shows initiative from your side, so take advantage of their experience and feedback and be gracious if they suggest improving aspects of your portfolio.

BUSINESS CARDS. You'll need a set of business cards to distribute at industry events and meetings. Simple business cards, which you can design and print yourself, are sufficient.

Include these details on your card:

Email	Landline number	Address
Website	Mobile number	

EMAIL SIGNATURE. Potential employers should have no trouble finding your contact details in every piece of correspondence, so make sure you create an email signature in your email program. It's surprising how often this vital piece of information is overlooked. Your email signature can be a copy of the information on your business card with additional links to relevant social networks, such as LinkedIn and Twitter.

RESUME AND COVER LETTER. Limit the length of your resume to one page, removing any unrelated employment information and writing "more information provided on request." in its place. The cover letter should be a relatively informal and short introduction to you, your background, and ambitions, while the resume focuses on academic and professional achievements, detailing specific skills and experience.

JULIE SMITH

CONCEPT ART
ILLUSTRATION
PHOTOGRAPHY
WEB DESIGN

Wrong: It's a definite no-no to list all your skills for your job title, as in this example.

JULIE SMITH

CONCEPT ARTIST
email
website
telephone number

Right: Potential employers prefer to see that you're focused on one career, so be selective.

WEBSITE. Flashy websites can look impressive, but a simple website to promote your work can be just as effective. Design your website using a simple layout that makes it easy to browse your work and features your contact details prominently.

It is good practice to create sites that don't require visitors to download plug-ins and that can be viewed on a mobile phone browser. Include information such as your resume, making your website a one-stop source of information for all your activity. Maintaining an online blog with daily or weekly updates also helps promote your activity.

As with every other aspect of your work, attention to detail equals professionalism. Double-check your spelling in every email you send out and reply to questions in a timely manner.

Game Job Placement Agencies

Once you have everything ready, a good place to start searching for work is to sign up with a job placement agency that specializes in game development. The bigger recruitment agencies source jobs from all over the world, so don't limit yourself to contacting local agents. It'll be easier to find employment if you're willing to relocate since game development studios tend to congregate in select locations of the world.

U.K. and U.S. job placement agencies:

Datascope Recruitment Ltd., www.datascope.co.uk

Women in Games Jobs, www.womeningamesjobs.com

Aardvark Swift, www.aswift.com

Games Recruit, www.gamesrecruit.co.uk

Change Job, www.change-job.com

Wired Talent, www.wiredtalent.com

Game Recruiter, www.gamerecruiter.com

Game Developers and Job Directories

Some studios avoid using job placement agencies altogether, preferring to advertise vacancies through their own website. So it's worth checking in with your favorite developers or visit open job directories such as:

Gamasutra, www.gamasutra.com/jobs

ConceptArt.org, http://jobs.conceptart.org

EDGE, http://jobs.next-gen.biz

GamesIndustry.biz, www.gamesindustry.biz/jobs

GameJobHunter, www.gamejobhunter.com

Game Industry Grunts, www.gameindustrygrunts.com

LEVEL UP!

If you have the opportunity to email your resume directly to a studio, then this first contact should be short and concise. Most people would prefer to receive a short email where you introduce yourself and provide a link to your website. Avoid sending emails with image attachments, as they don't always make it through Internet security firewalls.

The more studios you contact the better because you'll likely get one response for every twenty studios you contact. Some companies only respond to follow-up emails, so if they don't contact you within a week or two after your first contact or interview, send them a brief and friendly email.

In the meantime, consider starting your own game development project. Game development is so cheap and accessible with today's technology that there's no reason why you can't flex your skills in a self-made team, particularly in the space of mobile game development.

All the best!